Art and Enlightenment

Scottish Aesthetics in the Eighteenth Century

Edited and Introduced
by Jonathan Friday

ia

IMPRINT ACADEMIC

Published in the UK by Imprint Academic
PO Box 200, Exeter EX5 5YX, UK

Published in the USA by Imprint Academic
Philosophy Documentation Center
PO Box 7147, Charlottesville, VA 22906-7147, USA

ISBN 0 907845 762

A CIP catalogue record for this book is available from the
British Library and US Library of Congress

Contents

Series Editor's Note

The principal purpose of volumes in this series is not to provide scholars with accurate editions, but to make the writings of Scottish philosophers accessible to a new generation of modern readers. In accordance with this purpose, certain changes have been made to the original texts:

- Spelling and punctuation have been modernized.
- In some cases, the selected passages have been given new titles.
- Some original footnotes and references have not been included.
- Some extracts have been shortened from their original length.
- Quotations from Greek have been transliterated, and passages in foreign languages translated, or omitted altogether.

Care has been taken to ensure that in no instance do these amendments truncate the argument or alter the meaning intended by the original author. For readers who want to consult the original texts, full bibliographical details are provided for each extract.

The Library of Scottish Philosophy was launched at the Third International Reid Symposium on Scottish Philosophy in July 2004 with an initial six volumes. Attractively produced and competitively priced, these appeared just fifteen months after the original suggestion of such a series. This remarkable achievement owes a great deal to the work and commitment of the editors of the individual volumes, but it was only possible because of the enthusiasm of the publisher, Keith Sutherland, and the outstanding work of Jon M.H. Cameron, Editorial and Administrative Assistant to the Centre for the Study of Scottish Philosophy.

Acknowledgements

Grateful acknowledgement is made to the Carnegie Trust for the Universities of Scotland for generous financial support for the Library of Scottish Philosophy in general, and to Mr George Stevenson for a subvention for this volume in particular.

Acknowledgement is also made to the University of Aberdeen Special Libraries and Collections for permission to reproduce the engraving of the Edinburgh Faculty of Advocates from *Modern Athens* (1829).

Gordon Graham, Aberdeen, June 2004

Introduction

There is something anachronistic about referring to the contents of this book as concerned with *aesthetics* in eighteenth-century Scotland. For although the term was coined in the eighteenth century — derived from the ancient Greek word *aestheticos*, meaning that which pertains to sense perception — it did not come into widespread use in Britain as the name for a particular approach to the philosophy of art until the 1830s. However if we disconnect the particular history of the concept of the aesthetic from what the term has come to mean, there is an important sense in which aesthetics as a subject of philosophical inquiry has its origins in eighteenth-century Britain, and in particular Scotland. Whenever claims such as this are made about the origins of a subject of study, particularly in the context of enlightenment Europe, care must be taken to remember that intellectual history is far too complex to allow for neat identifications of national origin. Many of the thinkers whose work is collected in this volume saw themselves as involved in a debate that extended well beyond the Scottish or British national boundaries, and all took inspiration from the continent, and in particular French thinkers. At the end of the eighteenth century we do find Dugald Stewart expressing a certain patriotic pride in the achievements of Scottish philosophy and learning, and indeed drawing a contrast between the empiricism and inductivism of British philosophy and the rationalist traditions of continental Europe. Nevertheless, the enlightenment ideal of a trans-national 'republic of ideas' to which the learned belong and contribute has a far more important role in the period than narrow national concerns.

In the light of such doubts about the suitability of applying the word 'aesthetics' to the great discourse about taste, beauty and the imagination that occurred in eighteenth-century Scotland,

and about identifying the study of such subjects in terms of national boundaries, what does it mean to say that modern aesthetics has its origins in eighteenth-century Scotland? If we try to distil some shared general characteristics from the many kinds of distinctively aesthetic theories from the past and present, one of them would be that aesthetics is concerned with a broad category of human experience. For the modern philosopher this typically means trying to understand art and its value through reflection upon the nature of experience of art. Much of our ordinary experience of the world is evaluatively neutral, but our experience of art usually has an evaluative quality in the sense that we respond with pleasure or dislike, interest or boredom, attention or repulsion. Our experience of art is like this, but so too are many experiences of the natural and built environment, and so we speak of there being an aesthetics of each of these. But just as familiar are other contemporary extensions of the range of aesthetic experience beyond that of art and the environment to the various objects that make up what is sometimes called 'mass culture'. In this extended sense, aesthetics is concerned with understanding the nature and value of certain objects through consideration of a distinctive kind of appreciative and evaluative experience of them, and those of their properties that are important to appreciation. In the eighteenth century this experience was thought to be produced by a mental faculty called 'taste', and the contents of this experience were qualities like beauty, sublimity, novelty and wit. Indeed, these qualities were typically identified with particular sentiments aroused by experience of objects possessing them. Art and nature were certainly thought of as paradigm possessor's of these qualities, but in general eighteenth-century philosophers of taste conceived of their investigations into the operations of taste and the experience it gives rise to as extending well beyond art and nature. What we now call aesthetic experience was understood in the enlightenment to be a pervasive and important force in the daily lives of educated human beings. This understanding of the extensive scope of aesthetic experience is one of the connections between the position of those author's gathered together in this collection, and the contemporary belief in a wide application of aesthetic reflection.

It is true that another general characteristic of aesthetic theories that can be extracted from traditional and contemporary versions of such theories is that aesthetic experience is 'disinterested' in

some sense or other. The notion of disinterestedness is nicely captured by the familiar expressions 'an interest in a work of art for its own sake' or as 'an end in itself'. In effect aesthetic experience is supposed to be a distinctive kind of unself-motivated contemplative attention to an object merely for what it offers imagination and the emotions. The way I have characterised disinterestedness conceives of it as a property of aesthetic experience that would not have been recognised by the philosophers of the Scottish enlightenment. Indeed, my characterisation owes more to that other supremely great enlightenment philosopher and founder of aesthetics, Immanuel Kant, whose *Critique of Judgment* (1790) did a very great deal to shape aesthetics after the eighteenth century. Kant's method, terminology and philosophical orientation is very different to that of the Scottish philosophers, none of whom would have known anything of Kant's writings on aesthetics. Nevertheless there is a good deal of overlap between the concerns of both, and some aspects of their conclusions. So although the Scots would have rejected the thought that aesthetic experience is disinterested in the Kantian sense, they nevertheless incorporate a different sense of disinterestedness into their philosophy of taste. Judgments of taste, or aesthetic judgments, are thought to be disinterested in the sense of unprejudiced. To avoid having an idiosyncratic and unreliable taste, we have to set aside our personal interests to judge fairly and objectively. Moreover, none of the Scots would have agreed with the Kantians that this feature of aesthetic judgment exhausts, or is even the most important element in the account of aesthetic experience. A number of philosophers of the age give the most important role to what they call 'delicacy of taste, or the capacity to make fine distinctions in the causes and pleasures of beauty and the other aesthetic properties.

This orientation of eighteenth-century philosophers of taste toward a distinctive kind of multi-faceted and multi-valenced appreciative experience of objects, and those of their qualities that cause the experience, provides the sense in which the thinkers in this anthology are properly concerned with aesthetics. And together with some of the French thinkers who inspired them, these philosophers began an approach to understanding art (and more) that has come to be called 'aesthetics'. What the British writers on these themes achieved however was far richer and more integrated with the other main branches of philosophy than any of their French counterparts. Part of the reason for this can be

traced to the empiricism and concern for the operations of the mind that characterised British philosophy of the age, and the kind of turn towards subjectivity and experience these interests occasioned. If it can be shown that there is something about the predominant philosophical concerns in Britain that brings questions of aesthetic experience to the fore, and that these issues were most fully developed in the context of those broader philosophical concerns, then we will have some grounds for saying that aesthetics has its origins in the British enlightenment. And if we have these grounds, then Scottish philosophers must be accorded a special place in the history of aesthetics. For although England and Ireland produced a small number of significant contributors to the debates about taste, beauty and the like, the vast majority of the important writers on the topic were Scots. Some of these were among the most important European intellectuals of their day — including Adam Smith, David Hume, Thomas Reid and (less famous today) Dugald Stewart. Indeed in a period of extraordinary intellectual innovation and output, it is hard to find a philosopher or serious thinker in eighteenth-century Scotland who did not concern themselves at some time or other with the aesthetic questions of the day.

It is worth reflecting upon why Scotland was such fertile ground for the development of aesthetic thought. There are two very broad categories of reason that are relevant here. On the one hand, Scotland's four universities, with their progressive curricula and tolerance of dissent provide part of the backdrop to the flowering of the Scottish enlightenment. Just as important was the revival of commercial life following the Act of Union and the rise of an educated middle class with both time and the inclination for intellectual pursuits. Many other social and cultural factors are relevant to the rise of Scottish intellectual culture during the eighteenth century and its preoccupation with aesthetic questions, and these would all belong together in one category of reasons. There are other reasons, however, that are more intellectual and philosophical, and which belong in a second category of reasons. Of particular importance here is the near universal adoption of a broadly Lockean account of the mind as the basis for Scottish philosophical innovation. John Locke's *Essay on Human Understanding* (1690), the classic empiricist account of the origins of human knowledge and the operations of the human mind in transforming sense experience into knowledge, is a crucially

important part of the background to the development and pursuit of aesthetic inquiry. The influence of Locke on Scottish philosophy of the period cannot, indeed, be underestimated. Francis Hutcheson, who is usually credited with initiating the tradition of aesthetics in Scotland, taught Locke's philosophy at Glasgow University in the early eighteenth century, and adopted a broadly Lockean framework for his own thought. Locke's influence continues to operate through the century, however, even in those who reject many of his conclusions. There are many elements of influence that could be distinguished, but in this context we can limit ourselves to some of those features of Locke's thought that had an important influence upon the rise of aesthetic inquiry and the form it takes.

For Locke, thought or mental experience is composed of a train of 'ideas' of various sorts. One of the most important distinctions between kinds of idea that Locke draws is between ideas of sensation and ideas of reflection. The former are ideas that are delivered to the mind by means of the senses. When we see, hear, taste, touch or smell something, these operations of the mind enable sensations, or 'impressions', of objects outside the mind. These impressions can also be combined by the mind into complex or abstract ideas that bring together elements taken from a number of different original impressions into a single idea. Ideas of reflection, by contrast, are ideas formed on the basis of reflection upon the operations of our own minds, such as perceiving, thinking, believing, doubting and the like. Locke often writes as if the ideas of reflection are produced by the mind turning its perceptual capacities upon its own operations, going so far as to say that reflection is enough like sensation that it 'might properly be called an internal sense'. Both the internal senses and the external senses are the producers of ideas, the stuff and substance of thought and mental experience. One set of ideas is produced by our world-directed perceptual senses, and the other by our analogous inwardly directed reflective capacities.

Locke's suggestion that the power of introspective reflection is analogous to the operation of an internal sense is a hint taken up and developed in eighteenth-century Scotland into an account of the origin of human values. Hutcheson is not the first to see how an internal sense might be important in aesthetics, but he is credited with developing the first detailed account of the internal senses of beauty and virtue. The contents of our mind are pro-

vided by ideas that can ultimately be traced back to sense impressions causally connected with the world outside the mind. We also have an internal sense, however, that continually surveys the ideas of sensation before the mind and produces pleasure or displeasure in response. For Hutcheson this model of explanation is as applicable to moral good or virtue as it is to aesthetic good or beauty. When the external senses encounter certain properties in objects or actions, the internal senses respond by producing pleasure or displeasure. The thought that beauty is a distinctive pleasure produced by an internal sense or faculty of taste that is responsive to the stimuli of the world as it is presented to the mind by the external senses is a common theme in the aesthetic inquiries of the period.

Another important element of Locke's account of the mind that deserves mention in this context is his notion of the association of ideas. This is an operation of the mind, and thus discovered through reflection, regarding the capacity of one idea to bring another before the mind. To see and thus form an idea of smoke can be the cause of another idea, that of fire, coming before the mind. This is so because the ideas of smoke and fire have a natural associative connection that leads the mind to bring one idea before itself as a result of another having been present. Although the association of ideas plays little role in the thought of Hutcheson and some other aesthetic theorists, for many others analysing the associations that occur during aesthetic experience is the primary tool of explanation. One quite straightforward role that association is given in aesthetic explanations is in regard to deviant or accidental judgments. If some particular works of art are always experienced by someone as unpleasant because they played a part in past miseries that have, as a result, become associated with those works, these associations are personal distortions of judgment amounting to prejudice. Another role given to the association of ideas by the philosophers of the period was that of explaining how the internal sense of beauty operates and judgments are made.

A third important influence of Locke upon eighteenth-century aesthetics is found in his metaphysical distinction between two kinds of properties that objects in the world possess. On the one hand, they have objective or 'primary' qualities — those they have wholly independently of the human mind — such as size, shape, weight texture and position. On the other hand, objects

have relational or 'secondary' qualities that are more subjective, having the character they do because of the way the mind is constructed to deal with certain invisible stimuli. The most famous example of a secondary quality is colour, which is possessed by objects in virtue of their various capacities to absorb or reflect frequencies of light, and in virtue of the way the eye and brain are constructed and operate. Colour experience may be caused by properties of objects, but objects do not possess colours in the absence of sentient beings with appropriate perceptual capacities and appropriate conditions for their normal functioning.

This distinction between primary and secondary qualities is, in one way or another, at the heart of many discussions of beauty in eighteenth-century Scotland. Most associated beauty with a reasonably distinct kind of pleasure — though accounts of this pleasure vary widely — and thus as a subjective and affective phenomenon. At the same time however most thought that the objects that cause this pleasure, and are called beautiful as a result, do so because they possess some feature more or less analogous to a secondary quality. This analogy between aesthetic and secondary qualities is sometimes adopted and sometimes rejected, but some sort of distinction between subjective aesthetic experience and its material causes is always in the background to the discussion. In recent years philosophers have returned to the metaphysical status of aesthetic qualities, and many have found inspiration in the work of the Scottish enlightenment. Indeed, some of the later accounts of beauty — such as those of Reid and Stewart — are striking as precursors to theories that became widespread in the twentieth century. For Reid, who is also notable for putting a new twist on the standard view that beauty is a secondary quality, develops an early formulation of the expression theory of art that in a slightly different form became predominant in the late nineteenth and early twentieth centuries. And Stewart's nominalist analysis of the multiple meanings of beauty is a striking anticipation of Wittgenstein's 'family resemblance' argument and the aesthetic applications of it popular in the decades after Wittgenstein's death in the 1950s.

Locke did not merely provide the framework of metaphysics and mental operations that later philosophers adapted and developed in relation to questions of taste, judgment, imagination, and the qualities with which they are concerned. For in a sense Locke provides the philosophical problem that serves as the catalyst of

aesthetic inquiry, because aesthetic experience is a particularly challenging instance of the problem. The Lockean picture of the mind of mankind is of the same quasi-mechanical ground of experience in each person. But since the contents of the mind are all traceable back to sense impressions and experience, and this varies between individuals, how do we account for the obvious order, uniformity and agreement in the experience of mankind — particularly with regard to knowledge and judgment? Indeed, if everyone's experience is different, and everyone's experience is subject to natural and idiosyncratic associations of ideas, how do we achieve anything like shared knowledge and judgment?

These questions in relation to judgment are particularly difficult. For on the one hand there is both a remarkable amount of agreement about what is and is not beautiful, and intractable differences on the same question. How is it that so much uniformity of aesthetic judgment is possible when, first, we all have different experiences and are susceptible to idiosyncratic associations of ideas; and second, there are aesthetic disputes that have the appearance of being irresolvable without the aesthetic judgments or context being formally different from those which attract agreement? We have alluded already to one kind of answer to this question that was commonly employed by eighteenth-century philosophers: each of us possesses an internal sense that, like the external senses, generally operates the same way in each person. If it is working properly we will make the same judgments as everyone else with similarly undistorted internal and external senses. There are other solutions to the Lockean problem, but the point in this context is that the issues discussed by the writers in this collection are not merely influenced by the structure of Locke's theory of mind, or indeed by the social, economic and cultural factors that led to the flowering of philosophy in eighteenth-century Scotland. They were also treating aesthetic questions because they posed a particular challenge for the Lockean philosophy that dominated their intellectual orientation. For this reason many of the philosophers of taste were not conscious of themselves as developing a new way to explain art, but rather their inquiries into aesthetic questions were a natural extension of, and integrated with, broader questions about the operations of the mind.

Notwithstanding Locke's crucial influence, not all of the questions discussed by the eighteenth-century philosophers of taste

can be easily traced back to Locke. Some questions — such as whether taste is natural or acquired and susceptible to improvement, and whether there are standards by which we can judge of its correct operation — have little basis in Locke and the topics of investigation have a life of their own in the Scottish discourse. One of the most important of these threads of inquiry with little relation to Locke is in the fascination of the eighteenth-century philosophers with the quality of the sublime. Although beauty remains a live critical and evaluative aesthetic concept for the contemporary world, we have for some time now lived in an age far less alive to and confident with the sublime. In the eighteenth century however it was a category of aesthetic experience of paramount importance — typically, indeed, thought more valuable than beauty. Also referred to as 'grandeur', 'magnificence' or 'elevation', the sublime was associated with experiences of the awe-inspiring, the powerful, the enormous, the elevated, and for some the terrifying in art and especially nature.

From its revival in late seventeenth-century France, through to its first British analysis by the critic John Dennis early in the eighteenth century, the notion of the sublime was first and foremost conceived of as a quality of literature, and discussion of it was primarily confined to the context of poetic drama and rhetorical speech. However, in a section of David Hume's *Treatise of Human Nature* (1740) we have one of the very first extensions of the concept of the sublime beyond the confines of literature. For Hume, grandeur is experienced when the mind has to conceive of great quantities of space or time, and for this reason the ancient is often preferred to the modern, and goods from far away thought to be particularly pleasing. The sublime is therefore freed from the constraints of literature and rhetoric, being rendered by Hume a quality of nature, art and human action, as common perhaps in ordinary experience as beauty, but more valuable because more powerfully pleasing. Subsequent philosophers immediately adopted Hume's extension of the concept of the sublime, though they provided very different explanations of the experience, with the emphasis increasingly put upon nature as the primary source of the sublime.

This extension of the concept from literature to nature, and thus to the other mimetic arts which were of course nature's imitator, did have some basis on the work of the third century Hellenist author Longinus — whose essay *Peri Hypsus* or 'On Great writing'

(though commonly translated today as 'On the Sublime') provided the classical source for the eighteenth-century reflection on this quality. For at one point in the essay when Longinus is trying to characterise the experience of hearing sublimity in a rhetorical speech, he likens it to the experience of large or powerful natural phenomena like mountains, large rivers and volcanoes erupting. Together with other analogies of the sublime as a quality of human character and action, Longinus seemed to give licence to the extension of the sublime beyond literature. The hint was robustly seized upon by the eighteenth-century philosophers of taste, and literature was rendered just one of many potentially sublime phenomena.

One of the greatest of the century's many theorists of the sublime was the Anglo-Irishman Edmund Burke, who falls outside the narrowly Scottish boundaries of this collection. But Burke, like Hume, Adam Smith and many other theorists or philosophers of the age saw in the sublime troubling moral implications that accompany its powerful aesthetic effects. Not just nature, but human beings and actions can also display grandeur; and this is not easily reconcilable with the requirements of a rational, liberal, peaceful and prosperous society. Hume makes this point neatly when he writes of the military heroism 'much admired by the generality of mankind' that:

> The infinite confusions and disorder, which it has caused in the world . . . the subversion of empires, the devastation of provinces, the sack of cities. As long as these are present to us, we are more inclined to hate than to admire the ambition of heroes. When we fix our view on the person himself, who is the author of all this mischief, there is something so dazzling in his character, *the mere contemplation of it so elevates the mind, that we cannot refuse it our admiration*. The pain that we receive from its tendency to society, is over-powered by a stronger and more immediate sympathy.[1]

Our attraction to the sublime is more powerful than our moral sentiments, and this is a worry of many of the writers on the sublime after Hume. Hume provides no resolution to the problem, but one way of addressing it is to provide an analysis of the sublime that removes the problem, by taming and limiting the quality's power. This is a standard strategy among many of the writers on the sublime after Hume.

[1] *Treatise of Human Nature* 3.III.ii (emphasis added).

If Hume gives us no clue in the *Treatise* how he would resolve the problem, in his seminal essay on the standard of taste we find him reflecting upon the extent to which works of the imagination are susceptible to moral criticism. This points to another theme of eighteenth-century aesthetic thought: the intersection between the aesthetic and the ethical. The sometimes qualified separation of aesthetic and ethical standards of evaluation in much contemporary aesthetic theory — another lingering effect of Kantian ways of thinking about aesthetic experience — is thoroughly alien to most of the thinkers of the Scottish enlightenment. From Hutcheson on, the mental operations responsible for, and the broad structure of explanation of, both moral and aesthetic judgment are closely intertwined. Both require clear and unprejudiced perception as well as a disposition to sympathy; both require affective responses to external stimuli; both require analogous use of the imagination. Another place that Hume addresses the issue, if rather obliquely, is in his equally famous essay on tragedy. The problem he addresses there is how events that would be painful to watch if real are capable of giving pleasure when presented in a well-constructed tragedy. Or to put it another way, how can our natural moral sympathies aroused by painful events be transformed and overcome by aesthetic responses to tragic art? Hume's classic treatment of the issue remains of interest today, and like his essay on the standard of taste, it repays careful study.

Hume's essay on the standard of taste is notable for its treatment of the possibilities of moral criticism of art, but it is more famous for its attempt to determine whether there is any basis for distinguishing between *either* correct and incorrect judgments of taste, *or* better and worse taste. A rational basis for either distinction is out of the question for Hume, but certain facts indicate to him not only that aesthetic judgments presuppose the possibility of agreement, but also that some people through their natural dispositions, education and experience are agreed by all to have a more refined and sensitive taste. And the judgments that issue from those with such refined capacities are more likely to attract the assent of the educated than the judgments of an uncultivated taste. Whenever such agreement among the true judges and the educated is reached, we have in that agreement a standard of better and worse taste. This summary of Hume's position does scant justice, however, to the richness of his investigation, which

proceeds almost seamlessly through a range of possible strategies for determining the standard of taste, none of which are explicitly accepted or rejected without qualification. The reader is left instead to acknowledge the weak but practical standard with which he ends his investigation, and to consider the possibilities for strengthening it.

The question of the standard of taste is a common theme among the philosophers of the age. Most thought a more robust standard possible than Hume's argument would appear to allow, but in attempting to defend their aesthetic standards they wrestle with interesting and challenging problems that are as alive for us today — in our age of unreflective relativism — as they were in the eighteenth century. But this sense that the issues and considerations of the eighteenth-century philosophers of taste are not far removed, if removed at all, from contemporary aesthetic questions and concerns is not limited to discussions of the standard of taste. It is one of the real pleasures of reading the contributors to this volume finding the issues so close to our own, and the discussion so challenging and informative.

Francis Hutcheson

(1694–1746)

Francis Hutcheson was one of the most important figures in the
Scottish enlightenment. Indeed a case can be made that he was
one of its intellectual fathers and educational instigators, even
though his connections with Ireland are every bit as strong as his
connections with Scotland. He was born in County Down, in the
north of Ireland, to a family of Presbyterian ministers of Scottish
origin, but returned to Scotland at a young age to the University of
Glasgow, where he studied for his degree and then his licence as a
minister, completing his studies in 1716. Three years later he
returned to Ireland and embarked on a career as a teacher and
scholar in Dublin. In 1729 he returned to Glasgow to take up the
Chair in Moral Philosophy, in which he remained until his death
in 1746. In this position his fame as a philosopher and teacher
grew enormously, and he was one of the first in Scotland to lec-
ture in English rather than Latin. His spirit of inquiry, intellectual
capacities and tolerance had a profound influence upon many of
his students, including Adam Smith, who warmly remembered
his influence upon them.

 In 1725 he published two essays under the title *Inquiry Into The
Original Of Our Idea Of Beauty And Virtue*. The following passage
is taken from the first of these essays — the *Inquiry Concerning,
Beauty, Order, Harmony and Design*. In it he argues that human
beings possess a special internal sense, analogous to the external
senses, by means of which we perceive beauty, harmony and pro-
portion. 'Beauty', he writes, 'is taken for the idea raised in us, and
a sense of beauty for our power of receiving this idea.' The task
Hutcheson sets himself is to explain what features of objects and
landscapes, excite the internal sense to form the pleasurable idea

of beauty. The resulting analysis of beauty and the operation of the internal sense is the starting point of the eighteenth-century Scottish discourse on aesthetics, and it remained influential throughout the century, even if many of his conclusions were progressively rejected.

Hutcheson distinguishes two kinds of beauty: original (or absolute) and comparative (or relative). Relative beauty is perceived to be possessed by an object in virtue of it imitating or representing something else — so that the beauty is perceived in the comparison of, for example, the picture and what it is a picture of. Absolute beauty, by contrast, is perceived to be possessed by objects themselves, independently of any other objects to which they are related as imitations — the beauty of nature being perhaps the paradigm instance of such non-imitative beauty. His analysis of original beauty as consisting of 'uniformity amidst variety' exercised a great influence on subsequent writers, though how much this analysis could be extended to comparative beauty — or the beauty of the fine arts — is a question that aroused much disagreement.

Further Reading

Peter Kivy, *The Seventh Sense*, 2nd edition, Oxford: Oxford University Press, 2003.

George Dickie, *The Century of Taste*, Oxford: Oxford University Press, 1996.

READING I

AN INQUIRY CONCERNING BEAUTY, ORDER, HARMONY, DESIGN[1]

I

Powers of Perception Distinct from Ordinary Sensation

To make the following observations understood, it may be necessary to premise some definitions, and observations, either universally acknowledged, or sufficiently proved by many writers both ancient and modern, concerning our percep-

[1] From *Inquiry Into The Original Of Our Idea Of Beauty And Virtue* (London, 1725).

tions called *sensations*, and the actions of the mind consequent upon them.

I. Those ideas which are raised in the mind upon the presence of external objects, and their acting upon our bodies, are called *sensations*. We find that the mind in such cases is passive, and has not power directly to prevent the perception or idea, or to vary it at its reception, as long as we continue our bodies in a state fit to be acted upon by the external object.

II. When two perceptions are entirely different from each other, or agree in nothing but the general idea of sensation, we call the powers of receiving those different perceptions different *senses*. Thus seeing and hearing denote the different powers of receiving the ideas of colours and sounds. And although colours have great differences among themselves, as also have sounds, yet there is a greater agreement among the most opposite colours, than between any colour and a sound. Hence we call all colours perceptions of the same sense. All the several senses seem to have their distinct organs, except *feeling*, which is in some degree diffused over the whole body.

III. The mind has a power of *compounding* ideas which were received separately; of *comparing* objects by means of the ideas, and of observing their *relations* and *proportions*; of *enlarging* and *diminishing* its ideas at pleasure, or in any certain *ratio* or degree; and of considering *separately* each of the simple ideas, which might perhaps have been impressed jointly in the sensation. This last operation we commonly call *abstraction*.

IV. The ideas of corporeal substances are compounded of the various simple ideas jointly impressed when they presented themselves to our senses. We define substances only by enumerating these sensible ideas; and such definitions may raise a clear enough idea of the substance in the mind of one who never immediately perceived the substance, provided he has separately received by his senses all the simple ideas which are in the composition of the complex one of the substance defined. But if there be any simple ideas which he has not received, or if he wants any of the senses necessary for the perception of them, no definition can raise any simple idea which has not been before perceived by the senses.

V. Hence it follows that when instruction, education, or prejudice of any kind, raise any desire or aversion toward an object, this desire or aversion must be founded upon an opinion of some

perfection, or some deficiency in those qualities for perception of which we have the proper senses. Thus if beauty be desired by one who has not the sense of sight, the desire must be raised by some apprehended regularity of figure, sweetness of voice, smoothness, or softness, or some other quality perceivable by the other senses, without relation to the ideas of colour.

VI. Many of our sensitive perceptions are pleasant, and many painful, immediately, and that without any knowledge of the cause of this pleasure or pain, or how the objects excite it, or are the occasions of it, or without seeing to what farther advantage or detriment the use of such objects might tend. Nor would the most accurate knowledge of these things vary either the pleasure or pain of the perception, however it might give a rational pleasure distinct from the sensible; or might raise a distinct joy from a prospect of farther advantage in the object, or aversion from an apprehension of evil.

VII. The simple ideas raised in different persons by the same object are probably [in] some way different when [people] disagree in their approbation or dislike, and in the same person when his fancy at one time differs from what it was at another. This will appear from reflecting on those objects to which we have now an aversion, though they were formerly agreeable. And we shall generally find that there is some accidental conjunction of a disagreeable idea which always recurs with the object, as in those wines to which men acquire an aversion after they have taken them in an emetic preparation, we are conscious that the idea is altered from what it was when that wine was agreeable, by the conjunction of the ideas of loathing and sickness of the stomach. The like change of idea may be insensibly made by the change of our bodies as we advance in years, or when we are accustomed to any object, which may occasion an indifference toward meats we were fond of in our childhood, and may make some objects cease to raise the disagreeable ideas which they excited upon our first use of them. Many of our simple perceptions are disagreeable only through the too great intenseness of the quality: thus moderate light is agreeable, very strong light may be painful; moderate bitter may be pleasant, a higher degree may be offensive. A change in our organs will necessarily occasion a change in the intenseness of the perception at least, nay sometimes will occasion a quite contrary perception: thus a warm hand shall feel that water cold which a cold hand shall feel warm.

We shall not find it perhaps so easy to account for the diversity of fancy about more complex ideas of objects, (including many) in which we regard many ideas of different senses at once, as (some) perceptions of those called *primary qualities*, and some *secondary*, as explained by Mr Locke: for instance, in the different fancies about architecture, gardening, dress. Of the two former, we shall offer something in Section VI [below]. As to dress, we may generally account for the diversity of fancies, from a like conjunction of ideas. Thus if either from anything in nature, or from the opinion of our country or acquaintance, the fancying of glaring colours be looked upon as an evidence of levity, or of any other evil quality of mind, or if any colour or fashion be commonly used by rustics, or by men of any disagreeable profession, employment, or temper, these additional ideas may recur constantly with that of the colour or fashion, and cause a constant dislike to them in those who join the additional ideas, although the colour or form be no way disagreeable of themselves, and actually do please others who join no such ideas to them. But there appears no ground to believe such a diversity in human minds, as that the same simple idea or perception should give pleasure to one and pain to another, or to the same person at different times, not to say that it seems a contradiction that the same simple idea should do so.

VIII. The only pleasure of sense which many philosophers seem to consider is that which accompanies the simple ideas of sensation. But there are far greater pleasures in those complex ideas of objects, which obtain the names of *beautiful*, *regular*, *harmonious*. Thus every one acknowledges he is more delighted with a fine face, a just picture, than with the view of any one colour, were it as strong and lively as possible; and more pleased with a prospect of the sun arising among settled clouds, and colouring their edges with a starry hemisphere, a fine landscape, a regular building, than with a clear blue sky, a smooth sea, or a large open plain, not diversified by woods, hills, waters, buildings. And yet even these latter appearances are not quite simple. So in music, the pleasure of fine composition is incomparably greater than that of any one note, however sweet, full, or swelling.

IX. Let it be observed that in the following papers the word *beauty* is taken for *the idea raised in us*, and a *sense* of beauty for *our power of receiving this idea*. *Harmony* also denotes *our pleasant ideas arising from composition of sounds*, and a *good ear* (as it is generally taken) a *power of perceiving this pleasure*. In the following sections,

an attempt is made to discover what is the immediate occasion of these pleasant ideas, or what real quality in the objects ordinarily excites them.

X. It is of no consequence whether we call these ideas of beauty and harmony perceptions of the external senses of seeing and hearing, or not. I should rather choose to call our power of perceiving these ideas an *internal sense*, were it only for the convenience of distinguishing them from other sensations of seeing and hearing which men may have without perception of beauty and harmony. It is plain from experience that many men have in the common meaning the senses of seeing and hearing perfect enough. They perceive all the *simple ideas* separately, and have their pleasures; they distinguish them from each other, such as one colour from another, either quite different, or the stronger or fainter of the same colour, when they are placed beside each other, although they may often confound their names when they occur apart from each other, as some do the names of green and blue. They can tell in separate notes, the higher, lower, sharper or flatter, when separately sounded; in figures they discern the length, breadth, wideness of each line, surface, angle; and may be as capable of hearing and seeing at great distances as any men whatsoever. And yet perhaps they shall find no pleasure in musical compositions, in painting, architecture, natural landscape, or but a very weak one in comparison of what others enjoy from the same objects. This greater capacity of receiving such pleasant ideas we commonly call a *fine genius* or *taste*. In music we seem universally to acknowledge something like a distinct sense from the external one of hearing, and call it a *good ear*; and the like distinction we should probably acknowledge in other objects, had we also got distinct names to denote these *powers* of perception by.

XII. This superior power of perception is justly called a *sense* because of its affinity to the other senses in this, that the pleasure does not arise from any *knowledge* of principles, proportions, causes, or of the usefulness of the object, but strikes us at first with the idea of beauty. Nor does the most accurate knowledge increase this pleasure of beauty, however it may superadd a distinct rational pleasure from prospects of advantage, or from the increase of knowledge.

XIII. And farther, the ideas of beauty and harmony, like other sensible ideas, are *necessarily* pleasant to us, as well as immedi-

ately so. Neither can any resolution of our own, nor any prospect of advantage or disadvantage, vary the beauty or deformity of an object. For as in the external sensations, no view of interest will make an object grateful, nor view of detriment distinct from immediate pain in the perception, make it disagreeable to the sense. So propose the whole world as a reward, or threaten the greatest evil, to make us approve a deformed object, or disapprove a beautiful one: dissimulation may be procured by rewards or threatenings, or we may in external conduct abstain from any pursuit of the beautiful, and pursue the deformed, but our *sentiments* of the forms, and of our *perceptions*, would continue invariably the same.

XIV. Hence it plainly appears that some objects are *immediately* the occasions of this pleasure of beauty, and that we have senses fitted for perceiving it, and that it is distinct from that *joy* which arises upon prospect of advantage. Nay, do not we often see convenience and use neglected to obtain beauty, without any other prospect of advantage in the beautiful form than the suggesting the pleasant ideas of beauty? Now this shows us that however we may pursue beautiful objects from self-love, with a view to obtain the pleasures of beauty, as in architecture, gardening, and many other affairs, yet there must be a *sense* of beauty, antecedent to prospects even of this advantage, without which sense these objects would not be thus advantageous, nor excite in us this pleasure which constitutes them advantageous. Our sense of beauty from objects, by which they are constituted good to us, is very distinct from our desire of them when they are thus constituted. Our desire of beauty may be counter-balanced by rewards or threatenings, but never our *sense* of it, even as fear of death may make us desire a bitter potion, or neglect those meats which the sense of taste would recommend as pleasant, but cannot make that potion agreeable to the *sense*, or meat disagreeable to it, which was not so antecedently to this prospect. The same holds true of the sense of beauty and harmony; that the pursuit of such objects is frequently neglected, from prospects of advantage, aversion to labour, or any other motive of interest does not prove that we have no *sense* of beauty, but only that our desire of it may be counter-balanced by a stronger desire. So gold out-weighing silver is never adduced as proof that the latter is void of gravity.

XV. Had we no such sense of beauty and harmony, houses, gardens, dress, equipage might have been recommended to us as

convenient, fruitful, warm, easy, but never as *beautiful*. And in faces I see nothing which could please us but liveliness of colour and smoothness of surface. And yet nothing is more certain than that all these objects are recommended under quite different views on many occasions. 'Tis true, what chiefly pleases in the countenance are the indications of moral dispositions; and yet, were we by the longest acquaintance fully convinced of the best moral dispositions in any person, with that countenance we now think deformed, this would never hinder our immediate dislike of the form, or our liking other forms more. And custom, education, or example could never give us perceptions distinct from those of the senses which we had the use of before, or recommend objects under another conception. But of the influence of custom, education, example, upon the sense of beauty, we shall treat below.

XVI. Beauty in corporeal forms is either *original* or *comparative*; or, if any like the terms better, *absolute* or *relative*. Only let it be observed that by absolute or original beauty is not understood any quality supposed to be in the object which should of itself be beautiful, without relation to any mind which perceives it. For beauty, like other names of sensible ideas, properly denotes the *perception* of some mind; so *cold, hot, sweet, bitter*, denote the sensations in our minds, to which perhaps there is no resemblance in the objects which excite these ideas in us, however we generally imagine otherwise. The ideas of beauty and harmony, being excited upon our perception of some primary quality, and having relation to figure and time, may indeed have a nearer resemblance to objects than these sensations, which seem not so much any pictures of objects as modifications of the perceiving mind; and yet, were there no mind with a sense of beauty to contemplate objects, I see not how they could be called beautiful. We therefore by absolute beauty understand only that beauty which we perceive in objects without comparison to anything external of which the object is supposed an imitation or picture, such as that beauty perceived from the works of nature, artificial forms, figures. Comparative or relative beauty is that which we perceive in objects commonly considered as *imitations* or *resemblances* of something else. These two kinds of beauty employ the three following sections.

II
Original or Absolute Beauty

I. Since it is certain that we have *ideas* of beauty and harmony, let us examine what *quality* in objects excites these ideas, or is the occasion of them. And let it be here observed that our inquiry is only about the qualities which are beautiful to *men*, or about the foundation of their sense of beauty. For as was above hinted, beauty has always relation to the sense of some mind, and when we afterwards show how generally the objects which occur to us are beautiful, we mean that such objects are agreeable to the sense of men, for there are many objects which seem no way beautiful to men, and yet other animals seem delighted with them: they may have senses otherwise constituted than those of men, and may have ideas of beauty excited by objects of a quite different form. We see animals fitted for every place, and what to men appears rude and shapeless, or loathsome, may be to them a paradise.

II. That we may more distinctly discover the general foundation or occasion of the ideas of beauty among men, it will be necessary to consider it first in its simpler kinds, such as occurs to us in regular figures; and we may perhaps find that the same foundation extends to all the more complex species of it.

III. The figures which excite in us the ideas of beauty seem to be those in which there is *uniformity amidst variety*. There are many conceptions of objects, which are agreeable upon other accounts, such as *grandeur*, *novelty*, *sanctity*, and some others, which shall be mentioned hereafter. But what we call beautiful in objects, to speak in the mathematical style, seems to be in compound ratio of uniformity and variety: so that where the uniformity of bodies is equal, the beauty is as the variety; and where the variety is equal, the beauty is as the uniformity. This may seem probable, and hold pretty generally.

First, the variety increases the beauty in equal uniformity. The beauty of an equilateral triangle is less than that of the square, which is less than that of a pentagon, and this again is surpassed by the hexagon. When indeed the number of sides is much increased, the proportion of them to the radius, or diameter of the figure, or of the circle to which regular polygons have an obvious relation, is so much lost to our observation, that the beauty does not always increase with the number of sides, and the want of parallelism in the sides of heptagons, and other figures of odd num-

bers, may also diminish their beauty. So in solids, the icosahedron surpasses the dodecahedron, and this the octahedron, which is still more beautiful than the cube, and this again surpasses the regular pyramid. The obvious ground of this is greater variety with equal uniformity

The greater uniformity increases the beauty amidst equal variety in these instances: an equilateral triangle, or even an isosceles, surpasses the scalene; a square surpasses the rhombus or lozenge, and this again the rhomboids, which is still more beautiful than the trapezium, or any figure with irregular curve sides. So the regular solids surpass all other solids of equal number of plane surfaces. And the same is observable not only in the five perfectly regular solids, but in all those which have any considerable uniformity, as cylinders, prisms, pyramids, obelisks, which please every eye more than any rude figures, where there is no unity or resemblance among the parts.

V. The same foundation we have for our sense of beauty in the works of nature. In every part of the world which we call beautiful there is a surprising uniformity amidst an almost infinite variety. Many parts of the universe seem not at all designed for the use of man; nay, it is but a very small spot with which we have any acquaintance. The figures and motions of the great bodies are not obvious to our senses, but found out by reasoning and reflection, upon many long observations; and yet as far as we can by sense discover, or by reasoning enlarge our knowledge and extend our imagination, we generally find their structure, order, and motion agreeable to our sense of beauty. Every particular object in nature does not indeed appear beautiful to us; but there is a great profusion of beauty over most of the objects which occur either to our senses, or reasonings upon observation. For not to mention the apparent situation of the heavenly bodies in the circumference of a great sphere, which is wholly occasioned by the imperfection of our sight in discerning distances, the forms of all the great bodies in the universe are nearly spherical, the orbits of their revolutions generally elliptic, and without great eccentricity, in those which continually occur to our observation. Now these are figures of great uniformity, and therefore pleasing to us.

VII. If we descend to the minuter works of nature, what great uniformity among all the species of plants and vegetables in the manner of their growth and propagation! How near the resemblance among all the plants of the same species, whose numbers

surpass our imagination! And this uniformity is not only observable in the form in gross (nay, in this it is not so very exact in all instances) but in the structure of their minutest parts, even of those which no eye unassisted with glasses can discern. In the almost infinite multitude of leaves, fruit, seed, flowers of any one species we often see a very great uniformity in the structure and situation of the smallest fibres. This is the beauty which charms an ingenious botanist. Nay, what great uniformity and regularity of figure is found in each particular plant, leaf, or flower! In all trees and most of the smaller plants the stalks or trunks are either cylinders, nearly, or regular prisms, the branches similar to their several trunks, arising at nearly regular distances when no accidents retard their natural growth. In one species the branches arise in pairs on the opposite sides, the perpendicular plain of direction of the immediately superior pair intersecting the plain of direction of the inferior nearly at right angles. In another species the branches spring singly, and alternately, all around in nearly equal distances; and the branches in other species sprout all in knots around the trunk, one for each year. And in each species all the branches in the first shoots preserve the same angles with their trunk; and they again sprout out into smaller branches exactly after the manner of their trunks. Nor ought we to pass over the great unity of colours which we often see in all the flowers of the same plant or tree, and often of a whole species, and their exact agreement in many shaded transitions into opposite colours, in which all the flowers of the same plant generally agree, nay often all the flowers of a species.

VIII. Again, as to the beauty of animals, either in their inward structure, which we come to the knowledge of by experience and long observation, or their outward form, we shall find surprising uniformity among all the species which are known to us, in the structure of those parts upon which life depends more immediately. And how amazing is the unity of mechanism when we shall find an almost infinite diversity of motions, all their actions in walking, running, flying, swimming; all their serious efforts for self-preservation, all their freakish contortions when they are gay and sportful, in all their various limbs, performed by one simple contrivance of a contracting muscle, applied with inconceivable diversities to answer all these ends.

IX. Among animals of the same species unity is very obvious, and this resemblance is the very ground of our ranking them in

such classes or species, notwithstanding the great diversities in bulk, colour, shape, which are observed even in those called of the same species. And then in each individual, how universal is that beauty which arises from the exact resemblance of all the external double members to each other, which seems the universal intention of nature, when no accident prevents it! We see the want of this resemblance never fails to pass for an imperfection, and want of beauty, though no other inconvenience ensues, as when the eyes are not exactly like, or one arm or leg is a little shorter or smaller than its fellow.

XI. The peculiar beauty of fowls can scarce be omitted, which arises from the great variety of feathers, a curious sort of machine adapted to many admirable uses, which retain a considerable resemblance in their structure among all the species, and frequently a perfect uniformity in those of the same species in the corresponding parts, and in the two sides of each individual, besides all the beauty of lively colours and gradual shades, not only in the external appearance of the fowl, resulting from an artful combination of shaded feathers, but often visible even in one feather separately.

XIII. Under *original beauty* we may include *harmony*, or *beauty of sound*, if that expression can be allowed, because harmony is not usually conceived as an imitation of anything else. Harmony often raises pleasure in those who know not what is the occasion of it; and yet the foundation of this pleasure is known to be a sort of uniformity. When the several vibrations of one note regularly coincide with the vibrations of another they make an agreeable composition: and such notes are called *concords*. Thus the vibrations of any one note coincide in time with two vibrations of its octave; and two vibrations of any note coincide with three of its fifth, and so on in the rest of the concords. Now no composition can be harmonious in which the notes are not, for the most part, disposed according to these natural proportions. Besides which, a due regard must be had to the *key*, which governs the whole, and to the *time* and *humour* in which the composition is begun, a frequent and inartificial change of any of which will produce the greatest and most unnatural discord. This will appear by observing the dissonance which would arise from tacking parts of different tunes together as one, although both were separately agreeable. A like uniformity is also observable among the *basses, tenors, and trebles* of the same tune.

There is indeed observable, in the best compositions, a mysterious effect of discords: they often give as great a pleasure as continued harmony, whether by refreshing the ear with variety, or by awakening the attention, and enlivening the relish for the succeeding harmony of concords, as shades enliven and beautify pictures, or by some other means not yet known. Certain it is, however, that they have their place, and some good effect in our best compositions. Some other powers of music may be considered hereafter.

XIV. But in all these instances of beauty let it be observed that the pleasure is communicated to those who never reflected on this general foundation, and that all here alleged is this, that the pleasant sensation arises only from objects in which there is *uniformity amidst variety.* We may have the sensation without knowing what is the occasion of it, as a man's taste may suggest ideas of sweets, acids, bitters, though he be ignorant of the forms of the small bodies, or their motions, which excite these perceptions in him.

IV
Of the Relative or Comparative Beauty

I. If the preceding thoughts concerning the foundation of *absolute beauty* be just, we may easily understand wherein *relative beauty* consists. All beauty is relative to the sense of some mind perceiving it; but what we call *relative* is that which is apprehended in any object commonly considered as an *imitation* of some original. And this beauty is founded on a conformity, or a kind of unity between the original and the copy. The original may be either some object in nature, or some established idea; for if there be any known idea as a standard, and rules to fix this image or ideas by, we may make a beautiful imitation. Thus a statuary, painter, or poet may please with a *Hercules*, if his piece retains that grandeur, and those marks of strength and courage which we imagine in that hero.

And farther, to obtain comparative beauty alone, it is not necessary that there be any beauty in the original. The imitation of absolute beauty may indeed in the whole make a more lovely piece, and yet an exact imitation shall still be beautiful, though the original were entirely void of it. Thus the deformities of old age in a picture, the rudest rocks or mountains in a landscape, if well represented, shall have abundant beauty, though perhaps not so

great as if the original were absolutely beautiful, and as well represented. Nay, perhaps the novelty may make us prefer the representation of irregularity.

II. The same observation holds true in the descriptions of the poets either of natural objects or persons; and this relative beauty is what they should principally endeavour to obtain, as the peculiar beauty of their works. By the *moratae fabulae* of Aristotle, we are not to understand virtuous manners, but a just representation of manners or characters as they are in nature, and that the actions and sentiments be suited to the characters of the persons to whom they are ascribed in epic and dramatic poetry. Perhaps very good reasons may be suggested from the nature of our passions to prove that a poet should not draw his characters perfectly virtuous. These characters indeed abstractly considered might give more pleasure, and have more beauty than the imperfect ones which occur in life with a mixture of good and evil; but it may suffice at present to suggest against this choice that we have more lively ideas of imperfect men with all their passions, than of morally perfect heroes such as really never occur to our observation, and of which consequently we cannot judge exactly as to their agreement with the copy. And farther, through consciousness of our own state we are more nearly touched and affected by the imperfect characters, since in them we see represented, in the persons of others, the contrasts of inclinations, and the struggles between the passions of self-love and those of honour and virtue which we often feel in our own breasts. This is the perfection of beauty for which Homer is justly admired, as well as for the variety of his characters.

III. Many other beauties of poetry may be reduced under this class of *relative beauty*. The *probability* is absolutely necessary to make us imagine *resemblance*. It is by resemblance that *similitudes*, *metaphors*, and *allegories* are made beautiful, whether either the subject or the thing compared to it have beauty or not; the beauty indeed is greater when both have some original beauty or dignity as well as resemblance, and this is the foundation of the rule of studying *decency* in metaphors and similes as well as likeness. The *measures* and *cadence* are instances of harmony, and come under the head of absolute beauty.

IV. We may here observe a strange proneness in our minds to make perpetual comparisons of all things which occur to our observation, even of those which are very different from each

other. There are certain resemblances in the motions of all animals upon like passions, which easily found a comparison; but this does not serve to entertain our fancy. Inanimate objects have often such positions as resemble those of the human body in various circumstances. These airs or gestures of the body are indications of certain dispositions of the mind, so that our very passions and affections, as well as other circumstances, obtain a resemblance to natural inanimate objects. Thus a tempest at sea is often an emblem of wrath; a plant or tree drooping under the rain of a person in sorrow; a poppy bending its stalk, or a flower withering when cut by the plough resembles the death of a blooming hero; an aged oak in the mountains shall represent an old empire; a flame seizing a wood shall represent a war. In short, everything in nature, by our strange inclination to resemblance, shall be brought to represent other things, even the most remote, especially the passions and circumstances of human nature in which we are more nearly concerned; and to confirm this and furnish instances of it one need only look into Homer or Virgil. A fruitful fancy would find in a grove, or a wood an emblem for every character in a commonwealth, and every turn of temper or station in life.

V. Concerning that kind of comparative beauty which has a necessary relation to some established idea, we may observe that some works of art acquire a distinct beauty by their correspondence to some universally supposed intention in the artificers, or the persons who employed him. And to obtain this beauty sometimes they do not form their works so as to attain the highest perfection of original beauty separately considered, because a composition of this relative beauty, along with some degree of the original kind, may give more pleasure than a more perfect original beauty separately. Thus we see that strict regularity in laying out of gardens in parterres, vistas, parallel walks, is often neglected to obtain an imitation of nature even in some of its wildness. And we are more pleased with this imitation, especially when the scene is large and spacious, than with the more confined exactness of regular works. So likewise in the monuments erected in honour of deceased heroes, although a cylinder, or prism, or regular solid may have more original beauty than a very acute pyramid or obelisk, yet the latter pleases more by answering better to supposed intentions of stability and being conspicuous. For the same reason, cubes or square prisms are generally chosen for the pedestals of statues, and not any of the more beautiful sol-

ids, which do not seem so secure from rolling. This may be the reason too why columns or pillars look best when made a little taper from the middle, or a third from the bottom, that they may not seem top-heavy and in danger of falling.

VI. The like reason may influence artists in many other instances to depart from the rules of original beauty as above laid down. And yet this is no argument against our sense of beauty being founded, as was above explained, on uniformity amidst variety, but only evidence that our sense of beauty of the original kind may be varied and overbalanced by another kind of beauty.

VII. This beauty arising from correspondence to intention would open to curious observers a new scene of beauty in the works of nature, by considering how the mechanism of the various parts known to us seems adapted to the perfection of that part, and yet in subordination to the good of some system or whole. We generally suppose the good of the greatest whole, or of all beings, to have been the intention of the Author of nature, and cannot avoid being pleased when we see any part of this design executed in the systems we are acquainted with. The observations already made on this subject are in everyone's hand, in the treatise of our late improvers of *mechanical philosophy*. We shall only observe here that everyone has a certain pleasure in seeing any design well executed by curious mechanism, even when his own advantage is no way concerned, and also in discovering the design to which any complex machine is adapted, when he has perhaps had a general knowledge of the machine before, without seeing its correspondence or aptness to execute any design.

VI
Of the Universality of the Sense of Beauty

I. We before insinuated that all beauty has a relation to some perceiving power. And, consequently, since we know not how great a variety of senses there may be among animals, there is no form in nature concerning which we can pronounce that it has no beauty; for it may still please some perceiving power. But our *Inquiry* is confined to men; and before we examine the *universality* of this sense of beauty, or their agreement in approving uniformity; it may be proper to consider whether, as the other senses which give us pleasure do also give us pain, so this sense of

beauty does make some objects disagreeable to us, and the occasion of pain.

That many objects give no pleasure to our sense is obvious: many are certainly void of beauty. But then there is no form which seems necessarily disagreeable of itself, when we dread no other evil from it, and compare it with nothing better of the kind. Many objects are naturally displeasing, and distasteful to our external senses, as well as other pleasing and agreeable, as smells, tastes, and some separate sounds; but as to our sense of beauty, no composition of objects which give not unpleasant simple ideas, seems positively unpleasant or painful of itself, had we never observed anything better of the kind. Deformity is only the absence of beauty, or deficiency in the beauty expected in any species. Thus bad music pleases rustics who never heard any better, and the finest ear is not offended with tuning of instruments if it be not too tedious, where no harmony is expected; and yet much smaller dissonancy shall offend amidst the performance, where harmony is expected. A rude heap of stones is no way offensive to one who shall be displeased with irregularity in architecture, where beauty was expected. And had there been a species of that form which we now call ugly or deformed, and had we never seen or expected greater beauty, we should have received no disgust from it, although the pleasure would not have been so great in this form as in those we now admire. Our sense of beauty seems designed to give us positive pleasure, but not positive pain or disgust, any farther than what arises from disappointment.

II. There are indeed many faces which at first view are apt to raise dislike; but this is generally not from any deformity which of itself is positively displeasing, but either from want of expected beauty, or much more from their carrying some natural indications of morally bad dispositions, which we all acquire a faculty of discerning in countenances, airs, and gestures. That this is not occasioned by any form positively disgusting will appear from this, that if upon long acquaintance we are sure of finding sweetness of temper, humanity, and cheerfulness, although the bodily form continues, it shall give us no disgust or displeasure; whereas if anything were naturally disagreeable, or the occasion of pain, or positive distaste, it would always continue so, even although the aversion we might have toward it were counterbalanced by other considerations. There are horrors raised by some objects, which are only the effect of fear of ourselves, or compassion towards oth-

ers, when either reason, or some foolish association of ideas, makes us apprehend danger, and not the effect of anything in the form itself; for we find that most of those objects which excite horror at first, when experience or reason has removed the fear, may become the occasions of pleasure as ravenous beasts, a tempestuous sea, a craggy precipice, a dark shady valley.

III. We shall see hereafter that associations of ideas make objects pleasant and delightful which are not naturally apt to give any such pleasures; and the same way, the casual conjunctions of ideas may give a disgust where there is nothing disagreeable in the form itself. And this is the occasion of many fantastic aversions to figures of some animals, and to some other forms. Thus swine, serpents of all kinds, and some insects really beautiful enough, are beheld with aversion by many people who have got some accidental ideas associated to them. And for distastes of this kind no other account can be given.

IV. But as to the universal agreement of mankind in their sense of beauty from uniformity amidst variety, we must consult experience. And as we allow all men reason, since all men are capable of understanding simple arguments, though few are capable of complex demonstrations, so in this case it must be sufficient to prove this sense of beauty universal if all men are better pleased with uniformity in the simpler instances than the contrary, even when there is no advantage observed attending it; and likewise if all men, according as their capacity enlarges, so as to receive and compare more complex ideas, have a greater delight in uniformity, and are pleased with its more complex kinds, both original and relative.

Now let us consider if ever any person was void of this sense in the simpler instances. Few trials have been made in the simplest instances of harmony, because as soon as we find an ear incapable of relishing complex compositions, such as our tunes are, no farther pains are employed about such. But in figures, did ever any man make choice of a trapezium, or any irregular curve, for the ichnography or plan of his house, without necessity, or some great motive of convenience? Or to make the opposite walls not parallel, or unequal in height? Were ever trapeziums, irregular polygons or curves, chosen for the forms of doors or windows, though these figures might have answered the uses as well, and would have often saved a great part of the time, labour, and expense to workmen which are now employed in suiting the

stones and timber to the regular forms? Among all the fantastic modes of dress, none was ever quite void of uniformity, if it were only in the resemblance of the two sides of the same robe, and in some general aptitude to the human form. The Pictish painting had always relative beauty, by resemblance to other objects, and often those objects were originally beautiful. However justly we might here apply Horace's censure of impertinent descriptions in poetry — 'For such things there is a place, but not just now' — never were any so extravagant as to affect such figures as are made by the casual spilling of liquid colours. Who was ever pleased with an inequality of heights in windows of the same range, or dissimilar shapes of them? With unequal legs or arms, eyes or cheeks in a mistress? It must however be acknowledged that interest may often counterbalance our sense of beauty in this affair as well as in others, and superior good qualities may make us overlook such imperfections.

V. Nay farther, it may perhaps appear that regularity and uniformity are so copiously diffused through the universe, and we are so readily determined to pursue this as the foundation of beauty in works of art, that there is scarcely anything ever fancied as beautiful where there is not really something of this uniformity and regularity. We are indeed often mistaken in imagining that there is the greatest possible beauty, where it is but very imperfect; but still it is some degree of beauty which pleases, although there may be higher degrees which we do not observe; and our sense acts with full regularity when we are pleased, although we are kept by a false prejudice from pursuing objects which would please us more.

A Goth, for instance, is mistaken when from education he imagines the architecture of his country to be the most perfect; and a conjunction of some hostile ideas may make him have an aversion to Roman buildings, and study to demolish them, as some of our reformers did the popish buildings, not being able to separate the ideas of the superstitious worship from the forms of the buildings where it was practised. And yet it is still real beauty which pleases the Goth, founded upon uniformity amidst variety. For the Gothic pillars are uniform to each other, not only in their sections, which are lozenge-formed, but also in their heights and ornaments. Their arches are not one uniform curve, but yet they are segments of similar curves, and generally equal in the same ranges. The very Indian buildings have some kind of uniformity,

and many of the Eastern nations, though they differ much from us, yet have great regularity in their manner, as well as the Romans in theirs. Our Indian screens, which wonderfully supply our imaginations with ideas of deformity, in which nature is very churlish and sparing, do want indeed all the beauty arising from proportion of parts and conformity to nature; and yet they cannot divest themselves of all beauty and uniformity in the separate parts. And this diversifying the human body into various contortions may give some wild pleasure from variety, since some uniformity to the human shape is still retained.

VII. What has been said will probably be assented to if we always remember in our inquiries into the universality of the sense of beauty that there may be real beauty where there is not the greatest, and that there are an infinity of different forms which may all have some unity, and yet differ from each other. So that men may have different fancies of beauty, and yet uniformity be the universal foundation of our approbation of any form whatsoever as beautiful. And we shall find that it is so in architecture, gardening, dress, equipage, and furniture of houses, even among the most uncultivated nations, where uniformity still pleases, without any other advantage than the pleasure of the contemplation of it.

XI. The *association of ideas* above hinted at is one great cause of the apparent diversity of fancies in the sense of beauty, as well as in the external senses, and often makes men have an aversion to objects of beauty, and a liking to others void of it, but under different conceptions than those of beauty or deformity. And here it may not be improper to give some instances of some of these associations. The beauty of trees, their cool shades, and their aptness to conceal from observation have made groves and woods the usual retreat to those who love solitude, especially to the religious, the pensive, the melancholy, and the amorous. And do not we find that we have so joined the ideas of these dispositions of mind with those external objects that they always recur to us along with them? The cunning of the heathen priests might make such obscure places the scene of the fictitious appearances of their deities; and hence we join ideas of something divine to them. We know the like effect in the ideas of our churches, from the perpetual use of them only in religious exercises. The faint light in Gothic buildings has had the same association of a very foreign

idea which our poet [John Milton] shows in his epithet: *A dim religious light*.

In like manner it is known that often all the circumstances of actions, or places, or dresses of persons, or voice, or song, which have occurred at any time together, when we were strongly affected by any passion, will be so connected that any one of these will make all the rest recur. And this is often the occasion both of great pleasure and pain, delight and aversion to many objects which of themselves might have been perfectly indifferent to us; but these approbations, or distastes, are remote from the ideas of beauty, being plainly different ideas.

XII. There is also another charm in music to various persons, which is distinct from harmony and is occasioned by its raising agreeable passions. The human voice is obviously varied by all the stronger passions: now when our ear discerns any resemblance between the air of a tune, whether sung or played upon an instrument, either in its time, or modulation, or any other circumstance, to the sound of the human voice in any passion, we shall be touched by it in a very sensible manner, and have melancholy, joy, gravity, thoughtfulness excited in us by a sort of *sympathy* or *contagion*. The same connection is observable between the very air of a tune and the words expressing any passion which we have heard it fitted to, so that they shall both recur to us together, though but one of them affects our senses.

Now in such a diversity of pleasing or displeasing ideas which may be joined with forms of bodies, or tunes, when men are of such different dispositions, and prone to such a variety of passions, it is no wonder that they should often disagree in their fancies of objects, even although their sense of beauty and harmony were perfectly uniform; because many other ideas may either please or displease, according to persons' tempers and past circumstances. We know how agreeable a very wild country may be to any person who has spent the cheerful days of his youth in it, and how disagreeable very beautiful places may be if they were the scenes of his misery. And this may help us in many cases to account for the diversities of fancy, without denying the uniformity of our internal sense of beauty.

VII
Of the Power of Custom, Education, and Example, as to our Internal Senses

I. Custom, Education, and Example are so often alleged in this affair, as the occasion of our relish for beautiful objects, and for our approbation of, or delight in a certain conduct in life in a moral species, that it is necessary to examine these three particularly, to make it appear that there is a natural power of perception, or sense of beauty in objects, antecedent to all custom, education, or example.

II. Custom, as distinct from the other two, operates in this manner. As to actions, it only gives a disposition to the mind or body more easily to perform those actions which have been frequently repeated, but never leads us to apprehend them under any other view than what we were capable of apprehending them under at first, nor gives us any new power of perception about them. We are naturally capable of sentiments of fear, and dread of any powerful presence; and so custom may connect the ideas of religious horror to certain buildings; but custom could never have made a being naturally incapable of fear receive such ideas. So had we no other power of perceiving or forming ideas of actions but as they were advantageous or disadvantageous, custom could only have made us more ready at perceiving the advantage or disadvantage of actions. But this is not to our present purpose.

As to our approbation of, or delight in external objects, when the blood or spirits, of which anatomists talk, are roused, quickened, or fermented as they call it, in any agreeable manner by medicine or nutriment, or any gland frequently stimulated to secretion, it is certain that to preserve the body easy, we shall delight in objects of taste which of themselves are not immediately pleasant to it, if they promote that agreeable state which the body had been accustomed to. Further, custom will so alter the state of the body that what at first raised uneasy sensations will cease to do so, or perhaps raise another agreeable idea of the same sense. But custom can never give us the idea of a sense different from those we had antecedent to it: it will never make the blind approve objects as coloured, or those who have no taste approve meats as delicious, however they might approve them as strengthening or exhilarating. Were our glands and the parts about them void of feeling, did we perceive no pleasure from cer-

tain brisker motions in the blood, custom could never make stimulating or intoxicating fluids or medicines agreeable, when they were not so to the taste. So by like reasoning, had we no natural sense of beauty from uniformity, custom could never have made us imagine any beauty in objects; if we had no ear, custom could never have given us pleasures of harmony. When we have these natural senses antecedently, custom may make us capable of extending our views farther and of receiving more complex ideas of beauty in bodies, or harmony in sounds, by increasing our attention and quickness of perception. But however custom may increase our power of receiving or comparing complex ideas, yet it seems rather to weaken than strengthen the ideas of beauty, or the impressions of pleasure from regular objects, else how is it possible that any person could go into the open air on a sunny day, or clear evening, without the most extravagant raptures, such as Milton represents our ancestor in upon his first creation? For such any person would fall into upon the first representation of such a scene.

Custom in like manner may make it easier for any person to discern the use of a complex machine and approve it as advantageous; but he would never have imagined it beautiful had he no natural sense of beauty. Custom may make us quicker in apprehending the truth of complex theorems, but we all find the pleasure or beauty of theorems as strong at first as ever. Custom makes us more capable of retaining and comparing complex ideas, so as to discern more complicated uniformity which escapes the observation of novices in any art; but all this presupposes a natural sense of beauty in uniformity. For had there been nothing in forms which constituted the necessary occasion of pleasure to our senses, no repetition of indifferent ideas as to pleasure or pain, beauty or deformity, could ever have made them grow pleasing or displeasing.

III. The effect of education is this, that thereby we receive many speculative opinions which are sometimes true and sometimes false, and are often led to believe that objects may be naturally apt to give pleasure or pain to our external senses which in reality have no such qualities. And farther, by education there are some strong associations of ideas without any reason, by mere accident sometimes, as well as by design, which it is very hard for us ever after to break asunder. Thus aversions are raised to darkness, and to many kinds of meat, and to certain innocent actions.

Approbations without ground are raised in like manner. But in all these instances, education never makes us apprehend any qualities in objects which we have not naturally senses capable of perceiving. We know what sickness of the stomach is, and may without ground believe that very healthful meats will raise this; we by our sight and smell receive disagreeable ideas of the food of swine, and their sties, and perhaps cannot prevent the recurring of these ideas at table. But never were men naturally blind prejudiced against objects as of a disagreeable colour, or in favour of others as of a beautiful colour. They perhaps hear men dispraise one colour, and may imagine this colour to be some quite different sensible quality of the other senses, but that is all. And the same way, a man naturally void of taste could by no education receive the ideas of taste, or be prejudiced in favour of meats as delicious. So had we no natural sense of beauty and harmony we could never be prejudiced in favour of objects or sounds as beautiful or harmonious. Education may make an inattentive Goth imagine that his countrymen have attained the perfection of architecture, and an aversion to their enemies the Roman may have joined some disagreeable ideas to their very buildings, and excited them to their demolition; but he had never formed these prejudices had he been void of a sense of beauty. Did ever blind men debate whether purple or scarlet were the finer colour, or could any education prejudice them in favour of either as colours?

Thus education and custom may influence our internal senses, where they are antecedently, by enlarging the capacity of our minds to retain and compare the parts of complex compositions; and then if the finest objects are presented to us we grow conscious of a pleasure far superior to what common performances excite. But all this presupposes our sense of beauty to be natural. Instruction in anatomy, observation of nature and those airs of the countenance and attitudes of body which accompany any sentiment, action, or passion, may enable us to know where there is a just imitation. But why should an exact imitation please upon observation if we had not naturally a sense of beauty in it, more than the observing the situation of fifty or a hundred pebbles thrown at random? And should we observe them ever so often, we should never dream of their growing beautiful.

IV. There is something worth our observation as to the manner of rooting out the prejudices of education, not quite foreign to the present purpose. When the prejudice arises from association

of ideas without any natural connection, we must frequently force ourselves to bear representations of those objects, or the use of them when separated from the disagreeable idea; and this may at last disjoin the unreasonable association, especially if we can join new agreeable ideas to them. Thus opinions of superstition are best removed by pleasant conversation of persons we esteem for their virtue, or by observing that they despise such opinions. But when the prejudice arises from an apprehension or opinion of natural evil as the attendant or consequent of any object or action, if the evil be apprehended to be the constant and immediate attendant, a few trials without receiving any damage will remove the prejudice, as in that against meats. But where the evil is not represented as the perpetual concomitant, but as what may possibly or probably at some time or other accompany the use of the object, there must be frequent reasoning with ourselves, or a long series of trials without any detriment, to remove the prejudice. Such is the case of our fear of spirits in the dark and in churchyards. And when the evil is represented as the consequence perhaps a long time after, or in a future state, it is then hardest of all to remove the prejudice; and this is only to be effected by slow processes of reason, because in this case there can be no trials made. And this is the case of superstitious prejudices against actions apprehended as offensive to the Deity; and hence it is that they are so hard to root out.

George Turnbull

(1698–1748)

George Turnbull was born in Alloa, near Stirling, the son of a minister. He enrolled at the University of Edinburgh at the then not uncommonly young age of 13, but various diversions kept him from completing his degree until ten years later. During these years in Edinburgh, Turnbull was a member of the Rankenian Club, founded in 1716 by a group of young students, many of whom became in due course leading figures in the Scottish enlightenment. After graduating from Edinburgh in 1721, Turnbull took up the post of Regent at Marischal College in Aberdeen where he became a leading intellectual force and important educator of the philosophers who founded the Scottish common sense school of thought. His interest in the moral philosophy of Shaftesbury and the natural philosophy of Newton had a profound effect upon the Aberdeen curriculum, and he became one of the first to employ the experimental method in moral philosophy, an approach most famously associated with Hume.

Despite his prominence in Aberdeen, Turnbull fell out with the Principal of Marischal College, and resigned his post in 1727. His reputation for learning however was sufficient to enable him to be regularly employed as the tutor and guardian to young aristocrats on their continental grand tours. This latter experience, together with his continued study of moral and natural philosophy, profoundly influenced his intellectual development, and in particular the contents of his significant publications – all of which appeared in the early 1740s soon after his ordination as an Anglican minister.

A Treatise on Ancient Painting, more than any of his other works, reflects his experience accompanying young men on the grand

tour. Turnbull is not interested in the study of art for its own sake, but as a means to moral education and improvement. Much of the work consists of surveys of the work of the great inheritors of the classical tradition in painting, from Raphael and Michelangelo through Poussin, but in several places he reflects upon the moral importance of the study of great art and it is from these sections that the following passage is drawn. He argues that the works of art encountered on the grand tour play a role in shaping moral character and sensibility, and thus have a role in education analogous to the experiment in the natural sciences.

Strictly speaking, Turnbull was not really an innovator in Scottish *aesthetics*, since he treats of art as a means to moral education, rather than attempting an analysis of the experience of art and beauty. But his *Treatise on Ancient Painting*, with its closely drawn analogies between the study of art and science, had a profound and wide influence upon Scottish enlightenment thought. In particular, the connection Turnbull develops between the development of moral character and the development of the faculty of taste is a theme continually returned to by philosophers throughout the Scottish enlightenment.

Further Reading

Alexander Broadie, 'Art and Aesthetic Theory', in Broadie, (ed.) *The Cambridge Companion to the Scottish Enlightenment*, Cambridge: Cambridge University Press, 2003.

READING II
A TREATISE ON ANCIENT PAINTING[1]

There are subjects of a more important nature than paintings and sculptures, in whatever light they are considered, that ought principally to employ the thoughts of a traveller, who has it in his view to qualify himself for the service of his own country by visiting foreign ones. But one point aimed at in this Treatise is to show how mean, insipid and trifling the fine arts are when they are quite alienated from their better and nobler, genuine purposes which, as well as those of their sister poetry, are truly philosophical and moral; that is, to convey in an agreeable manner into the mind the knowledge of men and things; or to instruct us in

[1] From A Treatise on Ancient Painting (London, 1740).

morality, virtue and human nature. And it necessarily follows that the chief design of travelling must be somewhat of greater moment that barely to learn how to distinguish an original medal from a counterfeit one, a *Greek* from a *Roman* statue, or one painter's hand from another's; since it is here proved that even with regard to the arts of design that kind of knowledge is but idle and trivial; and that by it alone one has no better title to the character of a person of good taste in them, than a mere verbal critic has to that of a polite scholar in the classics.

Let us consider a little the pretended reasons for sending your gentleman to travel. They may be reduced to these two: 'That they may see the remains of ancient arts, and the best productions of modern sculptors and painters' and 'That they may see the world and study mankind.'

Now as for the first, how it should be offered as a reason for sending young gentlemen abroad is indeed very unaccountable when one considers upon what footing education is amongst us at present; unless it could be thought that one may be jolted by an *Italian* chaise into the knowledge and taste that are evidently pre-requisite to travelling with advantage, even in that view; or that such intelligence is the necessary mechanical effect of a certain climate upon the understanding, and will be instantaneously infused into one at his arrival on the classic ground. For in our present method of educating young gentlemen either in public schools or by private tutors, what is done that can in any degree prepare them for making proper and useful reflections upon the fine arts and their performances? Are not the arts of design quite severed in modern education not only from philosophy, their connection with which is not so obvious, or at least so generally acknowledged; but likewise from classical studies, where not only their usefulness must be readily owned by all who have the slightest notion of them, but where the want of proper help from ancient statues, bas-reliefs and paintings for understanding ancient authors, the poets in particular, is daily felt by teachers and students. It is not more ridiculous to dream of one's acquiring a strange language merely by sucking in foreign air, than to imagine that those who have never been directed at home into the right manner of considering the fine arts; those who have no idea of their true beauty, scope and excellence (not to mention such as have not the least notion of drawing) that such should all at once

so soon as they tread Italian soil become immediately capable of understanding these arts, and of making just reflections upon their excellent productions. And yet this is plainly the case with regard to the greater part of our young travellers. And for that reason I have endeavoured in the following essay to lead young gentlemen and those concerned in their education, into a juster notion of the fine arts than is commonly entertained even by the plurality of their professed admirers; by distinguishing the fine taste of them from the false learning that too frequently passes for it; and by showing in what respects alone the study of them belongs to gentlemen, whose high birth and fortune call them to the most important of all studies, that of men, manners and things, or virtue and public good.

The ancients considered education in a very extensive view, as comprehending all the arts and sciences, and employing them all to this one end: to form at the same time the head and the heart, the sense and the imagination, reason and the temper, that the whole man might be made truly virtuous and rational. And how they managed it, or thought it ought to be managed, to gain this noble scope, we may learn from their way of handling any one of the arts or discoursing on morals. Whatever is the more immediate subject of their inquiries, we find them as it has been observed, calling upon all of the arts and sciences for its embellishment and illustration. Let us therefore consider a little the natural union and close dependence of the liberal arts, and enquire how these were explained by the ancients . . .

If pictures of natural beauties are exact copies of some particular parts of nature, or done after them, as they really happened in nature, they are in that case no more than such appearances more accurately preserved by copies of them, than they can be by imagination and memory, in order to their being contemplated and examined as frequently and seriously as we please. It is the same as preserving fine thoughts and sentiments by writing, without trusting to memory, that they may not be lost. This is certainly too evident to be insisted upon. On the other hand, if landscapes are not copied from any particular appearances in nature, but imaginary; yet if they are conformable to nature's appearances and laws, being composed by combining together such scattered beauties of nature as make a beautiful whole; even in this case, the study of pictures is still the study of nature itself. For if the composition be agreeable to nature's settled laws and proportions, it

may exist, and all such representations show what nature's laws would produce in supposed circumstances. The former sort may therefore be called a register of nature, and the latter a supplement to nature, or rather to the observers and lovers of nature. And in both cases landscapes are samples or experiments in natural philosophy, because they serve to fix before our eyes beautiful effects of nature's laws until we have admired them and accurately considered the laws from which such visible beauties and harmonies result.

Though one be as yet altogether unacquainted with landscapes (by which I would all along be understood to mean views and prospects of nature) he may easily comprehend what superior pleasures one must have, who has an eye formed by comparing landscapes with nature in the contemplation of nature itself, in his morning or evening walks, to one who is not at all conversant in painting. Such a one will be more attentive to nature; he will let nothing escape his observation because he will feel a vast pleasure in observing and choosing picturesque skies, scenes and other appearances that would be really beautiful in pictures. He will delight in observing what is really worthy of being painted, what circumstances a good genius would take hold of, what parts he would leave out, and what he would add, and for what reasons. The laws of light and colours, which properly speaking, produce all the various phenomena of the visible world, would afford to such an inexhaustible fund of the most agreeable entertainment; while the ordinary spectator of nature can hardly receive any satisfaction from his eye, but what may be justly compared with the ordinary titillation a common ear feels in respect of the exquisite joy a refined piece of music gives to a skilful, well-formed one, to a person instructed in the principles of true composition and inured to good performance.

Nor is another pleasure to be passed by unmentioned, that the eye formed by right instruction in good pictures, to the accurate and careful observance of nature's beauties, will have in recalling to mind, upon seeing certain appearances in nature, the landscapes of great masters he has seen, and their particular genius's and tastes. He will ever be discerning something suited to the particular turn of one or other of them; something a Titian, a Poussin, a Salvator Rosa, or a Claude Lorrain has already represented, or would not have let go without imitating, and making a good use of in landscape. Nature would send such a one to pictures, and

pictures would send him to nature. And thus the satisfaction he would receive from the one or the other would be always double.

In short, pictures which represent visible beauties, or the effects of nature in the visible world, by the different modifications of light and colours, in consequence of the laws which relate to light, are samples of what these laws do or may produce. And therefore they are as proper samples or experiments to help and assist us in the study of those laws, as any samples or experiments are in the study of the laws of gravity, elasticity, or of any other quality in the natural world. They are then samples or experiments in natural philosophy. The same observation may be thus set in another light. Nature has given us a sense of beauty and order in visible objects, and it has not certainly given us this or any other sense for any other reason but that it might be improved by due culture and exercise. Now in what can the improvement of this sense and taste consist, but in being able to choose from nature such parts as being combined together according to nature's laws, would make beautiful systems? This is certainly its proper business and entertainment, and what else is this but painting or a taste in painting? For painting aims at visible harmony, as music at harmony of sounds. But how else can either the eye or the ear, the sense of visible or audible harmony, be formed and improved to perfection, but by exercise and instruction about these harmonies, by means of proper examples? Pictures, therefore, in whatever sense they are considered have a near relation to philosophy, and a very close connection with education, if it be any part of its design to form our taste of nature, and improve our senses of visible harmonies and beauties, or to make us intelligent spectators and admirers of the visible world.

But I proceed to consider historical or moral pictures, which must immediately be acknowledged, in consequence of the very definition of them, to be proper samples and experiments in teaching human nature and moral philosophy. For what are historical pictures but imitations of parts of human life, representations of characters and manners? And are not such representations samples or specimens in moral philosophy by which any part of human nature or of the moral world may be brought near to our view, and fixed before us until it is fully compared with nature itself, and is found to be a true image and consequently to point out some moral conclusion with complete force of evidence? Moral characters and actions described by the good poet

are readily owned to be very proper subjects for the philosopher to examine and compare with the human heart and the real springs and consequences of actions . . . But moral pictures must be for the same reason proper samples in the school of morals. For what passions or actions may not be represented by pictures; what degrees, tones or blendings of affections; what frailties, what penances, what emotions in our hearts; what manners, or what characters cannot the pencil exhibit to the life? Moral pictures as well as moral poems are indeed mirrors in which we may view our inward features, gestures, airs and attitudes; but do not these, by a universal language, mark the different affections and dispositions of the mind? What character, what passions, what movement of the soul, may not be thus most powerfully expressed by a skilful hand? The design of moral pictures is, therefore, by that means, to show us to ourselves; to reflect our image upon us in order to attract our attention the more closely to it, and to engage us in conversation with ourselves, and an accurate consideration of our make and frame.

As it has been observed, with respect to landscapes, so in this case likewise. Pictures may bring parts of nature to our view which could never have been seen or observed by us in real life, and they must engage our attention more closely to nature itself than mere lessons upon nature can do without such assistance, nothing being so proper to fix the mind as the double employment of comparing copies with originals. And in general, all that has been said to show that landscapes are proper samples or experiments in natural philosophy, as being either registers or supplements to nature, is obviously applicable to moral pictures with relation to moral philosophy. We have already had occasion to remark that it is because the poet and painter have this advantage, that whereas the historian is confined to fact, they can select such circumstances in their representations as are fittest to instruct or move; that it is for this reason Aristotle recommends these arts as better teachers of morals than the best histories, and calls them the more catholic or universal. I shall only add upon this head that as certain delicate vessels in the human body cannot be discerned by the naked eye, but must be magnified in order to be rendered visible, so without the help of magnifiers, not only several nice parts of our moral fabric would escape our observation, but no features, no characters of whatever kind would be sufficiently attended to. Now the imitative arts become magnifi-

ers in the moral way by means of choosing those circumstances which are most proper to exhibit the workings and consequences of affections in the strongest light that may be, or to render them most striking and conspicuous. All is nature that is represented, if all be agreeable to nature; what is not so, whether in painting or poetry, will be rejected even by every common beholder . . . But a fiction that is consonant to nature may convey a moral lesson more strikingly than can be done by any real story, and is as sure a foundation to build a conclusion upon, since from what is conformable to nature, no erroneous or seductive rule can be inferred.

Thus, therefore, it is evident that pictures as well as poems have a very near relation to philosophy and a very close connection with moral instruction and education . . . The conclusion I have now chiefly in view is that good moral paintings, whether by words or by the pencil, are proper samples in moral philosophy, and ought therefore to be employed in teaching it, for the same reason that experiments are made use of in teaching natural philosophy. And this is as certain as that experiments or samples of manners, affections, actions, and characters must belong to moral philosophy, and be proper samples for evincing and enforcing its doctrines — for such are moral paintings.

Three

David Hume

(1711–1776)

Hume was one of the very greatest of the Scottish enlightenment thinkers, and among the most controversial of the Scottish philosophers. He was born in Edinburgh, but spent his youth and some of his middle years at Ninewells in the county of Berwickshire. He was the son of a legal advocate who never practiced, living instead the life of the country gentleman and landlord. When he was still an infant, Hume's father died and his mother took charge of his education, though Hume records in his biographical essay that from a young age he was seized by a passion for literature that remained with him throughout his life. After studying at Edinburgh University Hume travelled to France, where he devoted his time to intense study and writing at La Flache, the renowned Jesuit college and centre of learning. At the age of twenty six he began to publish *The Treatise of Human Nature*, the book that would eventually be recognized as the most philosophically significant among his many great works. Composed of three parts, the first of which consists of an analysis of the operations of the mind, the second part analyses the passions, or feelings and emotions, and the final part questions of morality. The conclusions, particularly in the first and final parts of the *Treatise*, are acknowledged by Hume to have a sceptical orientation, in the sense that many of our beliefs — such as that one thing is the cause of another or that some action is morally good — have no basis in reason, but in imagination and sentiment. This scepticism earned Hume a notorious reputation, further heightened by his perceived and implicit atheism. Hume thought his scepticism was generally misunderstood, and although he certainly was an atheist, he took care never to pronounce that position in order to avoid

controversy. His position on religion was most fully explored in his posthumously published *Dialogues Concerning Natural Religion*, which is another of his, and the Scottish enlightenment's, greatest works. Whatever care Hume took to avoid controversy, there were elements of Edinburgh society that believed his beliefs and influence to be sufficiently baneful to have successfully campaigned to ensure his application for a chair in philosophy at Edinburgh University was rejected. Even his opponents tended to acknowledge Hume's genius, however; and his pre-eminent position in the intellectual life of Edinburgh and beyond was rarely questioned — even if his views were under constant attack.

Two of the readings in this collection are taken from Hume's *Treatise*. The first is a brief statement of his view that beauty and deformity are species of pleasure and pain that arise in response to qualities of objects, and in the context of the passage the beauty of the human body is taken as the model though care is also taken to emphasise that the beauty of nature and art have the same explanation. The second extract from the *Treatise* is concerned with the effect of small and great quantities of space and time upon the imagination, which is the basis of Hume's analysis of the sublime. It is not always obvious that Hume's discussion of the effects upon the imagination of certain phenomena is concerned with the sublime. Hume prefers the common synonyms of the sublime — greatness, grandeur, elevation and enlargement of the soul — as well as focusing upon what he elsewhere characterises as the appropriate responses to greatness, esteem and admiration.

More closely connected to his discussion of beauty is his seminal essay on the standard of taste. For if beauty is simply a sentiment of pleasure aroused by some feature of an object, what sense is there to the claim that there is a right or wrong, or better or worse, taste for beauty? How could a pleasure or its absence be right or wrong? At the same time however, we tend to believe the taste of all is not on an equal level — that there are grounds for rejecting some judgments of taste. The task Hume sets himself in his essay on the standard of taste is the exploration of the possibilities for grounding this latter belief. Consistent with his scepticism about the powers of reason to provide the foundations for belief, Hume seeks his standard in the agreement of sentiments across a large number of people — and in particular those who exhibit the kinds of qualities that underwrite critical ability.

The final essay, published together with the essay on taste in 1757, sets out and purportedly solves a puzzle concerning our response to the horrible events that occur in tragic drama. Such events would distress us enormously if we witnessed them happening in reality, so why is it that the same events in a well constructed play give us enormous pleasure? Hume's solution is an interesting one, but as the large literature on Hume's puzzle and his solution demonstrate, it remains a very live question what the correct solution is.

Further Reading

Dabney Townsend, *Hume's Aesthetic Theory*, London: Routledge, 2001.

George Dickie, *The Century of Taste*, Oxford: Oxford University Press, 1996.

READING III

OF BEAUTY AND DEFORMITY[1]

Whether we consider the body as a part of ourselves, or assent to those philosophers who regard it as something external, it must be allowed to be near enough connected with us to form one of these double relations, which I have asserted to be necessary to the causes of pride and humility. Wherever, therefore, we can find the other relation of impressions to join to this of ideas, we may expect with assurance either of these passions, according as the impression is pleasant or uneasy. But *beauty* of all kinds gives us a peculiar delight and satisfaction; as *deformity* produces pain, upon whatever subject it may be placed, and whether surveyed in an animate or inanimate object. If the beauty or deformity, therefore, be placed upon our own bodies, this pleasure or uneasiness must be converted into pride or humility, as having in this case all the circumstances requisite to produce a perfect transition of impressions and ideas. These opposite sensations are related to the opposite passions. The beauty or deformity is closely related to self, the object of both these passions. No wonder, then, our own beauty becomes an object of pride, and deformity of humility.

[1] From *Treatise of Human Nature* (London, 1739).

But this effect of personal and bodily qualities is not only a proof of the present system, by showing that the passions arise not in this case without all the circumstances I have required, but may be employed as a stronger and more convincing argument. If we consider all the hypotheses, which have been formed either by philosophy or common reason, to explain the difference betwixt beauty and deformity, we shall find that all of them resolve into this, that beauty is such an order and construction of parts, as either by the *primary constitution* of our nature, by *custom*, or by *caprice*, is fitted to give a pleasure and satisfaction to the soul. This is the distinguishing character of beauty, and forms all the difference betwixt it and deformity, whose natural tendency is to produce uneasiness. Pleasure and pain, therefore, are not only necessary attendants of beauty and deformity, but constitute their very essence. And indeed, if we consider that a great part of the beauty, which we admire either in animals or in other objects, is derived from the idea of convenience and utility, we shall make no scruple to assent to this opinion. That shape, which produces strength, is beautiful in one animal; and that which is a sign of agility in another. The order and convenience of a palace are no less essential to its beauty, than its mere figure and appearance. In like manner the rules of architecture require, that the top of a pillar should be more slender than its base, and that because such a figure conveys to us the idea of security, which is pleasant; whereas the contrary form gives us the apprehension of danger, which is uneasy. From innumerable instances of this kind, as well as from considering that beauty like wit, cannot be defined, but is discerned only by a taste or sensation, we may conclude, that beauty is nothing but a form, which produces pleasure, as deformity is a structure of parts, which conveys pain; and since the power of producing pain and pleasure make in this manner the essence of beauty and deformity, all the effects of these qualities must be derived from the sensation; and among the rest pride and humility, which of all their effects are the most common and remarkable.

This argument I esteem just and decisive; but in order to give a greater authority to the present reasoning, let us suppose it false for a moment, and see what will follow. It is certain, then, that if the power of producing pleasure and pain forms not the essence of beauty and deformity, the sensations are at least inseparable from the qualities, and it is even difficult to consider them apart.

Now there is nothing common to natural and moral beauty, (both of which are the causes of pride) but this power of producing pleasure; and as a common effect supposes always a common cause, it is plain the pleasure must in both cases be the real and influencing cause of the passion. Again, there is nothing originally different betwixt the beauty of our bodies and the beauty of external and foreign objects, but that the one has a near relation to ourselves, which is wanting in the other. This original difference, therefore, must be the cause of all their other differences, and among the rest, of their different influence upon the passion of pride, which is excited by the beauty of our person, but is not affected in the least by that of foreign and external objects. Placing, then, these two conclusions together, we find they compose the preceding system betwixt them, *viz.* that pleasure, as a related or resembling impression, when placed on a related object, by a natural transition, produces pride; and its contrary, humility. This system, then, seems already sufficiently confirmed by experience; though we have not yet exhausted all our arguments.

It is not the beauty of the body alone that produces pride, but also its strength and force. Strength is a kind of power; and therefore the desire to excel in strength is to be considered as an inferior species of *ambition*. For this reason the present phenomenon will be sufficiently accounted for, in explaining that passion.

Concerning all other bodily accomplishments we may observe in general, that whatever in ourselves is either useful, beautiful, or surprising, is an object of pride; and it's contrary, of humility. Now it is obvious, that everything useful, beautiful or surprising, agrees in producing a separate pleasure, and agrees in nothing else. The pleasure, therefore, with the relation to self must be the cause of the passion.

Though it should be questioned, whether beauty be not something real, and different from the power of producing pleasure, it can never be disputed, that as surprise is nothing but a pleasure arising from novelty, it is not, properly speaking, a quality in any object, but merely a passion or impression in the soul . . .

READING IV

OF CONTIGUITY AND DISTANCE IN SPACE AND TIME[2]

There is an easy reason, why every thing contiguous to us, either in space or time, should be conceived with a peculiar force and vivacity, and excel every other object, in its influence on the imagination. Our self is intimately present to us, and whatever is related to self must partake of that quality. But where an object is so far removed as to have lost the advantage of this relation, why, as it is farther removed, its idea becomes still fainter and more obscure, would, perhaps, require a more particular examination.

It is obvious, that the imagination can never totally forget the points of space and time, in which we are existent; but receives such frequent advertisements of them from the passions and senses, that however it may turn its attention to foreign and remote objects, it is necessitated every moment to reflect on the present. It is also remarkable, that in the conception of those objects, which we regard as real and existent, we take them in their proper order and situation, and never leap from one object to another, which is distant from it, without running over, at least in a cursory manner, all those objects, which are interposed betwixt them. When we reflect, therefore, on any object distant from ourselves, we are obliged not only to reach it at first by passing through all the intermediate space betwixt ourselves and the object, but also to renew our progress every moment; being every moment recalled to the consideration of ourselves and our present situation. It is easily conceived, that this interruption must weaken the idea by breaking the action of the mind, and hindering the conception from being so intense and continued, as when we reflect on a nearer object. The *fewer* steps we make to arrive at the object, and the *smoother* the road is, this diminution of vivacity is less sensibly felt, but still may be observed more or less in proportion to the degrees of distance and difficulty.

Here then we are to consider two kinds of objects, the contiguous and remote; of which the former, by means of their relation to ourselves, approach an impression in force and vivacity; the latter by reason of the interruption in our manner of conceiving them, appear in a weaker and more imperfect light. This is their effect on

[2] From *Treatise of Human Nature* (London, 1739).

the imagination. If my reasoning be just, they must have a proportionable effect on the will and passions. Contiguous objects must have an influence much superior to the distant and remote. Accordingly we find in common life, that men are principally concerned about those objects, which are not much removed either in space or time, enjoying the present, and leaving what is afar off to the care of chance and fortune. Talk to a man of his condition thirty years hence, and he will not regard you. Speak of what is to happen tomorrow, and he will lend you attention. The breaking of a mirror gives us more concern when at home, than the burning of a house, when abroad, and some hundred leagues distant.

But farther; though distance both in space and time has a considerable effect on the imagination, and by that means on the will and passions, yet the consequence of a removal in *space* are much inferior to those of a removal in *time*. Twenty years are certainly but a small distance of time in comparison of what history and even the memory of sense may inform them of, and yet I doubt if a thousand leagues, or even the greatest distance of place this globe can admit of, will so remarkably weaken our ideas, and diminish our passions. A *West-India* merchant will tell you, that he is not without concern about what passes in *Jamaica*; though few extend their views so far into futurity, as to dread very remote accidents.

The cause of this phenomenon must evidently lie in the different properties of space and time. Without having recourse to metaphysics, any one may easily observe, that space or extension consists of a number of co-existent parts disposed in a certain order, and capable of being at once present to the sight or feeling. On the contrary, time or succession, though it consists likewise of parts, never presents to us more than one at once; nor is it possible for any two of them ever to be co-existent. These qualities of the objects have a suitable effect on the imagination. The parts of extension being susceptible of an union to the senses, acquire an union in the fancy; and as the appearance of one part excludes not another, the transition or passage of the thought through the contiguous parts is by that means rendered more smooth and easy. On the other hand, the incompatibility of the parts of time in their real existence separates them in the imagination, and makes it more *difficult* for that faculty to trace any long succession or series of events. Every part must appear single and alone, nor can regularly have entrance into the fancy without banishing what is sup-

posed to have been immediately precedent. By this means any distance in time causes a greater interruption in the thought than an equal distance in space, and consequently weakens more considerably the idea, and consequently the passions; which depend in a great measure, on the imagination, according to my system.

There is another phenomenon of a like nature with the foregoing, viz. *the superior effects of the same distance in futurity above that in the past*. This difference with respect to the will is easily accounted for. As none of our actions can alter the past, it is not strange it should never determine the will. But with respect to the passions the question is yet entire, and well worth the examining.

Besides the propensity to a gradual progression through the points of space and time, we have another peculiarity in our method of thinking, which concurs in producing this phenomenon. We always follow the succession of time in placing our ideas and from the consideration of any object pass more easily to that which follows immediately after it than to that which went before it. We may learn this, among other instances, from the order, which is always observed in historical narrations. Nothing but an absolute necessity can oblige an historian to break the order of time, and in his *narration* give the precedence to an event, which was in *reality* posterior to another.

This will easily be applied to the question in hand, if we reflect on what I have before observed, that the present situation of the person is always that of the imagination, and that it is from thence we proceed to the conception of any distant object. When the object is past, the progression of the thought in passing from it to the present is contrary to nature, as proceeding from one point of time to that which is preceding, and from that to another preceding, in opposition to the natural course of the succession. On the other hand, when we turn our thought to a future object, our fancy flows along the stream of time, and arrives at the object by an order, which seems most natural, passing always from one point of time to that which is immediately posterior to it. This *easy* progression of ideas favours the imagination, and makes it conceive its object in a stronger and fuller light, than when we are continually opposed in our passage, and are obliged to overcome the difficulties arising from the natural propensity of the fancy. A small degree of distance in the past has, therefore, a greater effect, in interrupting and weakening the conception, than a much

greater in the future. From this effect of it on the imagination is derived its influence on the will and passions.

There is another cause, which both contributes to the same effect, and proceeds from the same quality of the fancy, by which we are determined to trace the succession of time by a similar succession of ideas. When from the present instant we consider two points of time equally distant in the future and in the past, it is evident, that, abstractly considered, their relation to the present is almost equal. For as the future will *sometime* be present, so the past was *once* present. If we could, therefore, remove this quality of the imagination, an equal distance in the past and in the future, would have a similar influence. Nor is this only true, when the fancy remains fixed, and from the present instant surveys the future and the past; but also when it changes its situation, and places us in different periods of time. For as on the one hand, in supposing ourselves existent in a point of time interposed betwixt the present instant and the future object, we find the future object approach to us, and the past retire, and become more distant: So on the other hand, in supposing ourselves existent in a point of time interposed betwixt the present and the past, the past approaches to us, and the future becomes more distant. But from the property of the fancy above-mentioned we rather choose to fix our thought on the point of time interposed betwixt the present and the future, than on that betwixt the present and the past. We advance, rather than retard our existence; and following what seems the natural succession of time, proceed from past to present, and from present to future. By which means we conceive the future as flowing every moment nearer us, and the past as retiring. An equal distance, therefore, in the past and in the future, has not the same effect on the imagination; and that because we consider the one as continually increasing, and the other as continually diminishing. The fancy anticipates the course of things, and surveys the object in that condition, to which it tends, as well as in that, which is regarded as the present.

Thus we have accounted for three phenomena, which seem pretty remarkable. Why distance weakens the conception and passion: Why distance in time has a greater effect than that in space: And why distance in past time has still a greater effect than that in future. We must now consider three phenomena, which seem to be, in a manner, the reverse of these: Why a very great distance increases our esteem and admiration for an object: Why

such a distance in time increases more than that in space: And a distance in past time more than that in future. The curiousness of the subject will, I hope, excuse my dwelling on it for some time.

To begin with the first phenomenon, why a great distance increases our esteem and admiration for an object; it is evident that the mere view and contemplation of any greatness, whether successive or extended, enlarges the soul, and gives it a sensible delight and pleasure. A wide plain, the ocean, eternity, a succession of several ages; all these are entertaining objects, and excel every thing, however beautiful, which accompanies not its beauty with a suitable greatness. Now when any very distant object is presented to the imagination, we naturally reflect on the interposed distance, and by that means, conceiving something great and magnificent, receive the usual satisfaction. But as the fancy passes easily from one idea to another related to it, and transports to the second all the passions excited by the first, the admiration, which is directed to the distance, naturally diffuses itself over the distant object. Accordingly we find, that it is not necessary the object should be actually distant from us, in order to cause our admiration; but that it is sufficient, if, by the natural association of ideas, it conveys our view to any considerable distance. A great traveller, though in the same chamber, will pass for a very extraordinary person; as a *Greek* medal, even in our cabinet, is always esteemed a valuable curiosity. Here the object, by a natural transition, conveys our view to the distance; and the admiration, which arises from that distance, by another natural transition, returns back to the object.

But though every great distance produces an admiration for the distant object, a distance in time has a more considerable effect than that in space. Ancient busts and inscriptions are more valued than *Japan* tables: And not to mention the *Greeks* and *Romans*, it is certain we regard with more veneration the old *Chaldeans* and *Egyptians*, than the modern *Chinese* and *Persians*, and bestow more fruitless pains to clear up the history and chronology of the former, than it would cost to make a voyage, and be certainly informed of the character, learning and government of the latter. I shall be obliged to make a digression in order to explain this phenomenon.

It is a quality very observable in human nature, that any opposition, which does not entirely discourage and intimidate us, has rather a contrary effect, and inspires us with a more than ordinary

grandeur and magnanimity. In collecting our force to overcome the opposition, we invigorate the soul, and give it an elevation with which otherwise it would never have been acquainted. Compliance, by rendering our strength useless, makes us insensible of it; but opposition awakens and employs it.

This is also true in the inverse. Opposition not only enlarges the soul; but the soul, when full of courage and magnanimity, in a manner seeks opposition.

> *Spumantemque dari pecora inter inertia votis*
> *Optat aprum, aut fulvum descendere monte leonem.*

Whatever supports and fills the passions is agreeable to us; as on the contrary, what weakens and enfeebles them is uneasy. As opposition has the first effect, and facility the second, no wonder the mind, in certain dispositions, desires the former, and is averse to the latter.

These principles have an effect on the imagination as well as on the passions. To be convinced of this we need only consider the influence of *heights* and *depths* on that faculty. Any great elevation of place communicates a kind of pride or sublimity of imagination, and gives a fancied superiority over those that lie below; and, *vice versa*, a sublime and strong imagination conveys the idea of ascent and elevation. Hence it proceeds, that we associate, in a manner, the idea of whatever is good with that of height, and evil with lowness. Heaven is supposed to be above, and hell below. A noble genius is called an elevate and sublime one. *Atque udam spernit humum fugiente penna.* On the contrary, a vulgar and trivial conception is stilled indifferently low or mean. Prosperity is denominated ascent, and adversity descent. Kings and princes are supposed to be placed at the top of human affairs; as peasants and day-labourers are said to be in the lowest stations. These methods of thinking, and of expressing ourselves, are not of so little consequence as they may appear at first sight.

It is evident to common sense, as well as philosophy, that there is no natural nor essential difference betwixt high and low, and that this distinction arises only from the gravitation of matter, which produces a motion from the one to the other. The very same direction, which in this part of the globe is called *ascent*, is denominated *descent* in our antipodes; which can proceed from nothing but the contrary tendency of bodies. Now it is certain, that the tendency of bodies, continually operating upon our senses, must

produce, from custom, a like tendency in the fancy, and that when we consider any object situated in an ascent, the idea of its weight gives us a propensity to transport it from the place, in which it is situated, to the place immediately below it, and so on, till we come to the ground, which equally stops the body and our imagination. For a like reason we feel a difficulty in mounting, and pass not without a kind of reluctance from the inferior to that which is situated above it; as if our ideas acquired a kind of gravity from their objects. As a proof of this, do we not find, that the facility, which is so much studied in music and poetry, is called the fall or cadency of the harmony or period; the idea of facility communicating to us that of descent, in the same manner as descent produces a facility?

Since the imagination, therefore, in running from low to high, finds an opposition in its internal qualities and principles, and since the soul, when elevated with joy and courage, in a manner seeks opposition and throws itself with alacrity into any scene of thought or action, where its courage meets with matter to nourish and employ it; it follows, that every thing, which invigorates and enlivens the soul, whether by touching the passions or imagination, naturally conveys to the fancy this inclination for ascent, and determines it to run against the natural stream of its thoughts and conceptions. This aspiring progress of the imagination suits the present disposition of the mind; and the difficulty, instead of extinguishing its vigour and alacrity, has the contrary effect, of sustaining and increasing it. Virtue, genius, power, and riches are for this reason associated with height and sublimity; as poverty, slavery, and folly are conjoined with descent and lowness. Were the case the same with us as *Milton* represents it to be with the angels, to whom *descent is adverse*, and who *cannot sink without labour and compulsion*, this order of things would be entirely inverted; as appears hence, that the very nature of ascent and descent is derived from the difficulty and propensity, and consequently every one of their effects proceeds from that origin.

All this is easily applied to the present question, why a considerable distance in time produces a greater veneration for the distant objects than a like removal in space. The imagination moves with more difficulty in passing from one portion of time to another, than in a transition through the parts of space; and that because space or extension appears united to our senses, while time or succession is always broken and divided. This difficulty, when joined with a small distance, interrupts and weakens the

fancy: But has a contrary effect in a great removal. The mind, elevated by the vastness of its object, is still farther elevated by the difficulty of the conception; and being obliged every moment to renew its efforts in the transition from one part of time to another, feels a more vigorous and sublime disposition, that in a transition through the parts of space, where the ideas flow along with easiness and facility. In this disposition, the imagination, passing, as is usual, from the consideration of the distance to the view of the distant objects, gives us a proportionable veneration for it; and this is the reason why all the relicts of antiquity are so precious in our eyes, and appear more valuable than what is brought even from the remotest parts of the world.

The third phenomenon I have remarked will be a full confirmation of this. It is not every removal in time, which has the effect of producing veneration and esteem. We are not apt to imagine our posterity will excel us, or equal our ancestors. This phenomenon is the more remarkable, because any distance in futurity weakens not our ideas so much as an equal removal in the past. Though a removal in the past, when very great, increases our passions beyond a like removal in the future, yet a small removal has a greater influence in diminishing them.

In our common way of thinking we are placed in a kind of middle station betwixt the past and future; and as our imagination finds a kind of difficulty in running along the former, and a facility in following the course of the latter, the difficulty conveys the notions of ascent, and the facility of the contrary. Hence we imagine our ancestors to be, in a manner, mounted above us, and our posterity to lie below us. Our fancy arrives not at the one without effort, but easily reaches the other: Which effort weakens the conception, where the distance is small; but enlarges and elevates the imagination, when attended with a suitable object. As on the other hand, the facility assists the fancy in a small removal, but takes off from its force when it contemplates any considerable distance.

It may not be improper, before we leave this subject of the will, to resume, in a few words, all that has been said concerning it, in order to set the whole more distinctly before the eyes of the reader. What we commonly understand by *passion* is a violent and sensible emotion of mind, when any good or evil is presented, or any object, which, by the original formation of our faculties, is fitted to excite an appetite. By *reason* we mean affections of the very

same kind with the former; but such as operate more calmly, and cause no disorder in the temper: Which tranquillity leads us into a mistake concerning them, and causes us to regard them as conclusions only of our intellectual faculties. Both the *causes* and *effects* of these violent and calm passions are pretty variable, and depend, in a great measure, on the peculiar temper and disposition of every individual. Generally speaking, the violent passions have a more powerful influence on the will; though it is often found, that the calm ones, when corroborated by reflection, and seconded by resolution, are able to control them in their most furious movements. What makes this whole affair more uncertain, is, that a calm passion may easily be changed into a violent one, either by a change of temper, or of the circumstances and situation of the object, as by the borrowing of force from any attendant passion, by custom, or by exciting the imagination. Upon the whole, this struggle of passion and of reason, as it is called, diversifies human life, and makes men so different not only from each other, but also from themselves in different times. Philosophy can only account for a few of the greater and more sensible events of this war; but must leave all the smaller and more delicate revolutions, as dependent on principles too fine and minute for her comprehension.

READING V

OF THE STANDARD OF TASTE[3]

The great variety of taste, as well as of opinion, which prevails in the world, is too obvious not to have fallen under everyone's observation. Men of the most confined knowledge are able to remark a difference of taste in the narrow circle of their acquaintance, even where the persons have been educated under the same government, and have early imbibed the same prejudices. But those who can enlarge their view to contemplate distant nations and remote ages, are still more surprised at the great inconsistence and contrariety. We are apt to call *barbarous* whatever departs widely from our own taste and apprehension; but soon find the epithet of reproach retorted on us. And the highest arrogance and self-conceit is at last startled, on observing an equal assurance on all sides, and scruples, amidst such a contest of sentiment, to pronounce positively in its own favour.

[3] From *Four Dissertations* (London, 1757).

As this variety of taste is obvious to the most careless inquirer, so will it be found, on examination, to be still greater in reality than in appearance. The sentiments of men often differ with regard to beauty and deformity of all kinds, even while their general discourse is the same. There are certain terms in every language which import blame, and others praise; and all men who use the same tongue must agree in their application of them. Every voice is united in applauding elegance, propriety, simplicity, spirit in writing; and in blaming fustian, affectation, coldness, and a false brilliancy. But when critics come to particulars, this seeming unanimity vanishes; and it is found, that they had affixed a very different meaning to their expressions. In all matters of opinion and science, the case is opposite; the difference among men is there oftener found to lie in generals than in particulars, and to be less in reality than in appearance. An explanation of the terms commonly ends the controversy: and the disputants are surprised to find that they had been quarrelling, while at bottom they agreed in their judgment.

Those who found morality on sentiment, more than on reason, are inclined to comprehend ethics under the former observation; and to maintain, that, in all questions which regard conduct and manners, the difference among men is really greater than at first sight it appears. It is indeed obvious, that writers of all nations and all ages concur in applauding justice, humanity, magnanimity, prudence, veracity; and in blaming the opposite qualities. Even poets and other authors, whose compositions are chiefly calculated to please the imagination, are yet found, from Homer down to Fenelon, to inculcate the same moral precepts, and to bestow their applause and blame on the same virtues and vices. This great unanimity is usually ascribed to the influence of plain reason, which, in all these cases, maintains similar sentiments in all men, and prevents those controversies to which the abstract sciences are so much exposed. So far as the unanimity is real, this account may be admitted as satisfactory. But we must also allow, that some part of the seeming harmony in morals may be accounted for from the very nature of language. The word *virtue*, with its equivalent in every tongue, implies praise, as that of *vice* does blame; and no one, without the most obvious and grossest impropriety, could affix reproach to a term, which in general acceptation is understood in a good sense; or bestow applause, where the idiom requires disapprobation. Homer's general pre-

cepts, where he delivers any such, will never be controverted; but it is obvious, that, when he draws particular pictures of manners, and represents heroism in Achilles, and prudence in Ulysses, he intermixes a much greater degree of ferocity in the former, and of cunning and fraud in the latter, than Fenelon would admit of. The sage Ulysses, in the Greek poet, seems to delight in lies and fictions, and often employs them without any necessity, or even advantage. But his more scrupulous son, in the French epic writer, exposes himself to the most imminent perils, rather than depart from the most exact line of truth and veracity.

The admirers and followers of the Koran insist on the excellent moral precepts interspersed throughout that wild and absurd performance. But it is to be supposed, that the Arabic words, which correspond to the English, equity, justice, temperance, meekness, charity, were such as, from the constant use of that tongue, must always be taken in a good sense: and it would have argued the greatest ignorance, not of morals, but of language, to have mentioned them with any epithets, besides those of applause and approbation. But would we know, whether the pretended prophet had really attained a just sentiment of morals, let us attend to his narration, and we shall soon find, that he bestows praise on such instances of treachery, inhumanity, cruelty, revenge, bigotry, as are utterly incompatible with civilized society. No steady rule of right seem there to be attended to; and every action is blamed or praised, so far only as it is beneficial or hurtful to the true believers.

The merit of delivering true general precepts in ethics is indeed very small. Whoever recommends any moral virtues, really does no more than is implied in the terms themselves. That people who invented the word *charity*, and used it in a good sense, inculcated more clearly, and much more efficaciously, the precept, *be charitable*, than any pretended legislator or prophet, who should insert such a *maxim* in his writings. Of all expressions, those which, together with their other meaning, imply a degree either of blame or approbation, are the least liable to be perverted or mistaken.

It is natural for us to seek a *Standard of Taste*; a rule by which the various sentiments of men may be reconciled; at least a decision afforded confirming one sentiment, and condemning another.

There is a species of philosophy, which cuts off all hopes of success in such an attempt, and represents the impossibility of ever attaining any standard of taste. The difference, it is said, is very

wide between judgment and sentiment. All sentiment is right; because sentiment has a reference to nothing beyond itself, and is always real, wherever a man is conscious of it. But all determinations of the understanding are not right, because they have a reference to something beyond themselves, to wit, real matter of fact; and are not always conformable to that standard. Among a thousand different opinions which different men may entertain of the same subject, there is one, and but one, that is just and true: and the only difficulty is to fix and ascertain it. On the contrary, a thousand different sentiments, excited by the same object, are all right; because no sentiment represents what is really in the object. It only marks a certain conformity or relation between the object and the organs or faculties of the mind; and if that conformity did not really exist, the sentiment could never possibly have being. Beauty is no quality in things themselves: it exists merely in the mind which contemplates them; and each mind perceives a different beauty. One person may even perceive deformity, where another is sensible of beauty; and every individual ought to acquiesce in his own sentiment, without pretending to regulate those of others. To seek the real beauty, or real deformity, is as fruitless an inquiry, as to pretend to ascertain the real sweet or real bitter. According to the disposition of the organs, the same object may be both sweet and bitter; and the proverb has justly determined it to be fruitless to dispute concerning tastes. It is very natural, and even quite necessary, to extend this axiom to mental, as well as bodily taste; and thus common sense, which is so often at variance with philosophy, especially with the sceptical kind, is found, in one instance at least, to agree in pronouncing the same decision.

But though this axiom, by passing into a proverb, seems to have attained the sanction of common sense; there is certainly a species of common sense, which opposes it, at least serves to modify and restrain it. Whoever would assert an equality of genius and elegance between Ogilby and Milton, or Bunyan and Addison, would be thought to defend no less an extravagance, than if he had maintained a mole-hill to be as high as Tenerife, or a pond as extensive as the ocean. Though there may be found persons, who give the preference to the former authors; no one pays attention to such a taste; and we pronounce, without scruple, the sentiment of these pretended critics to be absurd and ridiculous. The principle of the natural equality of tastes is then totally forgot, and while we admit it on some occasions, where the objects seem near an equal-

ity, it appears an extravagant paradox, or rather a palpable absurdity, where objects so disproportioned are compared together.

It is evident that none of the rules of composition are fixed by reasonings *a priori*, or can be esteemed abstract conclusions of the understanding, from comparing those habitudes and relations of ideas, which are eternal and immutable. Their foundation is the same with that of all the practical sciences, experience; nor are they anything but general observations, concerning what has been universally found to please in all countries and in all ages. Many of the beauties of poetry, and even of eloquence, are founded on falsehood and fiction, on hyperboles, metaphors, and an abuse or perversion of terms from their natural meaning. To check the sallies of the imagination, and to reduce every expression to geometrical truth and exactness, would be the most contrary to the laws of criticism; because it would produce a work, which, by universal experience, has been found the most insipid and disagreeable. But though poetry can never submit to exact truth, it must be confined by rules of art, discovered to the author either by genius or observation. If some negligent or irregular writers have pleased, they have not pleased by their transgressions of rule or order, but in spite of these transgressions: they have possessed other beauties, which were conformable to just criticism; and the force of these beauties has been able to overpower censure, and give the mind a satisfaction superior to the disgust arising from the blemishes. Ariosto pleases; but not by his monstrous and improbable fictions, by his bizarre mixture of the serious and comic styles, by the want of coherence in his stories, or by the continual interruptions of his narration. He charms by the force and clearness of his expression, by the readiness and variety of his inventions, and by his natural pictures of the passions, especially those of the gay and amorous kind: and, however, his faults may diminish our satisfaction, they are not able entirely to destroy it. Did our pleasure really arise from those parts of his poem, which we denominate faults, this would be no objection to criticism in general: it would only be an objection to those particular rules of criticism, which would establish such circumstances to be faults, and would represent them as universally blameable. If they are found to please, they cannot be faults, let the pleasure which they produce be ever so unexpected and unaccountable.

But though all the general rules of art are founded only on experience, and on the observation of the common sentiments of

human nature, we must not imagine, that, on every occasion, the feelings of men will be conformable to these rules. Those finer emotions of the mind are of a very tender and delicate nature, and require the concurrence of many favourable circumstances to make them play with facility and exactness, according to their general and established principles. The least exterior hindrance to such small springs, or the least internal disorder, disturbs their motion, and confounds the operations of the whole machine. When we would make an experiment of this nature, and would try the force of any beauty or deformity, we must choose with care a proper time and place, and bring the fancy to a suitable situation and disposition. A perfect serenity of mind, a recollection of thought, a due attention to the object; if any of these circumstances be wanting, our experiment will be fallacious, and we shall be unable to judge of the catholic and universal beauty. The relation, which nature had placed between the form and the sentiment, will at least be more obscure; and it will require greater accuracy to trace and discern it. We shall be able to ascertain its influence, not so much from the operation of each particular beauty, as from the durable admiration which attends those works that have survived all the caprices of mode and fashion, all the mistakes of ignorance and envy.

The same Homer who pleased at Athens and Rome two thousand years ago, is still admired at Paris and at London. All the changes of climate, government, religion, and language, have not been able to obscure his glory. Authority or prejudice may give a temporary vogue to a bad poet or orator; but his reputation will never be durable or general. When his compositions are examined by posterity or by foreigners, the enchantment is dissipated, and his faults appear in their true colours. On the contrary, a real genius, the longer his works endure, and the more wide they are spread, the more sincere is the admiration which he meets with. Envy and jealousy have too much place in a narrow circle; and even familiar acquaintance with his person may diminish the applause due to his performances: but when these obstructions are removed, the beauties, which are naturally fitted to excite agreeable sentiments, immediately display their energy; and while the world endures, they maintain their authority over the minds of men.

It appears, then, that amidst all the variety and caprice of taste, there are certain general principles of approbation or blame,

whose influence a careful eye may trace in all operations of the mind. Some particular forms or qualities, from the original structure of the internal fabric are calculated to please, and others to displease; and if they fail of their effect in any particular instance, it is from some apparent defect or imperfection in the organ. A man in a fever would not insist on his palate as able to decide concerning flavours; nor would one affected with the jaundice pretend to give a verdict with regard to colours. In each creature there is a sound and a defective state; and the former alone can be supposed to afford us a true standard of taste and sentiment. If, in the sound state of the organ, there be an entire or a considerable uniformity of sentiment among men, we may thence derive an idea of the perfect beauty; in like manner as the appearance of objects in daylight, to the eye of a man in health, is denominated their true and real colour, even while colour is allowed to be merely a phantasm of the senses.

Many and frequent are the defects in the internal organs, which prevent or weaken the influence of those general principles, on which depends our sentiment of beauty or deformity. Though some objects, by the structure of the mind, be naturally calculated to give pleasure, it is not to be expected that in every individual the pleasure will be equally felt. Particular incidents and situations occur, which either throw false light on the objects, or hinder the true from conveying to the imagination the proper sentiment and perception.

One obvious cause why many feel not the proper sentiment of beauty, is the want of that *delicacy* of imagination which is requisite to convey a sensibility of those finer emotions. This delicacy everyone pretends to: everyone talks of it; and would reduce every kind of taste or sentiment to its standard. But as our intention in this essay is to mingle some light of the understanding with the feelings of sentiment, it will be proper to give a more accurate definition of delicacy than has hitherto been attempted. And not to draw our philosophy from too profound a source, we shall have recourse to a noted story in *Don Quixote*.

It is with good reason, says Sancho to the squire with the great nose, that I pretend to have a judgment in wine: this is a quality hereditary in our family. Two of my kinsmen were once called to give their opinion of a hogshead, which was supposed to be excellent, being old and of good vintage. One of them tastes it, considers it; and, after mature reflection, pronounces the wine to be

good, were it not for a small taste of leather which he perceived in it. The other, after using the same precautions, gives also his verdict in favour of the wine; but with the reserve of a taste of iron, which he could easily distinguish. You cannot imagine how much they were both ridiculed for their judgment. But who laughed in the end? On emptying the hogshead, there was found at the bottom an old key with a leathern thong tied to it.

The great resemblance between mental and bodily taste will easily teach us to apply this story. Though it be certain that beauty and deformity, more than sweet and bitter, are not qualities in objects, but belong entirely to the sentiment, internal or external, it must be allowed, that there are certain qualities in objects which are fitted by nature to produce those particular feelings. Now, as these qualities may be found in a small degree, or may be mixed and confounded with each other, it often happens that the taste is not affected with such minute qualities, or is not able to distinguish all the particular flavours, amidst the disorder in which they are presented. Where the organs are so fine as to allow nothing to escape them, and at the same time so exact as to perceive every ingredient in the composition, this we call delicacy of taste, whether we employ these terms in the literal or metaphorical sense. Here then the general rules of beauty are of use, being drawn from established models, and from the observation of what pleases or displeases, when presented singly and in a high degree; and if the same qualities, in a continued composition, and in a smaller degree, affect not the organs with a sensible delight or uneasiness, we exclude the person from all pretensions to this delicacy. To produce these general rules or avowed patterns of composition, is like finding the key with the leathern thong, which justified the verdict of Sancho's kinsmen, and confounded those pretended judges who had condemned them. Though the hogshead had never been emptied, the taste of the one was still equally delicate, and that of the other equally dull and languid; but it would have been more difficult to have proved the superiority of the former, to the conviction of every bystander. In like manner, though the beauties of writing had never been methodised, or reduced to general principles; though no excellent models had ever been acknowledged, the different degrees of taste would still have subsisted, and the judgment of one man been preferable to that of another; but it would not have been so easy to silence the bad critic, who might always insist upon his particular sentiment,

and refuse to submit to his antagonist. But when we show him an avowed principle of art; when we illustrate this principle by examples, whose operation, from his own particular taste, he acknowledges to be conformable to the principle; when we prove that the same principle may be applied to the present case, where he did not perceive or feel its influence: he must conclude, upon the whole, that the fault lies in himself, and that he wants the delicacy which is requisite to make him sensible of every beauty and every blemish in any composition or discourse.

It is acknowledged to be the perfection of every sense or faculty, to perceive with exactness its most minute objects, and allow nothing to escape its notice and observation. The smaller the objects are which become sensible to the eye, the finer is that organ, and the more elaborate its make and composition. A good palate is not tried by strong flavours, but by a mixture of small ingredients, where we are still sensible of each part, notwithstanding its minuteness and its confusion with the rest. In like manner, a quick and acute perception of beauty and deformity must be the perfection of our mental taste; nor can a man be satisfied with himself while he suspects that any excellence or blemish in a discourse has passed him unobserved. In this case, the perfection of the man, and the perfection of the sense of feeling are found to be united. A very delicate palate, on many occasions, may be a great inconvenience both to a man himself and to his friends. But a delicate taste of wit or beauty must always be a desirable quality, because it is the source of all the finest and most innocent enjoyments of which human nature is susceptible. In this decision the sentiments of all mankind are agreed. Wherever you can ascertain a delicacy of taste, it is sure to meet with approbation; and the best way of ascertaining it is, to appeal to those models and principles which have been established by the uniform consent and experience of nations and ages.

But though there be naturally a wide difference, in point of delicacy, between one person and another, nothing tends further to increase and improve this talent, than *practice* in a particular art, and the frequent survey or contemplation of a particular species of beauty. When objects of any kind are first presented to the eye or imagination, the sentiment which attends them is obscure and confused; and the mind is, in a great measure, incapable of pronouncing concerning their merits or defects. The taste cannot perceive the several excellences of the performance, much less

distinguish the particular character of each excellency, and ascertain its quality and degree. If it pronounce the whole in general to be beautiful or deformed, it is the utmost that can be expected; and even this judgment, a person so unpractised will be apt to deliver with great hesitation and reserve. But allow him to acquire experience in those objects, his feeling becomes more exact and nice: he not only perceives the beauties and defects of each part, but marks the distinguishing species of each quality, and assigns it suitable praise or blame. A clear and distinct sentiment attends him through the whole survey of the objects; and he discerns that very degree and kind approbation or displeasure which each part is naturally fitted to produce. The mist dissipates which seemed formerly to hang over the object; the organ acquires greater perfection in its operation, and can pronounce, without danger of mistake, concerning the merits of every performance. In a word, the same address and dexterity which practice gives to the execution of any work, is also acquired by the same means in the judging of it.

So advantageous is practice to the discernment of beauty, that, before we can give judgment on any work of importance, it will even be requisite that that very individual performance be more than once perused by us, and be surveyed in different lights with attention and deliberation. There is a flutter or hurry of thought which attends the first perusal of any piece, and which confounds the genuine sentiment of beauty. The relation of the parts is not discerned: the true characters of style are little distinguished. The several perfection and defects seem wrapped up in a species of confusion, and present themselves indistinctly to the imagination. Not to mention, that there is a species of beauty, which, as it is florid and superficial, pleases at first; but being found incompatible with a just expression either of reason or passion, soon palls upon the taste, and is then rejected with disdain, at least rated at a much lower value.

It is impossible to continue in the practice of contemplating any order of beauty, without being frequently obliged to form *comparisons* between the several species of and degrees of excellence, and estimating their proportion to each other. A man who has had no opportunity of comparing the different kinds of beauty, is indeed totally unqualified to pronounce an opinion with regard to any object presented to him. By comparison alone we fix the epithets of praise or blame, and learn how to assign the due degree of each.

The coarsest daubing contains a certain lustre of colours and exactness of imitation, which are so far beauties, and would affect the mind of a peasant or Indian with the highest admiration. The most vulgar ballads are not entirely destitute of harmony or nature; and none but a person familiarized to superior beauties would pronounce their members harsh, or narration uninteresting. A great inferiority of beauty gives pain to a person conversant in the highest excellence of the kind, and is for that reason pronounced a deformity; as the most finished object with which we are acquainted is naturally supposed to have reached the pinnacle of perfection, and to be entitled to the highest applause. One accustomed to see, and examine, and weigh the several performances, admired in different ages and nations, can alone rate the merits of a work exhibited to his view, and assign its proper rank among the productions of genius.

But to enable a critic the more fully to execute this undertaking, he must preserve his mind free from all *prejudice,* and allow nothing to enter into his consideration, but the very object which is submitted to his examination. We may observe, that every work of art, in order to produce its due effect on the mind, must be surveyed in a certain point of view, and cannot be fully relished by persons whose situation, real or imaginary, is not conformable to that which is required by the performance. An orator addresses himself to a particular audience, and must have a regard to their particular genius, interests, opinions, passions, and prejudices; otherwise he hopes in vain to govern their resolutions, and inflame their affections. Should they even have entertained some prepossessions against him, however unreasonable, he must not overlook this disadvantage: but, before he enters upon the subject, must endeavour to conciliate their affection, and acquire their good graces. A critic of a different age or nation, who should peruse this discourse, must have all these circumstances in his eye, and must place himself in the same situation as the audience, in order to form a true judgment of the oration. In like manner, when any work is addressed to the public, though I should have a friendship or enmity with the author, I must depart from this situation, and, considering myself as a man in general, forget, if possible, my individual being, and my peculiar circumstances. A person influenced by prejudice complies not with this condition, but obstinately maintains his natural position, without placing himself in that point of view which the performance supposes. If

the work be addressed to persons of a different age or nation, he makes no allowance for their peculiar views and prejudices; but, full of the manners of his own age and country, rashly condemns what seemed admirable in the eyes of those for whom alone the discourse was calculated. If the work be executed for the public, he never sufficiently enlarges his comprehension, or forgets his interest as a friend or enemy, as a rival or commentator. By this means his sentiments are perverted; nor have the same beauties and blemishes the same influence upon him, as if he had imposed a proper violence on his imagination, and had forgotten himself for a moment. So far his taste evidently departs from the true standard, and of consequences loses all credit and authority.

It is well known, that, in all questions submitted to the understanding, prejudice is destructive of sound judgment, and perverts all operations of the intellectual faculties: it is no less contrary to good taste; nor has it less influence to corrupt our sentiment of beauty. It belongs to *good sense* to check its influence in both cases; and in this respect, as well as in many others, reason, if not an essential part of taste, is at least requisite to the operations of this latter faculty. In all the nobler productions of genius, there is a mutual relation and correspondence of parts; nor can either the beauties or blemishes be perceived by him whose thought is not capacious enough to comprehend all those parts, and compare them with each other, in order to perceive the consistence and uniformity of the whole. Every work of art has also a certain end or purpose for which it is calculated; and is to be deemed more or less perfect, as it is more or less fitted to attain this end. The object of eloquence is to persuade, of history to instruct, of poetry to please, by means of the passions and the imagination. These ends we must carry constantly in our view when we peruse any performance; and we must be able to judge how far the means employed are adapted to their respective purposes. Besides, every kind of composition, even the most poetical, is nothing but a chain of propositions and reasonings; not always, indeed, the justest and most exact, but still plausible and specious, however disguised by the colouring of the imagination. The persons introduced in tragedy and epic poetry must be represented as reasoning, and thinking, and concluding, and acting, suitably to their character and circumstances; and without judgment, as well as taste and invention, a poet can never hope to succeed in so delicate an undertaking. Not to mention, that the same excellence of

faculties which contributes to the improvement of reason, the same clearness of conception, the same exactness of distinction, that same vivacity of apprehension, are essential to the operations of true taste, and are its infallible concomitants. It seldom or never happens, that a man of sense who has experience in any art, cannot judge of its beauty; and it is no less rare to meet with a man who has a just taste without a sound understanding.

Thus, though the principles of taste be universal, and nearly, if not entirely, the same in all men; yet few are qualified to give judgment on any work of art, or establish their own sentiment as the standard of beauty. The organs of internal sensation are seldom so perfect as to allow the general principles their full play, and produce a feeling correspondent to those principles. They either labour under some defect, or are vitiated by some disorder; and by that means excite a sentiment, which may be pronounced erroneous. When a critic has no delicacy, he judges without any distinction, and is only affected by the grosser and more palpable qualities of the object: the finer touches pass unnoticed and disregarded. Where he is not aided by practice, his verdict is attended with confusion and hesitation. Where no comparison has been employed, the most frivolous beauties, such as rather merit the name of defects, are the object of his admiration. Where he lies under the influence of prejudice, all his natural sentiments are perverted. Where good sense is wanting, he is not qualified to discern the beauties of design and reasoning, which are the highest and most excellent. Under some or other of these imperfections, the generality of men labour, and hence a true judge in the finer arts is observed, even during the most polished ages, to be so rare a character: strong sense, united to delicate sentiment, improved by practice, perfected by comparison, and cleared of all prejudice, can alone entitle critics to this valuable character; and the joint verdict of such, wherever they are to be found, is the true standard of taste and beauty.

But where are such critics to be found? By what marks are they to be known? How distinguish them from pretenders? These questions are embarrassing; and seem to throw us back into the same uncertainty from which, during the course of this essay, we have endeavoured to extricate ourselves.

But if we consider the matter aright, these are questions of fact, not of sentiment. Whether any particular person be endowed with good sense and a delicate imagination, free from prejudice,

may often be the subject of dispute, and be liable to great discussion and inquiry: but that such a character is valuable and estimable, will be agreed in by all mankind. Where these doubts occur, men can do no more than in other disputable questions which are submitted to the understanding: they must produce the best arguments that their invention suggests to them; they must acknowledge a true and decisive standard to exist somewhere, to wit, real existence and matter of fact; and they must have indulgence to such as differ from them in their appeals to this standard. It is sufficient for our present purpose, if we have proved, that the taste of all individuals is not upon an equal footing, and that some men in general, however difficult to be particularly pitched upon, will be acknowledged by universal sentiment to have a preference above others.

But, in reality, the difficulty of finding, even in particulars, the standard of taste, is not so great as it is represented. Though in speculation we may readily avow a certain criterion in science, and deny it in sentiment, the matter is found in practice to be much more hard to ascertain in the former case than in the latter. Theories of abstract philosophy, systems of profound theology, have prevailed during one age: in a successive period these have been universally exploded: their absurdity has been detected: other theories and systems have supplied their place, which again gave place to their successors: and nothing has been experienced more liable to the revolutions of chance and fashion than these pretended decisions of science. The case is not the same with the beauties of eloquence and poetry. Just expressions of passion and nature are sure, after a little time, to gain public applause, which they maintain forever. Aristotle, and Plato, and Epicurus, and Descartes, may successively yield to each other: but Terence and Virgil maintain a universal, undisputed empire over the minds of men. The abstract philosophy of Cicero has lost its credit: the vehemence of his oratory is still the object of our admiration.

Though men of delicate taste be rare, they are easily to be distinguished in society by the soundness of their understanding, and the superiority of their faculties above the rest of mankind. The ascendant, which they acquire, gives a prevalence to that lively approbation with which they receive any productions of genius, and renders it generally predominant. Many men, when left to themselves, have but a faint and dubious perception of beauty, who yet are capable of relishing any fine stroke which is pointed

out to them. Every convert to the admiration of the real poet or orator, is the cause of some new conversion. And though prejudices may prevail for a time, they never unite in celebrating any rival to the true genius, but yield at last to the force of nature and just sentiment. Thus, though a civilized nation may easily be mistaken in the choice of their admired philosopher, they never have been found long to err, in their affection for a favourite epic or tragic author.

But notwithstanding all our endeavours to fix a standard of taste, and reconcile the discordant apprehensions of men, there still remain two sources of variation, which are not sufficient indeed to confound all the boundaries of beauty and deformity, but will often serve to produce a difference in the degrees of our approbation or blame. The one is the different humours of particular men; the other, the particular manners and opinions of our age and country. The general principles of taste are uniform in human nature: where men vary in their judgments, some defect or perversion in the faculties may commonly be remarked; proceeding either from prejudice, from want of practice, or want of delicacy: and there is just reason for approving one taste, and condemning another. But where there is such a diversity in the internal frame or external situation as is entirely blameless on both sides, and leaves no room to give one the preference above the other; in that case a certain degree of diversity in judgment is unavoidable, and we seek in vain for a standard, by which we can reconcile the contrary sentiments.

A young man, whose passions are warm, will be more sensibly touched with amorous and tender images, than a man more advanced in years, who takes pleasure in wise, philosophical reflections, concerning the conduct of life, and moderation of the passions. At twenty, Ovid may be the favourite author, Horace at forty, and perhaps Tacitus at fifty. Vainly would we, in such cases, endeavour to enter into the sentiments of others, and divest ourselves of those propensities which are natural to us. We choose our favourite author as we do our friend, from a conformity of humour and disposition. Mirth or passion, sentiment or reflection; whichever of these most predominates in our temper, it gives us a peculiar sympathy with the writer who resembles us.

One person is more pleased with the sublime, another with the tender, a third with raillery. One has a strong sensibility to blemishes, and is extremely studious of correctness; another has a

more lively feeling of beauties, and pardons twenty absurdities and defects for one elevated or pathetic stroke. The ear of this man is entirely turned towards conciseness and energy; that man is delighted with a copious, rich, and harmonious expression. Simplicity is affected by one; ornament by another. Comedy, tragedy, satire, odes, have each its partisans, who prefer that particular species of writing to all others. It is plainly an error in a critic, to confine his approbation to one species or style of writing, and condemn all the rest. But it is almost impossible not to feel a predilection for that which suits our particular turn and disposition. Such performances are innocent and unavoidable, and can never reasonably be the object of dispute, because there is no standard by which they can be decided.

For a like reason, we are more pleased, in the course of our reading, with pictures and characters that resemble objects which are found in our own age and country, than with those which describe a different set of customs. It is not without some effort that we reconcile ourselves to the simplicity of ancient manners, and behold princesses carrying water from the spring, and kings and heroes dressing their own victuals. We may allow in general, that the representation of such manners is no fault in the author, nor deformity in the piece; but we are not so sensibly touched with them. For this reason, comedy is not easily transferred from one age or nation to another. A Frenchman or Englishman is not pleased with the *Andria* of Terence, or *Clitia* of Machiavel; where the fine lady, upon whom all the play turns, never once appears to the spectators, but is always kept behind the scenes, suitably to the reserved humour of the ancient Greeks and modern Italians. A man of learning and reflection can make allowance for these peculiarities of manners; but a common audience can never divest themselves so far of their usual ideas and sentiments, as to relish pictures which nowise resemble them.

But here there occurs a reflection, which may, perhaps, be useful in examining the celebrated controversy concerning ancient and modern learning; where we often find the one side excusing any seeming absurdity in the ancients from the manners of the age, and the other refusing to admit this excuse, or at least admitting it only as an apology for the author, not for the performance. In my opinion, the proper boundaries in this subject have seldom been fixed between the contending parties. Where any innocent peculiarities of manners are represented, such as those above

mentioned, they ought certainly to be admitted; and a man who is shocked with them, gives an evident proof of false delicacy and refinement. The poet's *monument more durable then brass*, must fall to the ground like common brick or clay, were men to make no allowance for the continual revolutions of manners and customs, and would admit of nothing but what was suitable to the prevailing fashion. Must we throw aside the pictures of our ancestors, because of their ruffs and farthingales? But where the ideas of morality and decency alter from one age to another, and where vicious manners are described, without being marked with the proper characters of blame and disapprobation, this must be allowed to disfigure the poem, and to be a real deformity. I cannot, nor is it proper I should, enter into such sentiments; and however I may excuse the poet, on account of the manners of his age, I can never relish the composition. The want of humanity and of decency, so conspicuous in the characters drawn by several of the ancient poets, even sometimes by Homer and the Greek tragedians, diminishes considerably the merit of their noble performances, and gives modern authors an advantage over them. We are not interested in the fortunes and sentiments of such rough heroes; we are displeased to find the limits of vice and virtue so much confounded; and whatever indulgence we may give to the writer on account of his prejudices, we cannot prevail on ourselves to enter into his sentiments, or bear an affection to characters which we plainly discover to be blameable.

The case is not the same with moral principles as with speculative opinions of any kind. These are in continual flux and revolution. The son embraces a different system from the father. Nay, there scarcely is any man, who can boast of great constancy and uniformity in this particular. Whatever speculative errors may be found in the polite writings of any age or country, they detract but little from the value of those compositions. There needs but a certain turn of thought or imagination to make us enter into all the opinions which then prevailed, and relish the sentiments or conclusions derived from them. But a very violent effort is requisite to change our judgment of manners, and excite sentiments of approbation or blame, love or hatred, different from those to which the mind, from long custom, has been familiarised. And where a man is confident of the rectitude of that moral standard by which he judges, he is justly jealous of it, and will not pervert

the sentiments of his heart for a moment, in complaisance to any writer whatsoever.

Of all speculative errors, those which regard religion are the most excusable in compositions of genius; nor is it ever permitted to judge of the civility or wisdom of any people, or even of single persons, by the grossness or refinement of their theological principles. The same good sense that directs men in the ordinary occurrences of life, is not hearkened to in religious matters, which are supposed to be placed altogether above the cognisance of human reason. On this account, all the absurdities of the pagan system of theology must be overlooked by every critic, who would pretend to form a just notion of ancient poetry; and our posterity, in their turn, must have the same indulgence to their forefathers. No religious principles can ever be imputed as a fault to any poet, while they remain merely principles, and take not such strong possession of his heart as to lay him under the imputation of *bigotry* or *superstition*. Where that happens, they confound the sentiments of morality, and alter the natural boundaries of vice and virtue. They are therefore eternal blemishes, according to the principle above mentioned; nor are the prejudices and false opinions of the age sufficient to justify them.

It is essential to the Roman Catholic religion to inspire a violent hatred of every other worship, and to represent all pagans, mahometans, and heretics, as the objects of divine wrath and vengeance. Such sentiments, though they are in reality very blameable, are considered as virtues by the zealots of that communion, and are represented in their tragedies and epic poems as a kind of divine heroism. This bigotry has disfigured two very fine tragedies of the French theatre, *Polieucte* and *Athalia*; where an intemperate zeal for particular modes of worship is set off with all the pomp imaginable, and forms the predominant character of the heroes. 'What is this', says the sublime Joad to Josabet, finding her in discourse with Mathan the priest of Baal, 'Does the daughter of David speak to this traitor? Are you not afraid lest the earth should open, and pour forth flames to devour you both? Or lest these holy walls should fall and crush you together? What is his purpose? Why comes that enemy of God hither to poison the air, which we breathe, with his horrid presence?' Such sentiments are received with great applause in the theatre of Paris; but at London the spectators would be full as much pleased to hear Achilles tell Agamemnon, that he was a dog in his forehead, and a deer in his

heart; or Jupiter threaten Juno with a sound drubbing, if she will not be quiet.

Religious principles are also a blemish in any polite composition, when they rise up to superstition, and intrude themselves into every sentiment, however remote from any connection with religion. It is no excuse for the poet, that the customs of his country had burdened life with so many religious ceremonies and observances, that no part of it was exempt from that yoke. It must forever be ridiculous in Petrarch to compare his mistress, Laura, to Jesus Christ. Nor is it less ridiculous in that agreeable libertine, Boccace, very seriously to give thanks to God Almighty and the ladies, for their assistance in defending him against his enemies.

READING VI
OF TRAGEDY[4]

It seems an unaccountable pleasure which the spectators of a well-written tragedy receive from sorrow, terror, anxiety, and other passions that are in themselves disagreeable and uneasy. The more they are touched and affected, the more are they delighted with the spectacle; and as soon as the uneasy passions cease to operate, the piece is at an end. One scene of full joy and contentment and security is the utmost that any composition of this kind can bear; and it is sure always to be the concluding one. If in the texture of the piece there be interwoven any scenes of satisfaction, they afford only faint gleams of pleasure, which are thrown in by way of variety, and in order to plunge the actors into deeper distress by means of that contrast and disappointment. The whole art of the poet is employed in rousing and supporting the compassion and indignation, the anxiety and resentment, of his audience. They are pleased in proportion as they are afflicted, and never are so happy as when they employ tears, sobs, and cries, to give vent to their sorrow, and relieve their heart swollen with the tenderest sympathy and compassion.

The few critics who have had some tincture of philosophy have remarked this singular phenomenon, and have endeavoured to account for it.

L'Abbé Dubos, in his *Reflections on Poetry and Painting*, asserts, that nothing is in general so disagreeable to the mind as the lan-

[4] From *Four Dissertations* (London, 1757).

guid, listless state of indolence into which it falls upon the removal of all passion and occupation. To get rid of this painful situation, it seeks every amusement and pursuit; business, gaming, shows, executions; whatever will rouse the passions and take its attention from itself. No matter what the passion is; let it be disagreeable, afflicting, melancholy, disordered; it is still better than that insipid languor which arises from perfect tranquillity and repose.

It is impossible not to admit this account as being, at least in part, satisfactory. You may observe, when there are several tables of gaming, that all the company run to those where the deepest play is, even though they find not there the best players. The view, or, at least, imagination of high passions, arising from great loss or gain, affects the spectator by sympathy, gives him some touches of the same passions, and serves him for a momentary entertainment. It makes the time pass the easier with him, and is some relief to that oppression under which men commonly labour when left entirely to their own thoughts and meditations.

We find that common liars always magnify, in their narrations, all kinds of danger, pain, distress, sickness, deaths, murders, and cruelties, as well as joy, beauty, mirth, and magnificence. It is an absurd secret which they have for pleasing their company, fixing their attention, and attaching them to such marvellous relation by the passions and emotions which they excite.

There is, however, a difficulty in applying to the present subject, in its full extent, this solution, however ingenious and satisfactory it may appear. It is certain that the same object of distress, which pleases in a tragedy, were it really set before us, would give the most unfeigned uneasiness, though it be then the most effectual cure to languor and indolence. Monsieur Fontenelle seems to have been sensible of this difficulty, and accordingly attempts another solution of the phenomenon, at least makes some addition to the theory above mentioned.

'Pleasure and pain', says he, 'which are two sentiments so different in themselves, differ not so much in their cause. From the instance of tickling it appears, that the movement of pleasure, pushed a little too far, becomes pain, and that the movement of pain, a little moderate, becomes pleasure. Hence it proceeds, that there is such a thing as a sorrow, soft and agreeable: it is a pain weakened and diminished. The heart likes naturally to be moved and affected. Melancholy objects suit it, and even disastrous and

sorrowful, provided they are softened by some circumstance. It is certain, that, on the theatre, the representation has almost the effect of reality; yet it has not altogether that effect. However we may be hurried away by the spectacle, whatever dominion the senses and imagination may usurp over the reason, there still lurks at the bottom a certain idea of falsehood in the whole of what we see. This idea, though weak and disguised, suffices to diminish the pain which we suffer from the misfortunes of those whom we love, and to reduce that affliction to such a pitch as converts it into pleasure. We weep for the misfortune of a hero to whom we are attached. In the same instant we comfort ourselves by reflecting, that it is nothing but a fiction: and it is precisely that mixture of sentiments which composes an agreeable sorrow, and tears that delight us. But as that affliction which is caused by exterior and sensible objects is stronger than the consolation which arises from an internal reflection, they are the effects and symptoms of sorrow that ought to predominate in the composition'.

This solution seems just and convincing: but perhaps it wants still some new addition, in order to make it answer fully the phenomenon which we here examine. All the passions, excited by eloquence, are agreeable in the highest degree, as well as those which are moved by painting and the theatre. The *Epilogues* of Cicero are, on this account chiefly, the delight of every reader of taste; and it is difficult to read some of them without the deepest sympathy and sorrow. His merit as an orator, no doubt depends much on his success in this particular. When he had raised tears in his judges and all his audience, they were then the most highly delighted, and expressed the greatest satisfaction with the pleader. The pathetic description of the butchery made by Verres of the Sicilian captains, is a masterpiece of this kind but I believe none will affirm, that the being present at a melancholy scene of that nature would afford any entertainment. Neither is the sorrow here softened by fiction; for the audience were convinced of the reality of every circumstance. What is it then which in this case raises a pleasure from the bosom of uneasiness, so to speak, and a pleasure which still retains all the features and outward symptoms of distress and sorrow?

I answer: this extraordinary effect proceeds from that very eloquence with which the melancholy scene is represented. The genius required to paint objects in a lively manner, the art employed in collecting all the pathetic circumstances, the judg-

ment displayed in disposing them; the exercise, I say, of these noble talents, together with the force of expression, and beauty of oratorical numbers, diffuse the highest satisfaction on the audience, and excite the most delightful movements. By this means, the uneasiness of the melancholy passions is not only overpowered and effaced by something stronger of an opposite kind, but the whole impulse of those passions is converted into pleasure, and swells the delight which the eloquence raises in us. The same force of oratory, employed on an uninteresting subject, would not please half so much, or rather would appear altogether ridiculous; and the mind, being left in absolute calmness and indifference, would relish none of those beauties of imagination or expression, which, if joined to passion, give it such exquisite entertainment. The impulse or vehemence arising from sorrow, compassion, indignation, receives a new direction from the sentiments of beauty. The latter, being the predominant emotion, seize the whole mind, and convert the former into themselves, at least tincture them so strongly as totally to alter their nature. And the soul being at the same time roused by passion and charmed by eloquence, feels on the whole a strong movement, which is altogether delightful.

The same principle takes place in tragedy; with this addition, that tragedy is an imitation, and imitation is always of itself agreeable. This circumstance serves still further to smooth the motions of passion, and convert the whole feeling into one uniform and strong enjoyment. Objects of the greatest terror and distress please in painting, and please more than the most beautiful objects that appear calm and indifferent. The affection, rousing the mind, excites a large stock of spirit and vehemence; which is all transformed into pleasure by the force of the prevailing movement. It is thus the fiction of tragedy softens the passion, by an infusion of a new feeling, not merely by weakening or diminishing the sorrow. You may by degrees weaken a real sorrow, till it totally disappears; yet in none of its gradations will it ever give pleasure; except, perhaps, by accident, to a man sunk under lethargic indolence, whom it rouses from that languid state.

To confirm this theory, it will be sufficient to produce other instances, where the subordinate movement is converted into the predominant, and gives force to it, though of a different, and even sometimes though of a contrary nature.

Novelty naturally rouses the mind, and attracts our attention; and the movements which it causes are always converted into any passion belonging to the object, and join their force to it. Whether an event excite joy or sorrow, pride or sham, anger or good-will, it is sure to produce a stronger affection, when new or unusual. And though novelty of itself be agreeable, it fortifies the painful, as well as agreeable passions.

Had you any intention to move a person extremely by the narration of any event, the best method of increasing its effect would be artfully to delay informing him of it, and first to excite his curiosity and impatience before you let him into the secret. This is the artifice practised by Iago in the famous scene of Shakespeare; and every spectator is sensible, that Othello's jealousy acquires additional force from his preceding impatience, and that the subordinate passion is here readily transformed into the predominant one.

Difficulties increase passions of every kind; and by rousing our attention, and exciting our active powers, they produce an emotion which nourishes the prevailing affection.

Parents commonly love that child most whose sickly infirm frame of body has occasioned them the greatest pains, trouble, and anxiety, in rearing him. The agreeable sentiment of affection here acquires force from sentiments of uneasiness.

Nothing endears so much a friend as sorrow for his death. The pleasure of his company has not so powerful an influence.

Jealousy is a painful passion; yet without some share of it, the agreeable affection of love has difficulty to subsist in its full force and violence. Absence is also a great source of complaint among lovers, and gives them the greatest uneasiness: yet nothing is more favourable to their mutual passion than short intervals of that kind. And if long intervals often prove fatal, it is only because, through time, men are accustomed to them, and they cease to give uneasiness. Jealousy and absence in love compose the *dolce peccante* of the Italians, which they suppose so essential to all pleasure.

There is a fine observation of the elder Pliny, which illustrates the principle here insisted on. 'It is very remarkable', says he, 'that the last works of celebrated artists, which they left imperfect, are always the most prized, such as the *Iris* of Aristides, the *Tyndarides* of Nicomachus, the *Medea* of Timomachus, and the *Venus* of Apelles. These are valued even above their finished productions. The broken lineaments of the piece, and the half-formed idea of

the painter, are carefully studied; and our very grief for that curious hand, which had been stopped by death, is an additional increase to our pleasure'.

These instances (and many more might be collected) are sufficient to afford us some insight into the analogy of nature, and to show us, that the pleasure which poets, orators, and musicians give us, by exciting grief, sorrow, indignation, compassion, is not so extraordinary or paradoxical as it may at first sight appear. The force of imagination, the energy of expression, the power of numbers, the charms of imitation; all these are naturally, of themselves, delightful to the mind: and when the object presented lays also hold of some affection, the pleasure still gives rise upon us, by the conversion of this subordinate movement into that which is predominant. The passion, though perhaps naturally, and when excited by the simple appearance of a real object, it may be painful; yet is so smoothed, and softened, and mollified, when raised by the finer arts, that it affords the highest entertainment.

To confirm this reasoning, we may observe, that if the movements of the imagination be not predominant above those of the passion, a contrary effect follows; and the former, being now subordinate, is converted into the latter, and still further increases the pain and affliction of the sufferer.

Who could ever think of it as a good expedient for comforting an afflicted parent, to exaggerate, with all the force of elocution, the irreparable loss which he has met with by the death of a favourite child? The more power of imagination and expression you here employ, the more you increase his despair and affliction.

The shame, confusion, and terror of Verres, no doubt, rose in proportion to the noble eloquence and vehemence of Cicero: so also did his pain and uneasiness. These former passions were too strong for the pleasure arising from the beauties of elocution; and operated, though from the same principle, yet in a contrary manner, to the sympathy, compassion, and indignation of the audience.

Lord Clarendon, when he approaches towards the catastrophe of the royal party, supposes that his narration must then become infinitely disagreeable; and he hurries over the king's death without giving us one circumstance of it. He considers it as too horrid a scene to be contemplated with any satisfaction, or even without the utmost pain and aversion. He himself, as well as the readers of that age, were too deeply concerned in the events, and felt a pain

from subjects which an historian and a reader of another age would regard as the most pathetic and most interesting, and, by consequence, the most agreeable.

An action, represented in tragedy, may be too bloody and atrocious. It may excite such movements of horror as will not soften into pleasure; and the greatest energy of expression, bestowed on descriptions of that nature, serves only to augment our uneasiness. Such is that action represented in the *Ambitious Step-mother*, where a venerable old man, raised to the height of fury and despair, rushes against a pillar, and striking his head upon it, besmears it all over with mingled brains and gore. The English theatre abounds too much with such shocking images.

Even the common sentiments of compassion require to be softened by some agreeable affection, in order to give a thorough satisfaction to the audience. The mere suffering of plaintive virtue, under the triumphant tyranny and oppression of vice, forms a disagreeable spectacle, and is carefully avoided by all masters of the drama. In order to dismiss the audience with entire satisfaction and contentment, the virtue must either convert itself into a noble courageous despair, or the vice receive its proper punishment.

Most painters appear in this light to have been very unhappy in their subjects. As they wrought much for churches and convents, they have chiefly represented such horrible subjects as crucifixions and martyrdoms, where nothing appears but tortures, wounds, executions, and passive suffering, without any action or affection. When they turned their pencil from this ghastly mythology, they had commonly recourse to Ovid, whose fictions, though passionate and agreeable, are scarcely natural or probable enough for painting.

The same inversion of that principle which is here insisted on, displays itself in common life, as in the effects of oratory and poetry. Raise so the subordinate passion that it becomes the predominant, it swallows up that affection which it before nourished and increased. Too much jealousy extinguishes love; too much difficulty renders us indifferent; too much sickness and infirmity disgusts a selfish and unkind parent.

What so disagreeable as the dismal, gloomy, disastrous stories, with which melancholy people entertain their companions? The uneasy passion being there raised alone, unaccompanied with any spirit, genius, or eloquence, conveys a pure uneasiness, and is attended with nothing that can soften it into pleasure or satisfaction.

John Baillie

(Date of Birth Unknown–1743)

Including John Baillie's essay on the sublime in this collection is to be rather free with the rubric that the authors all represent eighteenth-century Scottish aesthetic thought. The problem in this instance is that almost nothing is known about Baillie, and in particular there is no evidence that he was a Scot. Samuel Monk summarises succinctly what we know of Baillie:

> His name is not found in the D.N.B. [*Dictionary of National Biography*]. Ralph Strauss records the publication by Dodsley of his play, *The Married Coquet*, on 8 April, 1747, and of the *Essay* on April 20th of the same year . . . The *Biographia Dramatica* states that he was one of the 'physicians to St. George's Hospital, and also a physician to the English army in Flanders. He died of spotted fever at Ghent, in December, 1743.' . . . The date of his death seems to be correct, since it agrees with the appearance of Baillie's name in the list of deaths in . . . *The Monthly Magazine*.

My very slender justification for including him in a collection of Scottish aesthetics is, first, that Baillie is undoubtedly a Scottish surname. Secondly, that he might easily have been with the many Scottish regiments in Flanders taking part in the battles of the War of Austrian Succession. Thirdly, at one or two places in the essay he shows familiarity with Edinburgh, using its architecture as an illustrative example. Finally and most importantly, the essay is a very fine study of the sublime, was influential in its day and deserves to be read more — regardless of whether its author was a Scot or not.

Baillie's essay is one of the earlier treatments of the sublime and it owes a great deal to Longinus, while at the same time attempting to correct perceived flaws in the great Hellenist writer's

account of the quality. Baillie repeats the common complaint against Longinus, that his account of the sublime is confused and unclear, but he also criticises the Hellenist writer for his restriction of the sublime to great writing. Together with Hume, Baillie plays an important role in extending the range of objects that can possess sublimity. His analysis is to a large extent psychological, relying upon a Lockean conception of mind and the association of ideas. Given that these approaches came to dominate aesthetic writing after Baillie, he can be thought of as a pioneer of a sort. One of the unique features of Baillie's account of sublimity is the extent to which he interprets the experience of the sublime as calm and peaceful. Gerard is just one of those who acknowledged the influence of Baillie, but within a few years the powerfully contrasting analysis of the sublime by Edmund Burke would be published and change the discourse of the sublime forever. Baillie helps us to see that there were interesting alternatives developed by others, even if they are less remembered today.

Further Reading

Samuel H. Monk, *The Sublime: A Study of Critical Theories in Eighteenth-Century England*, New York: Modern Language Association, 1935.

Andrew Ashfield and Peter de Bolla, *The Sublime: A Reader in British Eighteenth-Century Aesthetic Theory*, Cambridge: CUP, 1996.

READING VII

AN ESSAY ON THE SUBLIME[1]

I

We are now, Palemon, to treat of that kind of writing, which of all others is the truly excellent and great manner, and which is peculiar to a genius noble, lofty, comprehensive. You will easily know I mean the sublime, and perhaps may tell me the talk is difficult; I acknowledge it, especially when I consider that we have already a great author upon the subject, who has received the approbation of ages, and who, in the opinion of most, has exhausted it — yet I have something to plead as my apology for my presumption, for such I believe it may be reckoned.

[1] (Published posthumously in 1747).

Notwithstanding Longinus entitles his treatise, *A Treatise Upon the Sublime*, yet whoever considers the full extent of the work, will perceive the author does not confine himself to the bare explanation of any one certain and particular manner in writing. Some part of his treatise regards the figurative style, some the pathetic, and indeed some part regards what I think is properly called the sublime — however, the bulk of the performance relates more to the perfection of writing in general, than to any particular kind or species.

As every different manner of writing has its peculiar character, it must likewise have its different principles, and to treat of them separately must undoubtedly be the clearer method. Besides, Longinus has entirely passed over the inquiry of what the sublime is, as a thing perfectly well known and is principally intent upon giving rules to arrive at the elevated turn and manner. That the sublime no sooner presents itself than we are affected by it, I readily acknowledge; but that we generally form accurate and distinct ideas upon this subject, is by no means true; and although in itself perfectly distinct from either the pathetic, or figurative manner, yet it is often confounded with both. The genuine work therefore of criticism is to define the limits of each kind of writing, and to prescribe their proper distinctions. Without this there can be no legitimate performance, which is the just conformity to the laws or rules of that manner of writing in which the piece is designed. But the manner must be defined before the rules can be established; and we must know, for example, what history is before we can know how it differs from novel and romance, and before we can judge how it ought to be conducted.

Hence it seems, that rules for the sublime should most naturally result from an inquiry what the sublime is; and if this is an inquiry which Longinus has entirely passed over, there is still room for further speculation. But as the sublime in writing is no more than a description of the sublime in nature, and as it were painting to the imagination what nature herself offers to the senses, I shall begin with an inquiry into the sublime of natural objects, which I shall afterwards apply to writing.

Few are so insensible, as not to be struck even at first view with what is truly sublime; and every person upon seeing a grand object is affected with something which as it were extends his very being, and expands it to a kind of immensity. Thus in viewing the heavens, how is the soul elevated; and stretching itself to

larger scenes and more extended prospects, in a noble enthusiasm of grandeur quits the narrow earth, darts from planet to planet, and takes in worlds at one view! Hence comes the name of sublime to everything which thus raises the mind to fits of greatness, and disposes it to soar above her mother earth; hence arises that exultation and pride which the mind ever feels from the consciousness of its own vastness. That object only can be justly called sublime, which in some degree disposes the mind to this enlargement of itself, and gives her a lofty conception of her own powers.

This exalted sensation, then, will always determine us to a right judgment; for wherever we feel the elevated disposition, there we are sure the sublime must be. But notwithstanding we acknowledge its presence, we are frequently ignorant what it is in objects which constitutes the grand, and gives them this power of expanding the mind. We often confess the sublime as we do the deity; it fills and dilates our soul without being able to penetrate into its nature, and define its essence. Yet however true this may be in many instances, a diligent inquiry may overcome the difficulty; and from an examination of particulars, we may come at such general principles, as shall enable us universally to define the sublime of every natural object.

We know by experience, that nothing produces this elevation equal to large prospects, vast extended views, mountains, the heavens, and an immense ocean. But what in these objects affects us? For we can view, without being the least exalted, a little brook, although as smooth a surface, nay, clearer stream than the Nile or Danube; but can we behold these vast rivers, or rather, the vaster ocean, without feeling an elevated pleasure? A flowery vale, or the verdure of a hill, may charm; but to fill the soul, and raise it to the sublime sensations, the earth must rise into an Alp, or Pyrrhenean, and mountains piled upon mountains, reach to the very heavens. May not also the clearness of the sky, and its agreeable azure, be viewed through a crevice without the least admiration? But when a flood of light bursts in, and the vast heavens are on every side widely extended to the eye, it is then the soul enlarges, and would stretch herself out to the immense expanse. Is it not, therefore, the vastness of these objects which elevates us, and shall we not by looking a little narrowly into the mind be convinced that large objects only are fitted to raise this exaltedness?

The soul naturally supposes herself present to all the objects she perceives, and has lower or higher conceptions of her own excellency, as this extensiveness of her being is more or less limited. A universal presence is one of the sublime attributes of the Deity; then how much greater an existence must the soul imagine herself when contemplating the heavens she takes in the mighty orbs of the planets, and is present to a universe, than when shrunk into the narrow space of a room, and how much nearer advancing to the perfections of the universal presence? This extending her being, raises in her a noble pride, and upon such occasions no wonder she conceives (as Longinus observes) something greater of herself. But as a consciousness of her own vastness is what pleases, so nothing can raise this consciousness but a vastness in the objects about which she is employed. For whatever the essence of the soul may be, it is the reflections arising from sensations only which makes her acquainted with herself, and know her faculties. Vast objects occasion vast sensations, and vast sensations give the mind a higher idea of her own powers. Small scenes (except from association, which I shall hereafter consider) have never this effect; the beauty of them may please, and the variety be agreeable, but the soul is never filled by them.

II

Thus far, Palemon, we have proceeded in a kind of investigation; we have first inquired what disposition of mind was created by grand objects, the sublime of nature; this we found to be an effort of the soul to extend its being, and hence an exultation, from a consciousness of its own vastness: we then in particular and confessed instances examined what it was in objects raised this disposition, which we afterwards found to be their magnitude, and this likewise in a more universal manner from the very nature of our minds.

Yet notwithstanding we have demonstrated that the vastness of the object constitutes the sublime, to render the sublime perfect, two things are requisite; a certain degree of uniformity, and that by long custom the objects do not become familiar to the imagination.

From reason, as well as from experience, we may be convinced how requisite uniformity is; for when the object is uniform, by seeing part, the least glimpse gives a full and complete idea of the

whole, and thus at once may be distinctly conveyed the vastest
sensation. On the contrary, where this uniformity is wanting, the
mind must run from object to object, and never get a full and com-
plete prospect. Thus instead of having one large and grand idea, a
thousand little ones are shuffled in. Here the magnitude of the
scene is entirely broke, and consequently the noble pride and sub-
lime sensation destroyed. For what a different conception must
the soul have of herself, when with the greatest facility she can
view the greatest objects, and when with pain she must hurry
from part to part, and with difficulty acquire even an incomplete
view? But as uniformity contributes much to the mind's receiving
a grand idea of the object itself, so likewise does it greatly flatter
that conscious pride I have already mentioned. Where an object is
vast, and at the same time uniform, there is to the imagination no
limit of its vastness, and the mind runs out into infinity, continu-
ally creating as it were from the pattern. Thus when the eye loses
the vast ocean, the imagination having nothing to arrest it, catches
up the scene and extends the prospect to immensity, which it
could by no means do, were the uniform surface broke by innu-
merable little islands scattered up and down, and the mind thus
led into the consideration of the various parts; for this adverting
to dissimilar parts ever destroys the creative power of the imagi-
nation. However beautiful the hemisphere may be when curled
over with little silver-tinged clouds, and the blue sky everywhere
breaking through, yet the prospect is not near so grand as when in
a vast and uniform heaven there is nothing to stop the eye, or limit
the imagination. You will here, Palemon, object the evening heav-
ens diversified by numberless stars, than which I grant nothing
can be more sublime; but I believe your acuteness will no sooner
start than resolve the difficulty. We who have considered the
fixed stars as so many suns, the centres of systems, and know the
planets, like our earth, move in vast orbits, how must our imagi-
nation, stretching to myriads of worlds, measure an immense
space between each revolving planet? It will not be here improper
to observe, that a solemn sedateness generally attends a sublime
turn; for although the pathetic may be often joined with it, yet of
itself the sublime rather composes, than agitates the mind; which
being filled with one large, simple, and uniform idea, becomes (if I
may use the expression) one simple, grand sensation.

Uncommonness, though it does not constitute the sublime of
natural objects, very much heightens its effect upon the mind: for

as great part of the elevation raised by vast and grand prospects, is owing to the mind's finding herself in the exercise of more enlarged powers, and hence judging higher of herself, custom makes this familiar, and she no longer admires her own perfection. It is here, as in all other things, variety is wanting; and indeed could there be a continual shifting of scenes, something of the admiration might be kept up, and even of that opinion the soul conceives of herself. But we are in a world too limited for such a change of prospects; a large mountain, the ocean, a rainbow, the heavens, and some few more of the like kind, yield all the variety we can here enjoy. The grandeur of the heavens seldom affects us, it is our daily object, and two or three days at sea would sink all that elevated pleasure we feel upon viewing a vast ocean; yet, upon particular occasions, both the one and the other of these objects will raise the mind, how much soever accustomed to them — and this is when by any circumstance the imagination is set to work, and by its creative power the object is rendered new. Thus in a clear evening heaven, each star awakens the imagination to new creation, and the whole firmament is extended out into systems of worlds; nay, perhaps, it is even true, that wherever the mind adverts to the vastness of the object, there she always feels the sublime sensation; but from long custom the object being made familiar, although before her, she does not advert to it. As kings themselves forget their dignity, till roused by the ensigns of power, they reassure their grandeur. Admiration, a passion always attending the sublime, arises from uncommonness, and constantly decays as the object becomes more and more familiar.

An attempt to determine the greatness requisite to constitute the sublime of objects, would be vain and fruitless; upon the other hand, there is no affirming, that an object, although truly grand, will equally affect all minds; some are naturally fitted to consider things in the most enlarged views; others as naturally dissect great objects themselves, and by a diminutive genius render what is truly magnificent, little, and mean; for no object is so grand, but is attended with some trifling circumstance, upon which a little mind will surely fix; the universe has its cockleshells, and its butterflies, the ardent pursuits of childish geniuses. Not that even great minds do not sometimes unbend, and amuse themselves with baubles; nay, they are not at all times equally fitted to receive sublime impressions; for when the soul flags and is depressed, the vastest object is incapable of raising her. But at other times, when

the blood moves brisk, the pulse beats high, and the soul has lofty conceptions of herself, she sublimes every thing about her, or to speak more truly, snatches herself away from the minute of things, and throws herself into grand prospects, and the magnificence of nature.

From all this it is evident how different are the degrees of greatness, fitted to raise this passion: first, the Nile within his banks; then when he swelling overflows them, and widely extends himself over the whole country; but above all, when the eye loses itself in the immense ocean, or the imagination in infinite space and the unbounded system of things.

III

These, then, are the general principles, nor am I aware how many objections will be made against them. Is there not a sublime in painting, in music, in architecture, but above all, in virtue? Yet are there large objects, or is there anything immense in Prodicus's *Hercules*, whose judgment or resolution is universally allowed noble and sublime? Here we must own the difficult part of our task begins; yet if the principles we have laid down be applied even to such things as seemingly contradict them, it will be no small confirmation of their soundness and truth. We shall therefore consider the sublime of the passions, the sublime of science, and of the arts, such as architecture, music, and painting, and the sublime of such objects as arise merely from association.

In searching into the sublime of the passions, it is not my intent to re-examine the disposition we feel upon viewing the grand and magnificent; but to inquire into those affections, which when they appear in another, are ever deemed great, and affect the person who contemplates them with an elevated turn of mind. For the sublime of the passions must influence the mind in the same manner as the sublime of natural objects, and must produce the same exaltedness of disposition. Were not their effect upon the mind, the same exaltedness of disposition, they would with impropriety, bear the same name, and could by no means be the subject of this inquiry.

Although names are at first arbitrarily imposed, yet things of like nature ought ever to be classed under like appellations; and nothing brings greater confusion into knowledge than giving like names to things of unlike nature. Language abounds with too

many inaccuracies of this kind, and hence arises the vast difficulty in adjusting and defining the proper limits to many things. Beauty attributed to ten thousand dissimilar objects has never yet, nor ever can be universally defined; for definition is the selecting of such common properties in objects as ever exist with the objects, and constitute their very nature, and thus regards a class, or arrangement of things similar, under the same head or appellation. Mathematicians, when they define a circle, disregarding the greatness or smallness, pitch upon a common property peculiar to the figure, by which they define and reduce all figures with this property under the same head. But if many things of different nature go by the same name, no one definition can be applicable to them. Beauty, indeed, when applied to figure and proportion, may be and has been defined, because here it regards a class. Thus when we call regular figures beautiful, and irregular ones deformed, we find the common property of uniformity amidst variety constitutes the beauty of the first, and the want of this uniformity, the ugliness or deformity of the latter.

But not to digress too far. It is equally incumbent upon the philosopher and critic to prevent names from being confounded, and to refer each thing to its proper class, if such there be; therefore when I treat of the sublime, I treat of a certain order of things, which from a similitude either in themselves, or their effects, are arranged under one head, and constitute a class or species. And let the name of sublime be ever so frequently applied to a thing, yet if it bears no relation to this class, either in itself, or its effect, it is falsely so called, and is not the business of this present inquiry. I have been the more particular, Palemon, upon this point, because I know how often the word sublime is improperly used.

Such affections, then, or passions, as produce in the person who contemplates them an exalted and sublime disposition, can alone with propriety be called sublime: but affections which are only felt by him in whose breast they are, can never be the immediate object of another's knowledge; and when we contemplate passions out of ourselves, we know them only at a kind of second hand. But as no affection can subsist without its proper object, the cause or motive of the affection; we must argue from the cause to the effect, and judge and determine of the passion merely from a consideration of its object. What one person, in whose breast they are, knows immediately and by sensation, another can only know mediately and by induction; and therefore in considering the sub-

lime of the passions, their objects only can be the proper subject for examination, the objects alone being really what affects the person who would contemplate the passions. And thus we judge of the courage of a person, by his steadiness in braving dangers; of his piety, by the just adoration he pays to the supreme being; and of his humanity, by his deportment to his fellow creatures. He himself can only know the affection as it exists in his own breast.

Now, if the objects of such passions as are universally allowed sublime, be themselves vast and extended, the principles I have already laid down will be as equally applicable to the sublime of the passions, as to the sublime of inanimate objects; and we shall find that loftiness of mind and elevated turn, which we feel upon contemplating any of these affections, to arise from the imagination being immediately thrown into large prospects, and extended scenes of action.

That affections unexceptionably sublime, are heroism; or desire of conquest, such as in an Alexander or a Caesar; love of one's country; of mankind in general, or universal benevolence; a desire of fame and immortality: nor has the contempt of death, power, or of honour, a less title to be numbered amongst the sublime affections.

Heroism, or pursuit of conquest, generally arises either from a desire of power, or passion for fame; or from both. Power and fame, therefore, are the objects of this affection, which let us separately consider.

It is not every power which is the ambition of a hero, nor every power which carries the idea of sublime. A Caligula commanding armies to fill their helmets with cockleshells, is a power mean and contemptible, although ever so absolute; but suppose an Alexander laying level towns, depopulating countries, and ravaging the whole world, how does the sublime rise, nay though mankind be the sacrifice to his ambition! The same may be said of power when it regards strength; for the greatest strength, even that of the giants of *terra filii*, if only employed in grinding the hardest adamant to powder, or in reducing the solidest gold to dust, has nothing sublime or grand. But consider them in their fabulous history rooting up mountains and piling Ossa upon Olympus, then is their strength attended with the sublime. Thus our idea of power is more or less sublime, as the power itself is more or less extended. The absolute authority of a master over his slaves, is a power nothing grand; yet the same authority in a prince is sub-

lime. But why? From his sway extending to multitudes, and from nations bowing to his commands. But it is in the almighty that this sublime is completed, who with a nod can shatter to pieces the foundations of a universe, as with a word he called it into being.

I cannot here pass over (although more properly belonging to the sublime of writing) the passage in Moses — 'God said, let there be light, and there was light'. The sublime of this passage consists in the idea it gives us of the power of the almighty; but his power with regard to what? A vastly diffused being, unlimited as his own essence, and hence the idea becomes so exalted. Let there be earth, and there was earth, surely would come infinitely short of the other, as the object or power presents itself to us infinitely more limited. From all this, I think I may fairly conclude, that the sublime of power is from its object being vast and immense.

I need say little upon the head of fame. To be praised not only by the present generation, but through the revolving circle of ages down to latest posterity, is stretching our expectations and our ideas to an immensity; and from this the sublime of the passion itself arises; for although the approbation of a worthy man ought to bear more weight than the undistinguishing applause of thousands, yet the desire of such a single approbation, however virtuous, has nothing great or sublime in it. Thus, if it be true of any one passion, that the vastness of its object constitutes the sublime, it is most strictly so of this; and whatever is the motive of heroism, whether desire of power, or of fame, or of both, the sublime of the affection is the greatness of its object.

As to the love of our country, or rather universal benevolence, which like the sun everywhere diffuses itself, who can have any idea of it, without taking into his view large societies, numberless nations, all mankind reaching from pole to pole, from the rising to the setting-sun? And this is the sublime of benevolence, extending itself to the remotest of humankind. But how would the sublime sink, if in this large scene the imagination should fix upon a narrow object, a child, a parent, or a mistress! Indeed, love to any of the individuals, nay, to all of them, when considered as individuals, and one by one, has nothing exalted; it is when we love them collectively, when we love them in vast bodies stretching over large countries, that we feel the sublime rise.

The affection of a parent to a child, although more intense, perhaps, than any other, yet has nothing great in it; nay, I will venture

to affirm, not even friendship itself, without it be accidental; as all the passions, by apt connection may exist with the sublime.

Thus when friendship prompts a man to sacrifice honours, wealth, and power, to despise the greatness of the world and brave death, it then becomes truly great; nor need I, Palemon, cloy you with the repeated reasons.

Hence the object of the passion only, not the intenseness of it, renders it great and noble; and hence a contempt of riches, of honours, power, and empire, may be justly reckoned amongst the grand affections. But perhaps it may be asked, how the contempt of that can be great, the desire of which I have already allowed so; or if it be true, that the contempt is great, how can I reconcile my former assertion to what Longinus affirms; to wit, nothing is great, the contempt of which is great, as riches, dignities, honours, and empire.

IV

Here, Palemon, I must observe that the sublime, and virtue, are quite different things; the decorum of actions, distinct from the exalted. Honours, dignities, and empire, in their own nature partake nothing of virtue; but that they do of the grand, I think I have plainly shown. Now in a moral sense it is certainly true, if in any circumstance the contempt of these things is great (by which Longinus can surely mean no more than becoming or virtuous,) in the same circumstance the desire of them can never be great; but if he understands the word great in its true and genuine sense, I cannot see why the desire, as well as the contempt of them may not be truly grand: for as the object is the same in both cases, and as it is the object which renders the affection sublime, in both cases there must be a sublime. And the passion of Caesar to conquest and empire, is no less sublime, than the stoic apathy of the philosopher (if such there ever was, or ever shall be,) who should reject them; though we might allow in the latter a more virtuous and laudable affection.

When virtue is at any time sublime, it is not that she is the same as the sublime, but that she associates with it, and from this association each acquires new charms: virtue becomes more commanding, the sublime more engaging. When Hercules rejecting the proffered luxury of palaces, and pomp of courts, prefers virtue, traverses the earth in the pursuit of honour, and thinks the whole

world scene little enough of action, how does the virtuous great-
ness of his soul charm and strike us with a sublime admiration!
Had he only preferred an honest retirement to rosy garlands, ban-
quet, song, and dance, the enticements of the alluring goddess,
where would have been the sublime? Indeed his resolution
would have been even then still virtuous.

A just order of affections, where no one desire, by a dissonance
and jarring with the rest, breaks the harmony of the passions, is
what constitutes the beauty and becomingness of character; and if
virtue be the pursuit of our greatest happiness in the good of soci-
ety, this becomingness is virtue herself: for proportioned affec-
tions render us most happy in ourselves, and most beneficial to
mankind; and a virtuous passion or appetite is such as the satisfy-
ing of it neither necessarily produces disturbance in the affec-
tions, nor disorder in society. I say necessarily, for often by
accident the most virtuous affection is attended with bad conse-
quences; but this is not equally true of the sublime passions.
Desire of fame, honours, or empire, often creates the greatest
tumult in the affections, and the greatest mischief to mankind.

Thus most of the sublime passions, when virtuous, are so by
association and accident; and although the indications of elevated
souls, yet are not always of virtuous. The hero who insults man-
kind, and ravages the earth merely for power and fame, is but an
immense monster, and as such only ought to be gazed at; he may
indeed, by a mild use of conquest, gild over the cruelty of his
actions, but can never render them solidly good. Yet such is the
force of the sublime, that even these men, who in one light can be
esteemed no other than the butchers of the human race, yet when
considered as braving dangers, conquering kingdoms, and
spreading the terror of their name to the rest of mankind, become
almost the objects of worship. But there is a sublime which is
always virtuous, and where the virtue as well as the sublime
increases with the object; I mean that of love; first to the particular
community whereof we are members; then to our native country;
to mankind in general; and last to the universal genius. When
once the soul can be raised to this noble enthusiasm, and can make
an infinitely great being the object of her love, and as it were take
him into her affections, it is then she feels the greatest sublime
possible, and conceives something infinitely grand of herself;
honours, dignity, and empire are objects truly little and mean to a
mind thus united with divinity.

Contempt of death is neither always virtuous, nor always sublime; the wretch who, intoxicated with liquor, braves death at a gallows, shows neither a virtuous nor a great soul; but a Cato, who will not barter the real dignity of character for all the false honours a cajoling Caesar can heap upon him, and who in cool deliberation, rather than drag a life in the slavery of vile submission, and mean adulations, chooses to die with liberty and his country, evinces, in the action, the grandeur and virtue of a Roman soul. In these circumstances, the contempt of death is both laudable and sublime; the fear of it, mean and despicable. Cato, in giving up life, had in view immortality and everlasting liberty, the sublime enjoyment of the almighty; whilst the orator, who basely courted life in mean flatteries to a tyrant, had in prospect nothing but the contracted space of a few years spent in abject slavery: and yet this, perhaps, was more pardonable in the orator than it would have been in the patriot. For besides the beauty of virtue in general, there is likewise a decorum or becomingness belonging to character. The easy manners of an Atticus can allow many things which would be deformed in the inflexible virtue of a Cato. The good-natured Atticus had the humanness, not the dignity of character to support; roughness and cruelty would have defaced and deformed his character, not compliance and submission. But for the rigid Roman to have lived quietly under tyranny, would have been such a breach of character, such a depravity in his manners, that he must have preferred a thousand deaths before it. For to see the stubborn oak bow to every blast, is unnatural, however agreeable it may be to see the yielding corn wave to the breeze.

I think now, Palemon, I have considered most, if not all the sublime passions, and have shown that the greatness of the object makes the sublime of the affections. This we shall find true, should we yet in another manner render the passions the objects of our senses. Allegory has already clothed most of them in human form, and should we attempt in the ancient way of fable to draw the sublime affections of their objects in emblematical portraitures, what a giant would heroism appear! Liberty, perhaps, like the deity, is too vast a being to be circumscribed by form; but fame has been already pictured to us, and pictured as a being of immense greatness. Nor does power deserve a less size: but how would benevolence, spreading out her downy wings wide as the arched heavens, kindly brood over the world! In

short, if we do these passions justice, we ought to paint them in all the grandeur and majesty Homer does his Neptune, under whose vast strides, forests and mountains trembled.

Before I conclude this subject, I must observe, that all the passions of the human mind may exist each with the other, and hence it frequently happens that the sublime affections are blended with those of a quite contrary nature. There ever enters in the description of storms (as I have already observed) some small degree of dread, and this dread may be so heightened (when a person is actually in one) as entirely to destroy the sublime. By this means an object in itself grand may by association lose most if not all its effect. Yet, Palemon, it seems strange that a being so simple, so much one as the mind, should at the same time feel joy and grief, pleasure and pain, in short, be the subject of contradictions; or can it be true that the mind can feel pleasure and pain at the same instant? Or rather, do not they succeed each other by such infinitely quick vicissitudes, as to appear instantaneous; as a lighted globe, moving in quick revolutions, seems one continued circle of fire? But which every way the mind perceives, it is certain to common observation, the most different passions and sensations possess the mind at the same time. The prick of a pin will give pain, while the most delicious food is flattering the palate, or the highest perfumes the smell. The sublime dilates and elevates the soul, fear sinks and contracts it; yet both are felt upon viewing what is great and awful. And we cannot conceive a deity armed with thunder without being struck with a sublime terror; but if we regard him as infinite source of happiness, the benign dispenser of benefits, it is not then the dreadful, but the joyous sublime we feel. From these associations there arises different kinds of sublime, where yet the sublime is the predominant; and from these associations, likewise, results a greater beauty to it. The fine blue of the heavens yields a more delightfully sublime prospect, than had they been of a dusky obscure colour. These connections, however, often occasion not only a confusion of terms, but even of ideas; nor indeed is it always so easy to separate our sensations. The grand may be so blended with the pathetic and warm, in the description of battles, as difficulty to be divided, and consequently the complex sensation arising from thence as difficulty resolved. By this means the pathetic is often mistaken for the sublime; but whoever considers the different nature of the two, will upon all occasions easily distinguish them.

The sublime, when it exists simple and unmixed, by filling the mind with one vast and uniform idea, affects it with a solemn sedateness; by this means the soul itself becomes, as it were, one simple grand sensation. Thus the sublime not hurrying us from object to object, rather composes than agitates, whilst the very essence of the pathetic conflicts in an agitation of the passions, which is ever effected by crowding into the thoughts a thousand different objects, and hurrying the mind into various scenes.

V

Before I proceed to examine the sublime in arts and sciences, it will not perhaps be entirely useless to observe, that objects in general delight from two sources; either because naturally fitted to please, from a certain harmony and disposition of their parts, or because long associated with objects really agreeable; and thus, though in themselves there be nothing at first delightful, they at last become so. Perhaps of this kind of association the fondness which a lover conceives even to the imperfections of his mistress, may not be the worst instance; a cast of the eye, a lisp, or any other little blemish, shall by a fond lover quickly be deified into a beauty, and receive more adoration than the real beautiful and charming.

Hence we see the powerful force of connection. Nor does this only happen in the whimsical imagination of a fond lover; the gravest philosophers also owe great part of their pleasure to this stealing of beauty from one object to deck and adorn another: for by daily experience we know, when certain pleasures have been raised in the mind by certain objects, from an association of this kind, the very same pleasure shall be raised, though the objects themselves which first occasioned them are not so much as painted in the imagination; and it is from this source that the beauty and delight of metaphor flows. Who ever thought of the rosy blush of his mistress, without feeling something like that agreeable sensation which the rose itself excites, not only by its colour, but even by its fragrance?

But to return to our present purpose; we may hence perceive, that objects which in themselves are not great and immense, if long connected with such, will often produce an exaltedness of mind; and this seems partly to be the case in architecture. The face of a fine building shall give a greater loftiness to the soul, than an

object vastly more extended; neither indeed does the size of any building seem to rise to that largeness as constitutes the sublime: whence, therefore, it is, that it raises this passion? One of the reasons certainly is, we have always found such buildings connected with great riches, power, and grandeur; and though the mind may not reflect on these connections, yet from what I before mentioned, the passion occasioned by these things may exist in the mind without the idea of the things themselves. Should the buildings be perfectly plain, without any manner of ornaments, though vastly large, as those in Edinburgh, they would not at all elevate the soul; for in these buildings we have found no necessary connection with power and grandeur. But besides this, with columns there is always connected the imagination of strength and durableness; and these working together, may very well give a sublimity to the mind. However, I am apt to think, we sometimes imagine a greater sublime in objects than what there really is. Thus in a fine building, the proportion of the parts, their aptitude, and a thousand other circumstances, which form the beauty of the structure, afford a refined delight, much different from the exalted disposition already mentioned; and may not two or three different pleasures existing in the mind at the same time, by a kind of reverberation on each other, increase the intenseness of each, as a parcel of diamonds, when artfully set, by a reciprocal reflection of their rays, strike the eye with redoubled lustre? What, indeed, is poetry, but the art of throwing a number of agreeable images together, whence each of them yields a greater delight than they possibly could separately. There might be something likewise said from the variety of the parts, and yet so uniform as not to distract the imagination. If a great crowd of ideas can be distinctly conveyed into a small portion of the mind, something of the pride of the sublime will be raised in her; for if she can take in so great a variety, and yet have room for so much more, she certainly must feel something exalted. That the uniformity does contribute to give this turn of mind, is plain by observing those buildings which abound in little and trifling ornaments, where every thing is broke into miniature. Here, though the bulk of the building be vastly large, no very great ideas are conveyed.

The sublime of painting consists mostly in finely representing the sublime of the passions, such as the tablature of Hercules; and what a greatness of mind he shows in Hercules! Behold what large scenes of action virtue points out to him in choosing them!

The indolence of pleasure affords no such vast prospects. The whole world was a scene little enough for his enlarged soul. Landscape painting may likewise partake of the sublime; such as representing mountains, etc. which shows how little objects by an apt connection may affect us with this passion: for the space of a yard of canvass, by only representing the figure and colour of a mountain, shall fill the mind with nearly as great an idea as the mountain itself.

I know so little of music, that I will not pretend to determine the sublime of it. This I know: all grave sounds, where the notes are long, exalt my mind much more than any other kind; and that wind-instruments are the most fitted to elevate; such as the hautboy, the trumpet, and organ. For as Pope has it:

> In more lengthened notes and flow,
> Deep, majestic, solemn organs blow.

In all acute sounds, the vibrations are short and quick; on the contrary, in the grave. And may not long sounds be to the ear what extended prospects are to the eye? Here also connection takes great place; the most fantastic jig of a bagpipe shall elevate a highlander more than the most solemn music; for to such they have been ever accustomed even in their martial engagements.

Whatever outward appearance the sublime of the mind assumes, that appearance likewise acquires a name similar to that turn of soul, as lofty, majestic, etc. And indeed whatever conveys to us the imagination of such a disposition in another, affects us also with the like passion. For example; a grave and sedate gesture, especially in princes, we call majestic and noble; and it even gives a small degree of loftiness to the spectator himself: for, as I before hinted, the true sublime of the mind is grave and composed, which in gesture can only be expressed by a grave and composed gate. Should a prince frisk about in short and quick motions, it would take away very much from the imagination of his possessing a great and elevated soul. And this also may be something the case in music; it being inconsistent with a sedate mind to run through all the quick notes and short turns of a jig. Though after all, I believe the pathetic in music is frequently taken for the sublime; and not only here, but even in other cases. Nor, indeed, is it always so easy to separate our sensations: the grand may be so blended with the pathetic and warm, (*viz.* in the description of a battle) as difficulty to be divided and conse-

quently the complex sensation arising from thence as difficulty resolved. Hence not only comes a confusion of terms, but even of ideas. With a great storm, when the swelling waves rise in mountains to the skies, and the black clouds thicken from all quarters of the heavens, there is always joined the apprehension of danger, which puts the passions into a hurry: here the complex sensation is generally esteemed the sublime; but from what I have already said it will appear, that the vastness only of the objects produces it, by no means the agitation of the passions, which, if nicely considered, has rather fear than the sublime for its cause. After this manner the sublime may be connected with any one passion, and from such connections different kinds of sublime will arise; I mean in a lax way of speaking; and indeed, from the different ways of blending it in objects, our pleasure may be greatly increased. Thus, the fine blue of the heavens makes the sublime itself yield a greater delight, and for the reason I before hinted.

Had I time, I would consider something of the sublime in sciences. But I shall only observe, that in mathematics it is the universal theorems, and the vast similarity in the properties of infinite curves. And in studying the sciences, it is the mark of a truly great mind not to dwell on the minutiae of things, but rather to consider their universal relations: studies which seem dry, become exalted and agreeable, by such a management.

I shall end with this one remark, that the eyes and ears are the only inlets to the sublime. Taste, smell, nor touch convey nothing that is great and exalted; and this may be some farther confirmation that large objects only constitute the sublime.

Five

Alexander Gerard

(1728–1795)

The son of an Aberdeenshire minister, Alexander Gerard gained his licence as a minister at the age of twenty and was appointed Professor of Moral Philosophy at Marischal College in Aberdeen at the young age of twenty four. At the age of twenty seven he had gained a reputation as an educational reformer, when his radical plan to revise the curriculum of the College was implemented. At the age of twenty eight he won the competition organised by the Edinburgh Society for the Encouragement of Arts, Sciences, Manufactures and Agriculture for the best essay on the subject of taste. Many of the Edinburgh intellectual elite were on the panel that selected Gerard's essay as the winner, including Hume. Indeed Hume takes quite a bit of trouble a few years later to assist Gerard with the publication of the essay, which appears in 1759. This is intriguing because Hume's far more famous essay on the standard of taste was published in 1757, the year after Gerard was awarded the prize. One can only wonder whether Hume's encounter with Gerard's essay provided part of the catalyst for his turning to the topic of taste. Hume's treatment of the issue is certainly very different and less confident of finding a solution than Gerard's alternative. When in 1780 the third edition of his *Essay on Taste* was published, Gerard added a substantial new section addressing the subject of the standard of taste, in which he defends an account of the standard very different from, and critical of, Hume's treatment of the topic. Gerard's solution to the problem presented there is implicit in the earlier essay that won the Edinburgh prize, but the section from the later edition makes the point far more explicitly. It is from this later addition to the essay that the following excerpt is taken.

Gerard distinguishes between taste in its direct exercise, or as a species of sensation, and taste as a 'reflex act' or species of discernment. The former is not susceptible to any standard because there are a large number of idiosyncratic reasons why people have the sentimental responses they do. As a species of discernment, however, taste is susceptible to the formulation of a standard, though not one that will reconcile divergent tastes. Rather it is a more modest standard that determines the difference between better and worse amidst competing judgments. To identify the standard, Gerard argues, we need to proceed using the method of inverse deduction — that is, inductive generalisation followed by an *a priori* deduction of these generalisations from fundamental principles already established — and this is just the methods that John Stuart Mill would later prescribe to situations such as aesthetics in which there is a complex of interacting causes responsible for a phenomenon.

Further Reading

George Dickie, *The Century of Taste*, Oxford: Oxford University Press, 1996.

W.J. Hipple, *The Beautiful, The Sublime and the Picturesque in Eighteenth Century British Aesthetic Theory*, Carbondale: Southern Illinois University Press, 1957.

READING VIII

OF THE STANDARD OF TASTE[1]

There is doubtless considerable difficulty in determining, what are the general qualities which gratify taste, and what it is that constitutes perfection of taste: but the difficulty is wholly of that kind which attends every accurate investigation, especially on an abstruse or delicate subject; as soon as the investigation is completed, the conclusions produce a full conviction of their truth. Few will entertain a doubt, whether novelty, sublimity, beauty, skilful imitation, and the like, are the qualities on which we fix our attention, and from which we derive our pleasure, when we survey the works of nature or the productions of human art. It will likewise be acknowledged without hesitation, that the perfection of taste conflicts in delicacy and justness, or

[1] From *Essay on Taste*, 3rd Edition (London, 1780).

more particularly, in sensibility, refinement, correctness, and the due proportion of its several principles.

But when we come to compare the taste of one man with that of another, we meet with difficulties of a different sort, which cannot be resolved so easily, nor in a manner so convincing. Though all agree that beauty pleases, it may still remain a question, whether beauty does or does not belong to this or that object; and it is a question which it seems often almost impossible to find the means of answering. Of what importance is it for deciding in any one instance, that correctness and delicacy are universally confessed to be perfections of taste? For which is the correct taste, or which the delicate? What one approves as correct, another censures as insipid or enervated; what one admires as delicate, another pronounces viciously refined, and a third perhaps blames as not altogether free from coarseness. The tastes of different men seldom coincide perfectly: and when they disagree, by what rule can we determine, to which the preference is due? The general principles may be rendered unexceptionable; but in applying them to particular cases, there is room for an endless variety of sentiments.

That there is a very great diversity of tastes among mankind, is plain from every day's experience; that this diversity must always continue, is no less plain from reflection on those principles of the mind, by the operation of which the several perceptions of taste are produced.

On every subject, in every point of view, the taste of one man obviously differs from that of another. In painting, some are pleased with correctness of design, some with richness of invention, and some with beauty of colouring. The excellence of music has been placed by some in simplicity, by others in a kind of rich variety; and others have put the highest value on those compositions which surprise the ear and display masterly execution. Some prefer the subtle, close, and nervous style of eloquence; others the more diffuse and copious manner of popular declamation. Every species of poetry, and every mode of poetical composition has had its patrons. Many have admired the sublimity and spirit of the ode; a great writer insinuates that he looks upon it as only harmonious extravagance. It has been made a question, whether an epic poem or a tragedy be the greatest work; each side of the question has had advocates of undoubted taste and judgment. Every age has something peculiar, which distinguishes its taste,

in dress, in manners, and in arts, from that of other ages. What is highly approved in one nation, is perfectly repugnant to the taste of another the most contiguous to it. The irregularities of Ariosto cannot prevent his being the favourite poet of his countrymen; the more artificial and connected plan of Tasso has determined most foreigners to give him the preference. Those theatrical entertainments which yield high pleasure to a Frenchman, appear insipid and uninteresting to an Englishman; and what suits the taste of the latter, would often shock the refinement of the former. The oriental style in writing, is reckoned inflated and fantastical, by Europeans; and the simplicity of composition which prevails in Europe, would be no less censured by an inhabitant of Persia or India.

The constitution of human nature renders this variety of tastes inevitable. It must be produced both by an original inequality and dissimilitude in the powers whose combination of forms taste, and by the different degrees and modes of culture which have been bestowed upon these powers.

Most of those internal senses which belong to taste, are exerted by the intervention of an external organ; and all men are not precisely alike in any of their external organs. There are eyes which can scarcely distinguish one colour from another: such eyes must render a person unfit for being a judge of painting, at least so far as colouring is concerned, in whatever degree of perfection he may possess the internal principles of judging. A person whose sight is feeble or obscure, cannot discern, and therefore cannot approve that variety and multiplicity of ornaments, which gives high pleasure to a person endued with acuter or distincter sight. To a very quick sense of hearing, that degree of sound will be painful, which gives music only the strength and fullness fit to gratify a duller organ.

But the original differences lie chiefly in the internal senses, or in those mental processes by which the sentiments of taste are produced. For instance, a degree of difficulty in conceiving an object, which is only sufficient to give one person a grateful feeling of exertion, may fatigue another, and render either novelty or variety in some cases unpleasant to him. On the contrary, a degree of facility which pleases one, may sink another into languor, and make uniformity or simplicity disgusting. This very difference of constitution leads the bold and active spirit to choose and to delight in a severity of exercise, a bustle of business, or an applica-

tion of thought, which would overwhelm an indolent and feeble mind: the quick change of companies and the incessant round of diversions, which is no more than enough to give play to the vivacity of the gay, would be a torment to persons of a more sedate turn; and the tranquillity in which these latter find their enjoyment, would be insupportable to the former. All the sentiments of taste have a great dependence on association; and must derive immense variety from the endless diversity which takes place, in the strength of the associating principles, in their particular modifications and combinations, in the tracks to which they have been most accustomed, in the nature and the number of accessory ideas which they connect with the objects of taste. Men differ much in sensibility of heart; and therefore must feel differently and judge differently, in all those cases in which the perceptions of taste are affected by the warmth or coldness of the heart. Men have very unequal measures of sagacity and quickness in inferring design and mental qualities from sensible appearances and effects; and consequently must differ in their tastes, in all the numberless cases, in which their pleasure has any dependence on such inferences; wherever, for example, that gratification results from a perception of the dexterity of the artist, wherever the passions are expressed by bodily features or attitudes, wherever character is indicated by delicate touches. They have very different degrees of skill in comparing, and are prone to very different sorts of comparison; and therefore must be differently affected in all those cases, in which the pleasure arises from a perception of the relation of the parts to the whole, or of the means to the end, from imitation, or from a comparative view of different objects.

The perceptions of each of the internal senses, are the result of these and the like mental energies; and they must be in every man duller or livelier, stronger or weaker, distincter or more confused, according to the perfection or the imperfection of those energies, by the combination of which they are produced. On this account it cannot be expected that any one of the internal senses should be equally good in all men. The internal senses which belong to taste are many; and each of them is distinct from the rest, in respect both of its principles and of its objects: they are generated by different mental processes; and they are adapted to the perception of different subjects or of different qualities of the same subject. A man may be well turned to those processes which generate one of the powers of taste, and consequently perfect in it, while he is

defective in another, by being naturally ill-disposed to those pro-
cesses which should produce it. Hence different men will excel in
different sorts of taste, and be chiefly attached each to a peculiar
set of subjects and qualities. This must introduce a variety and
dissonance into their decisions. One man is principally struck
with novelty, another with grandeur, another with beauty,
another with harmony, another with the ludicrous; and each
gives the preference to that which makes the strongest impression
on himself. Many of the forms of judgment, likewise, enter into
the operations of taste; and no two men are perfectly similar in
their powers of judgment.

The original diversities of taste, in this manner great and
unavoidable, cannot fail to be increased by the very unequal
degrees and dissimilar modes of exercise and culture, which it
receives in the several individuals: these would be sufficient to
produce diversity, though the powers of taste had been naturally
uniform in all. In the bulk of mankind, these powers receive no
culture: engrossed by attention to the necessaries of life, attached
to pursuits remote from the pleasures of the imagination, or by
some other means deprived of opportunities of exerting the inter-
nal senses, there taste remains wholly unimproved; or rather the
elements of taste which nature implanted in their souls, are extin-
guished, as seed, by being buried so deep as to prevent its vegetat-
ing, is corrupted and lost. Every difference in the degree of
exercise, which taste receives, produces a difference in the degree
of improvement which it reaches: every difference in the manner
of conducting its exercises, occasions a correspondent peculiarity
in its structure. If a person has access only to a few of those objects
which draw forth the powers of taste, and give them vigour, his
sentiments are formed upon these objects; they are confined to the
qualities which these exhibit, they cannot coincide with the senti-
ments of those men who have taken a wider range, who have been
conversant with a greater variety of objects, and from the contem-
plation of them have derived more extensive views. A man who
has spent his life in an uncultivated country, may have a high rel-
ish of the rude magnificence and wild sublimity of nature, but
cannot even conceive the beauties of a rich and highly improved
country; and when he is first introduced to them, amidst all his
admiration of regularity and fruitfulness, he feels disgust in the
absence of the grand, though rough and barren, scenes which
have been familiar to him. There are many instances of persons

who have visited the finest countries in the world, returning to their native mountains, and, from the peculiar taste which they had early acquired, as well as on account of other attachments, giving them the preference to the most delightful regions. It is in nations where the fine arts have been pursued and carried to perfection, or where the productions of great master abound, that taste in these arts becomes elegant and just. By accustoming himself to attend only either to the noble, or to the graceful, a man may render himself almost incapable of relishing the other. By confining his application to one of the fine arts, or by having opportunities of surveying productions only in that one art, a man may become an accurate judge in it, while he has no taste in the sister arts; a nice judge of poetry, is not necessarily a judge in painting, in music, or in architecture; he may either have no relish for them, or he may have a perverted relish. Our sentiments, as well as our opinions, are liable to be warped by prejudice: the sentiments of taste have, in every man, a distinctive tinge, derived from the peculiarities of his temper, his passions, his situations, and his habits.

It is the variety of tastes obvious in mankind that renders it necessary to enquire concerning a standard of taste. But the variety is so great as to render it difficult to fix a standard; and even doubtful, in the opinion of some, whether any standard can be fixed. Either we must allow that all these different and opposite tastes are equally good, or we must acknowledge that some of them deserve the preference, and that there are means of determining, which these are. The former supposition seems to have been so generally admitted, as to have passed into a proverb, that tastes are not to be disputed: yet it is too wide to be seriously admitted by any, in its full latitude. It would imply that every man is to himself an infallible judge of beauty and deformity, of excellence and defect; it would imply that the same objects, and the fame qualities of objects, may merit at once approbation and disgust; it would imply that our natural principles of taste, unlike to all the rest both of our mental faculties, and our bodily powers, are incapable of being either improved or perverted; it would infer that it is absurd to censure any relish, however singularly gross; it would put all critical discussions precisely on a level with Don Quixote's dissertations on giants and enchantments. The proverb, though frequently expressed, is never steadily or consistently adopted. Its authority is sometimes urged by persons whose sentiments are called in question; but it is disregarded by the same

persons, whenever they are disposed to call in question the sentiments of others. If they be at a loss, by what principles to support a decision which they have given, if they be unwilling to own that they have judged wrong, or to use the means of acquiring greater justness and delicacy of sentiment, they take shelter in the received maxim; they plead that this is their taste, and they have a right to indulge it. But there is no man who does not think himself entitled to find fault with the taste of another in some particular instances; and to find fault with any taste, necessarily implies the acknowledgement of a right and a wrong, and of a standard by means of which they may be distinguished; without taking this for granted, we could never dream of finding fault; but if *any* taste can be wrong, *none* has a claim to absolute authority, merely on account of its being taste. However frequently the indisputable equality of tastes may be retailed without examination or attention to its meaning, however frequently it may be applied to conceal want of taste, to disguise the perversion of it, or to excuse negligence in improving it; yet every man makes it evident at times, that he gives no credit to the maxim, that he knows some of the sentiments of taste to be right, others to be wrong; and that he admits some criterion by which, in some cases at least, they may be discriminated.

There is one situation in which we are peculiarly prone to admit the maxim which has been mentioned: when sentiments are very different, we readily acknowledge that a preference is due to one of them; but when the difference between them is inconsiderable, we are disposed to allow the same authority to both. It is not difficult to discover the cause of this inconsistency. There is scarcely any state of mind more uneasy than that in which it is solicitous to determine a point, and yet finds it impossible to determine to its own satisfaction: it hangs in painful suspense between opposite judgments. It is in this state, when it attempts to decide between turns of taste which differ but a little; it is involved in perplexity it is distracted by contrary principles of nearly equal force; it can find nothing in which it may rest with prefect acquiescence: It is eager to fly from this uneasiness; but finds no other means of flying from it, but to persuade itself, that there is no preference due to either turn, that each has an equal and an indisputable authority, and that consequently there is no room for a decision. When a taste differs widely from our own, we do not hesitate to pronounce it barbarous and unnatural; it is when the difference is

more minute, that we recur to the infallibility of sentiment. In this case we allow ourselves to admit sophistry, that we may banish suspense. It will by no means follow that the taste of one man is not juster than that of another, because we cannot easily decide, to which the preference is due, or because, when we give a preference, we cannot produce incontestable proofs of the rectitude of our judgment. In matters of science, opposite opinions may be supported by arguments of such equal plausibility, that a man who is not perfectly acquainted with the subject, cannot satisfy himself, to which of them he ought to yield assent; yet one of these opinions may be notwithstanding true, and the other false. In like manner, there may be a good and a bad in taste, though you be at a loss to pronounce, in a particular case, where it precisely lies; and you may be convinced that there is, though your propensity to dispel disagreeable suspense inclines you to stifle your conviction, and to suppose for a moment, that there is no certain criterion in the case.

It has been common to consider the pleasures of taste as belonging to the imagination. Perhaps this has contributed to introduce the opinion that taste cannot be reduced to any fixed standard. We are disposed to regard the imagination as an irregular and lawless power, the parent of whatever is fantastical and capricious. We acknowledge the pleasures and the pains of the external senses to be something real and substantial, for the perception of which there is an unalterable foundation in the constitution of our nature. But the pleasures of taste are thought to have no such permanent foundation: they are derived only from fancy; they depend on a particular turn of imagination, which cannot be expected to be the same in all men, which springs up without a sanction from reason, and again changes without its allowance, a new whimsy driving out the old. But this reasoning can have weight only with superficial thinkers. It is true that mere fancies, and these too absurd and preposterous, have been sometimes undeservedly honoured with the name of taste, as in the ever varying modes of dress, equipage, and furniture: yet even in these trivial subjects, everything is not wholly arbitrary; there are fixed principles of propriety, on which one mode may be approved and another condemned: and in the genuine province of taste, in the sublimer field of nature and the fine arts, though it be certain, and though it has been a great part of our business to prove, that

almost all the sentiments of taste are derived from certain exertions of the imagination, it is equally certain, and has been proved with the clearest evidence, that these exertions are as little capricious, as regular, as universal, and subject to as fixed laws, as the exertions of any other principle in the human constitution.

An argument against the possibility of fixing a standard of taste has been drawn from the very nature of sentiment. Sentiment, it is said, has not, like judgment, a reference to anything beyond itself, nor represents any quality inherent in the external object: it implies only a certain congruity between that object and the faculty by which it is perceived; this congruity does certainly take place whenever the sentiment which indicates it is felt; and consequently the sentiment cannot be false or wrong. This argument, however plausible, has no solidity. For, *first*, suppose it true that our sentiments mark some congruity between certain objects and our faculties, and nothing more; it will not follow that every sentiment is necessarily right, or that one taste may not be preferable to another. If this account of sentiment be just, it must be applicable to all our sensations, as well as to those of taste; but it is readily acknowledged concerning every one of the external senses, that in one man it is more acute than in another; and, therefore, it ought to be acknowledged, that one man may possess taste in greater perfection than another. One eye is more piercing, one ear more quick, one palate, one smell, or one touch, more delicate than another; and there are, in most cases, infallible means of determining to which the superiority belongs: and why should we hesitate to own, that one taste is superior to another? Or why despair of discovering some means of ascertaining which of them is the superior? There may be a congruity between an object and our organs, which undeniably implies a defect or imperfection in the latter: darkness agrees best with weak eyes; but this very conformity is a proof of their weakness. In like manner, the conformity of some objects to a man's taste may be such as shows it to be weak and imperfect. But, *secondly*, the supposition on which the argument proceeds, is not strictly true. Sentiment implies something more than a congruity between objects and our organs. It is not a *copy* of anything exterior; but it is the *result* of it: it is not an *image* of a quality inherent in the object; but it is the natural *effect* of it: and when a quality acknowledged to belong to an object, fails of producing its natural and usual effect upon a particular person,

the failure indicates a deficiency or perversion in that person's organs. *Thirdly,* taste implies judgment, as well as sentiment: and therefore, it must, in some respects at least, refer to something beyond ourselves, and be either right or wrong, according as it is conformable or not conformable to that external standard.

Taste may be considered in two different lights, the not distinguishing between which, has embarrassed the question concerning a fixed criterion of its sentiments, and bestowed some degree of plausibility on the assertion of the indisputable authority of every taste. It may be considered either as a species of *sensation*, or as a species of *discernment*. In the former light, it is mere feeling and perception; it is touched and affected by certain objects, and attaches us to them immediately and without reflection; it is simply the faculty by which we receive pleasure from the beauties, and pain from the faults and imperfections of those things about which we are conversant. In the other light, it is a faculty by which we distinguish the true causes of our pleasure or of our dislike; by a reflex act, it discerns the several qualities which are fit to excite pleasure or disgust; it estimates the degree of satisfaction or dissatisfaction which every object ought to produce. Taste considered in the former of these lights, in respect of what we may call its *direct exercise,* cannot properly admit any standard. The feelings of every man depend, in a great measure, on the original structure of his mind, which is unalterable: they depend on the precise degree and mode of improvement which his natural powers have received; while this remains the same, his feelings must also continue what they are; they can be changed only by a variation in the state of his improvement; but it is not possible that all men should either have the same opportunities of improving taste, or make the same use of the opportunities which they have. It is not, therefore, possible, that all men should be equally pleased, or that they should be pleased with precisely the same things. But notwithstanding this, there may be a standard of taste in respect of its *reflex act*: and it is only in respect of these, that a standard should be sought for. A standard of taste is not something by which all tastes may be reconciled and brought to coincide: it is only something by which it may be determined, which is the best among tastes various, contending, and incapable of coinciding perfectly. It is so far from being impossible to discover a standard which may answer this purpose to the impartial, that a standard may be

found, to which even they whose relish it condemns, may find themselves obliged to submit. The person who *feels* in a certain manner, and who cannot, by any means, bring himself, at present, to feel in a different manner, may yet be convinced that he feels amiss, and yield readily to a *judgment* in opposition to his feeling. This happens even with regard to the external senses. A person may perceive in himself an unconquerable antipathy to a particular species of food; and yet, if he can trace its origin to an accidental disgust, he will not, on account of his antipathy, pronounce that food either unwholesome or unpalatable, he will not be surprised that other men are fond of it, but on the contrary believe, that himself also should have been fond of it, if he had not happened to contract an unreasonable prejudice against it. There are persons who dislike particular colours: but they may sometimes be sensible that their dislike proceeds from a groundless association; and though it has taken so fast hold of their imagination, that they cannot get the better of it, yet they may be far from pretending that that colour ought to be generally disliked, may be disposed to give credit to those who say that they perceive it beautiful, and even able to discover a strong foundation for their judgment. In like manner, a man may be sensible, that his not receiving pleasure or disgust in the fine arts, does proceed, in particular instances, from an imperfection in his organs, from want of opportunity of improving his taste, or from a prejudice which he has contracted; and, from consciousness of this, may be ready to acknowledge that, in these instances, his own taste is false and of no authority, and that the very different taste of another deserves the preference. One who has a bad musical ear, is not surprised that he perceives not either the excellencies or the defects of a tune, or that he blunders in endeavouring to trace them out; but, disregarding his own feelings, appeals to, and acquiesces in, the decision of those whom he confesses to be better judges. One who has never had access to study the works of the great masters in painting or sculpture, will naturally be diffident of his own taste in these arts, disposed to pay a deference to that of others, who have had superior opportunities, and cautious of forming a decision concerning the merit of performances, upon his own feelings, however lively they may be. We often find persons candid enough to decline passing judgment, and to own that they cannot pronounce with impartiality, not only concerning the conduct,

but also concerning the works of a particular person, on account of their friendship for the author, or their enmity against him.

Nor needs it to appear absurd to assert, however oddly it may sound, that in some instances, "a man *ought not* to be pleased when he is, or *ought* to be pleased when he is not" that this may be evinced on solid principles, and that he himself may be convinced of it. This is precisely similar to every case in which reason and reflection are said to correct the reports of the senses. It is well known to philosophers, that many perceptions are ascribed to sight which really belong to touch, that all men think they see certain qualities of bodies, ideas of which only, are, in consequence of habit, suggested by visible appearances. Reason can demonstrate this; but the demonstration can have no influence even on the philosopher in the moment of sensation; he perceives just like other men; and, till he happens to reflect, thinks that he sees the tangible qualities of bodies. Just so, a man may have feelings in the fine arts, which he knows to be wrong, and which his knowing them to be wrong, cannot hinder his continuing to have. This is a remarkable difference between sentiment and opinion: no man can hold an *opinion* for a moment after he has discovered it to be false; but a man may clearly perceive a *sentiment* to be wrong, and yet find it for a long time impossible to abandon it. The firmest conviction of reason cannot prevent a perverted sensation; it must, in spite of that conviction, continue to be received, till the natural peculiarity or the habit which occasions it, be corrected by proper exercise and culture. Men, therefore, who are *affected* differently, may notwithstanding *judge* alike: and men who judge differently, may admit some common principles which serve as a test of both their judgments. Actually to reconcile the feelings, or even the discernment of all men, in matters of taste, is impossible: but it is not therefore impossible to find the means of determining which is sound, which not, and of estimating the degree of excellence or imperfection which belongs to each; or, in other words, to investigate the true standard of taste.

Six

Adam Smith

(1723–1790)

Competing with David Hume as the greatest of the Scottish enlightenment philosophers, Adam Smith is now primarily remembered as the most significant of the founders of modern political economy and among the earliest advocates of the benefits of free trade for increasing the overall wealth of a nation. He took his degree at the University of Glasgow, where he was drawn to natural philosophy until he began to attend the lectures of Francis Hutcheson, who steered him towards subjects in moral philosophy, which at the time would have included the operation of the mind and the acquisition of knowledge. After Glasgow he went to Oxford for two years on a scholarship and devoted his time to the study of rhetoric and *belles lettres*. It is reported that he was put off his planned career in the ministry by the reprimand he received when he was caught reading Hume's *Treatise of Human Nature* by the Master of the college in which he resided. In 1748 he moved to Edinburgh and began lecturing on rhetoric and *belles lettres*, initiating a subject of university instruction that inspired Hugh Blair's celebrated series of lectures on the subject given for many years at Edinburgh. In 1751 Smith was elected to the Chair of Logic at Glasgow University, and in 1752 transferred to the Chair of Moral Philosophy at the same university. His lectures in the latter role were divided into four parts: natural theology, ethics, justice or political philosophy, and political economy. The lectures on ethics provided the material for his *Theory of Moral Sentiments* (1759), and the material of his political economy lectures grew over the years into the basis for his renowned *Wealth of Nations* (1776). Between the publication of these two works, Smith resigned from his chair at Glasgow to become the personal tutor

to the young Duke of Buccleuch. Together with his pupil he travelled extensively in France meeting with many of the leading French philosophers of the day, some of whom — such as A.R.J. Turgot — shared Smith's interest in political economy. In 1766 he returned to his birthplace at Kirkcaldy, near Edinburgh, and spent the next ten years composing *The Wealth of Nations*.

For Smith ethics and aesthetics are intimately connected, and his writings on aesthetic matters are both scatted and interwoven into his *Theory of Moral Sentiments*. The extract that follows clearly illustrates the extension of the scope of aesthetic experience in eighteenth-century Scotland beyond the narrow confines of the fine arts and nature. Smith's subject is how custom and fashion influence our understanding of what is and isn't beautiful, concluding that in large measure beauty is the product of custom and the forces that mould it.

Further Reading

Andrew Ashfield and Peter de Bolla (eds.) *The Sublime: A Reader in Eighteenth Century Aesthetic Theory*, Cambridge: CUP, 1996.

READING IX

THE INFLUENCE OF CUSTOM UPON NOTIONS OF BEAUTY[1]

There are other principles besides those already enumerated, which have a considerable influence upon the moral sentiments of mankind, and are the chief causes of the many irregular and discordant opinions which prevail in different ages and nations concerning what is blameable or praise-worthy. These principles are custom and fashion, principles which extend their dominion over our judgments concerning beauty of every kind.

When two objects have frequently been seen together, the imagination acquires a habit of passing easily from the one to the other. If the first appear, we lay our account that the second is to follow. Of their own accord they put us in mind of one another, and the attention glides easily along them. Though, independent of custom, there should be no real beauty in their union, yet when custom has thus connected them together, we feel an impropriety in their separation. The one we think is awkward when it appears without its usual companion. We miss something which we

[1] From *Theory of Moral Sentiments* (London, 1759).

expected to find, and the habitual arrangement of our ideas is disturbed by the disappointment. A suit of clothes, for example, seems to want something if they are without the most insignificant ornament which usually accompanies them, and we find a meanness or awkwardness in the absence even of a haunch button. When there is any natural propriety in the union, custom increases our sense of it, and makes a different arrangement appear still more disagreeable than it would otherwise seem to be. Those who have been accustomed to see things in a good taste, are more disgusted by whatever is clumsy or awkward. Where the conjunction is improper, custom either diminishes, or takes away altogether, our sense of the impropriety. Those who have been accustomed to slovenly disorder lose all sense of neatness or elegance. The modes of furniture or dress which seem ridiculous to strangers, give no offence to the people who are used to them.

Fashion is different from custom, or rather is a particular species of it. That is not the fashion which everybody wears, but which those wear who are of a high rank, or character. The graceful, the easy, and commanding manners of the great, joined to the usual richness and magnificence of their dress, give a grace to the very form which they happen to bestow upon it. As long as they continue to use this form, it is connected in our imaginations with the idea of something that is genteel and magnificent, and though in itself it should be indifferent, it seems, on account of this relation, to have something about it that is genteel and magnificent too. As soon as they drop it, it loses all the grace, which it had appeared to possess before, and being now used only by the inferior ranks of people, seems to have something of their meanness and awkwardness.

Dress and furniture are allowed by all the world to be entirely under the dominion of custom and fashion. The influence of those principles, however, is by no means confined to so narrow a sphere, but extends itself to whatever is in any respect the object of taste, to music, to poetry, to architecture. The modes of dress and furniture are continually changing, and that fashion appearing ridiculous today which was admired five years ago, we are experimentally convinced that it owed its vogue chiefly or entirely to custom and fashion. Clothes and furniture are not made of very durable materials. A well-fancied coat is done in a twelve-month, and cannot continue longer to propagate, as the fashion, that form according to which it was made. The modes of

furniture change less rapidly than those of dress; because furniture is commonly more durable. In five or six years, however, it generally undergoes an entire revolution, and every man in his own time sees the fashion in this respect change many different ways. The productions of the other arts are much more lasting, and, when happily imagined, may continue to propagate the fashion of their make for a much longer time. A well-contrived building may endure many centuries: a beautiful air may be delivered down by a sort of tradition, through many successive generations: a well-written poem may last as long as the world; and all of them continue for ages together, to give the vogue to that particular style, to that particular taste or manner, according to which each of them was composed. Few men have an opportunity of seeing in their own times the fashion in any of these arts change very considerably. Few men have so much experience and acqaintance with the different modes which have obtained in remote ages and nations, as to be thoroughly reconciled to them, or to judge with impartiality between them, and what takes place in their own age and country. Few men therefore are willing to allow, that custom or fashion have much influence upon their judgments concerning what is beautiful, or otherwise, in the productions of any of those arts; but imagine that all the rules, which they think ought to be observed in each of them, are founded upon reason and nature, not upon habit or prejudice. A very little attention, however, may convince them of the contrary, and satisfy them that the influence of custom and fashion over dress and furniture is not more absolute than over architecture, poetry, and music.

Can any reason, for example, be assigned why the Doric capital should be appropriated to a pillar, whose height is equal to eight diameters; the Ionic volute to one of nine; and the Corinthian foliage to one of ten? The propriety of each of those appropriations can be founded upon nothing but habit and custom. The eye having been used to see a particular proportion connected with a particular ornament, would be offended if they were not joined together. Each of the five orders has its peculiar ornaments, which cannot be changed for any other, without giving offence to all those who know anything of the rules of architecture. According to some architects, indeed, such is the exquisite judgment with which the ancients have assigned to each order its proper ornaments, that no others can be found which are equally suitable. It seems, however, a little difficult to be conceived that these forms,

though, no doubt, extremely agreeable, should be the only forms which can suit those proportions, or that there should not be five hundred others which, antecedent to established custom, would have fitted them equally well. When custom, however, has established particular rules of building, provided they are not absolutely unreasonable, it is absurd to think of altering them for others which are only equally good, or even for others which, in point of elegance and beauty, have naturally some little advantage over them. A man would be ridiculous who should appear in public with a suit of clothes quite different from those which are commonly worn, though the new dress should in itself be ever so graceful or convenient. And there seems to be an absurdity of the same kind in ornamenting a house after a quite different manner from that which custom and fashion have prescribed; though the new ornaments should in themselves be somewhat superior to the common ones.

According to the ancient rhetoricians, a certain measure of verse was by nature appropriated to each particular species of writing, as being naturally expressive of that character, sentiment, or passion, which ought to predominate in it. One verse, they said, was fit for grave and another for gay works, which could not, they thought, be interchanged without the greatest impropriety. The experience of modern times, however, seems to contradict this principle, though in itself it would appear to be extremely probable. What is the burlesque verse in English, is the heroic verse in French. The tragedies of Racine and the *Henriad* of Voltaire, are nearly in the same verse with:

 Let me have your advice in a weighty affair.

The burlesque verse in French, on the contrary, is pretty much the same with the heroic verse of ten syllables in English. Custom has made the one nation associate the ideas of gravity, sublimity, and seriousness, to that measure which the other has connected with whatever is gay, flippant, and ludicrous. Nothing would appear more absurd in English, than a tragedy written in the Alexandrine verses of the French; or in French, than a work of the same kind in verses of ten syllables.

An eminent artist will bring about a considerable change in the established modes of each of those arts, and introduce a new fashion of writing, music, or architecture. As the dress of an agreeable man of high rank recommends itself, and how peculiar and fan-

tastical soever, comes soon to be admired and imitated; so the excellencies of an eminent master recommend his peculiarities, and his manner becomes the fashionable style in the art which he practices. The taste of the Italians in music and architecture has, within these fifty years, undergone a considerable change, from imitating the peculiarities of some eminent masters in each of those arts. Seneca is accused by Quintilian of having corrupted the taste of the Romans, and of having introduced a frivolous prettiness in the room of majestic reason and masculine eloquence. Sallust and Tacitus have by others been charged with the same accusation, though in a different manner. They gave reputation, it is pretended, to a style, which though in the highest degree concise, elegant, expressive, and even poetical, wanted, however, ease, simplicity, and nature, and was evidently the production of the most laboured and studied affectation. How many great qualities must that writer possess, who can thus render his very faults agreeable? After the praise of refining the taste of a nation, the highest eulogy, perhaps, which can be bestowed upon any author, is to say, that he corrupted it. In our own language, Mr Pope and Dr Swift have each of them introduced a manner different from what was practised before, into all works that are written in rhyme, the one in long verses, the other in short. The quaintness of Butler has given place to the plainness of Swift. The rambling freedom of Dryden, and the correct but often tedious and prosaic languor of Addison, are no longer the objects of imitation, but all long verses are now written after the manner of the nervous precision of Mr Pope.

Neither is it only over the productions of the arts, that custom and fashion exert their dominion. They influence our judgments, in the same manner, with regard to the beauty of natural objects. What various and opposite forms are deemed beautiful in different species of things? The proportions which are admired in one animal, are altogether different from those which are esteemed in another. Every class of things has its own peculiar conformation, which is approved of, and has a beauty of its own, distinct from that of every other species. It is upon this account that a learned Jesuit, father Buffier, has determined that the beauty of every object consists in that form and colour, which is most usual among things of that particular sort to which it belongs. Thus, in the human form, the beauty of each feature lies in a certain middle, equally removed from a variety of other forms that are ugly.

A beautiful nose, for example, is one that is neither very long, nor very short, neither very straight, nor very crooked, but a sort of middle among all these extremes, and less different from any one of them, than all of them are from one another. It is the form which Nature seems to have aimed at in them all, which, however, she deviates from in a great variety of ways, and very seldom hits exactly; but to which all those deviations still bear a very strong resemblance. When a number of drawings are made after one pattern, though they may all miss it in some respects, yet they will all resemble it more than they resemble one another; the general character of the pattern will run through them all; the most singular and odd will be those which are most wide of it; and though very few will copy it exactly, yet the most accurate delineations will bear a greater resemblance to the most careless, than the careless ones will bear to one another. In the same manner, in each species of creatures, what is most beautiful bears the strongest characters of the general fabric of the species, and has the strongest resemblance to the greater part of the individuals with which it is classed. Monsters, on the contrary, or what is perfectly deformed, are always most singular and odd, and have the least resemblance to the generality of that species to which they belong. And thus the beauty of each species, though in one sense the rarest of all things, because few individuals hit this middle form exactly, yet in another, is the most common, because all the deviations from it resemble it more than they resemble one another. The most customary form, therefore, is in each species of things, according to him, the most beautiful. And hence it is that a certain practice and experience in contemplating each species of objects is requisite, before we can judge of its beauty, or know wherein the middle and most usual form consists. The nicest judgment concerning the beauty of the human species, will not help us to judge of that of flowers, or horses, or any other species of things. It is for the same reason that in different climates, and where different customs and ways of living take place, as the generality of any species receives a different conformation from those circumstances, so different ideas of its beauty prevail. The beauty of a Moorish is not exactly the same with that of an English horse. What different ideas are formed in different nations concerning the beauty of the human shape and countenance? A fair complexion is a shocking deformity upon the coast of Guinea. Thick lips and a flat nose are a beauty. In some nations long ears that hang

down upon the shoulders are the objects of universal admiration. In China if a lady's foot is so large as to be fit to walk upon, she is regarded as a monster of ugliness. Some of the savage nations in North-America tie four boards round the heads of their children, and thus squeeze them, while the bones are tender and gristly, into a form that is almost perfectly square. Europeans are astonished at the absurd barbarity of this practice, to which some missionaries have imputed the singular stupidity of those nations among whom it prevails. But when they condemn those savages, they do not reflect that the ladies in Europe had, till within these very few years, been endeavouring, for near a century past, to squeeze the beautiful roundness of their natural shape into a square form of the same kind. And that, notwithstanding the many distortions and diseases which this practice was known to occasion, custom had rendered it agreeable among some of the most civilized nations which, perhaps, the world ever beheld.

Such is the system of this learned and ingenious Father, concerning the nature of beauty; of which the whole charm, according to him, would thus seem to arise from its falling in with the habits which custom had impressed upon the imagination, with regard to things of each particular kind. I cannot, however, be induced to believe that our sense even of external beauty is founded altogether on custom. The utility of any form, its fitness for the useful purposes for which it was intended, evidently recommends it, and renders it agreeable to us, independent of custom. Certain colours are more agreeable than others, and give more delight to the eye the first time it ever beholds them. A smooth surface is more agreeable than a rough one. Variety is more pleasing than a tedious undiversified uniformity. Connected variety, in which each new appearance seems to be introduced by what went before it, and in which all the adjoining parts seem to have some natural relation to one another, is more agreeable than a disjointed and disorderly assemblage of unconnected objects. But though I cannot admit that custom is the sole principle of beauty, yet I can so far allow the truth of this ingenious system as to grant, that there is scarce any one external form so beautiful as to please, if quite contrary to custom and unlike whatever we have been used to in that particular species of things: or so deformed as not to be agreeable, if custom uniformly supports it, and habituates us to see it in every single individual of the kind.

Henry Home, Lord Kames

(1696–1782)

Henry Home, a cousin of David Hume's (whose name was also, at an earlier time, rendered as Home), became Lord Kames in 1752 when he was appointed to the bench of the Courts of Session in Edinburgh after a long and distinguished career as an advocate, legal philosopher and chronicler. Although less famous today, he was one of the truly remarkable intellects of the Scottish enlightenment, and was to be found at the centre of the intellectual culture of Edinburgh in his day. In addition to his legal duties he wrote extensively on subjects of law, history, agricultural reform, and philosophy. His contribution to aesthetics consists of his extensive work, *The Elements of Criticism*, which for many decades was a standard textbook of rhetoric and style — thirty-six editions of the work were printed in the decades after its publication — as well as a theoretical account of the main aesthetic questions of the day.

Despite his close association with Hume, Kames' thought is closer to Hutcheson and Gerard, and openly critical of his cousin. Neither of the extracts reproduced here indicate a very original thinker, but rather someone who is systematising elements taken from elsewhere and at times avoiding the really challenging questions. Nevertheless, Kames' arguments are an important part of the dialogue of ideas about taste and beauty in eighteenth-century Scotland. A nineteenth-century commentator on Kames' aesthetics provides a fair estimation of his strengths and weaknesses:

The *Elements of Criticism* is a book no man can read without acquiring many new ideas . . . it is full of useful information, just criticism, and ingenious reasoning, laying down rules of composition and thought . . . the author is, however, a serious transgressor of his own excellent rules; his mind seems to have been so perpetually filled with ideas, that the obstruction occasioned by the arrangement of a sentence would cause a considerable interruption in their flow; hence he is at all times a brief, unmelodious composer.

Further Reading

William Lehman, *Henry Home, Lord Kames, and the Scottish Enlightenment*, The Hague: Martin Nijhoff, 1971.

John V. Price's 'Introduction' to Kames' *The Elements of Criticism*, Thoemmes Reprints, London: Routledge, 1993.

READING X

BEAUTY[1]

Having discoursed in general of emotions and passions, I proceed to a more narrow inspection of some particulars that serve to unfold the principles of the fine arts. It is the province of a writer upon ethics, to give a full enumeration of all the passions; and of each separately to assign the nature, the cause, the gratification, and the effect. But a treatise of ethics is not my province. I carry my view no farther than to the elements of criticism, in order to show that the fine arts are a subject of reasoning as well as of taste. An extensive work would be ill suited to a design so limited; and to keep within moderate bounds, the following plan may contribute. It has already been observed, that things are the causes of emotions, by means of their properties and attributes. This furnishes a hint for distribution. Instead of a painful and tedious examination of the several passions and emotions, I propose to confine my inquiries to such attributes, relations, and circumstances, as in the fine arts are chiefly employed to raise agreeable emotions. Attributes of single objects, as the most simple, shall take the lead; to be followed with particulars that depend on the relations of objects, and are not found in any one object singly considered. Dispatching next some coincident matters, I approach nearer to practice, by applying the principles unfolded in the foregoing parts of the work. This is a general view

[1] From *The Elements of Criticism* (1762).

of the intended method; reserving however a privilege to vary it in particular instances, where a different method may be more commodious. I begin with beauty, the most noted of all the qualities that belong to single objects.

The term *beauty,* in its native signification, is appropriated to objects of sight. Objects of the other senses may be agreeable, such as the sounds of musical instruments, the smoothness and softness of some surfaces: but the agreeableness denominated *beauty* belongs to objects of sight.

Of all the objects of the external senses, an object of sight is the most complex. In the very simplest, colour is perceived, figure, and length, breadth and thickness. A tree is composed of a trunk, branches, and leaves. It has colour, figure, size, and sometimes motion. By means of each of these particulars, separately considered, it appears beautiful: how much more so, when they enter all into one complex perception? The beauty of the human figure is extraordinary, being a composition of numberless beauties arising from the parts and qualities of the object, various colours, various motions, figure, size, etc.; all uniting in one complex perception, and striking the eye with combined force. Hence it is, that beauty, a quality so remarkable in visible objects, lends its name to express everything that is eminently agreeable. Thus, by a figure of speech, we say a beautiful sound, a beautiful thought or expression, a beautiful theorem, a beautiful event, a beautiful discovery in art or science. But as figurative expression is not our present theme, this chapter is confined to beauty in its genuine signification.

It is natural to suppose, that a perception so various as that of beauty, comprehending sometimes many particulars, sometimes few, should occasion emotions equally various. And yet all the various emotions of beauty maintain one general character of sweetness and gaiety.

Considering attentively the beauty of visible objects, we discover two kinds. One may be termed *intrinsic* beauty, because it is discovered in a single object viewed apart without relation to any other object. The examples above given, are of that kind. The other may be termed *relative* beauty, being founded on the relation of objects. The former is a perception of sense merely; for to perceive the beauty of a spreading oak or of a flowing river, no more is required but singly an act of vision. The latter is accompanied with an act of understanding and reflection; for of a fine

instrument or engine, we perceive not the relative beauty, until we be made acquainted with its use and destination. In a word, intrinsic beauty is ultimate: relative beauty is that of means relating to some good end or purpose. These different beauties agree in one capital circumstance, that both are equally perceived as spread upon the object. This will be readily admitted with respect to intrinsic beauty; but is not so obvious with respect to the other. The utility of the plough, for example, may make it an object of admiration or of desire; but why should utility make it appear beautiful? A principle mentioned above, will explain this doubt. The beauty of the effect, by an early transition of ideas, is transferred to the cause, and is perceived as one of the qualities of the cause. Thus a subject void of intrinsic beauty, appears beautiful from its utility. An old Gothic tower that has no beauty in itself, appears beautiful, considered as proper to defend against an enemy. A dwelling-house void of all regularity, is however beautiful in the view of convenience; and the want of form or symmetry in a tree, will not prevent its appearing beautiful, if it be known to produce good fruit.

When these two beauties concur in any object, it appears delightful. Every member of the human body possesses both in a high degree. The slender make of a horse destined for running, pleases every taste; partly from symmetry, and partly from utility.

The beauty of utility, being proportioned accurately to the degree of utility, requires no illustration. But intrinsic beauty, so complex as I have said, cannot be handled distinctly without being analysed into its constituent parts. If a tree be beautiful by means of its colour, its figure, its size, its motion, it is in reality possessed of so many different beauties, which ought to be examined separately, in order to have a clear notion of the whole. The beauty of colour is too familiar to need explanation. The beauty of figure requires an accurate discussion, for in it many circumstances are involved. When any portion of matter is viewed as a whole, the beauty of its figure arises from regularity and simplicity. Viewing the parts with relation to each other, uniformity, proportion, and order, contribute to its beauty. The beauty of motion deserves a chapter by itself; and another chapter is destined for grandeur, being distinguishable from beauty in a strict sense. For the definitions of regularity, uniformity, proportion, and order, if thought necessary, I remit my reader to the appendix at the end of the book. Upon simplicity I must make a few cursory observa-

tions, such as may be of use in examining the beauty of single objects.

A multitude of objects crowding into the mind at once, disturb the attention, and pass without making any impression, or any lasting impression. In a group, no single object makes the figure it would do apart, when it occupies the whole attention. For the same reason, even a single object, when it divides the attention by the multiplicity of its parts, equals not, in strength of impression, a more simple object comprehended in a single view. Parts extremely complex must be considered in portions successively; and a number of impressions in succession, which cannot unite because not simultaneous, never touch the mind like one entire impression made as it were at one stroke. This justifies simplicity in works of art, as opposed to complicated circumstances and crowded ornaments. There is an additional reason for simplicity, in works that make an impression of dignity or elevation. The mind attached to beauties of a high rank, cannot descend to inferior beauties. And yet, notwithstanding these reasons, we find profuse decoration prevailing in works of art. But this is no argument against simplicity. For authors and architects who cannot reach the higher beauties, endeavour to supply their want of genius by dealing in those that are inferior. In all ages, the best writers and artists have been governed by a taste for simplicity.

These things premised, I proceed to examine the beauty of figure, as arising from the above-mentioned particulars, *viz.* regularity, uniformity, proportion, order, and simplicity. To exhaust this subject, would of itself require a large volume. I limit myself to a few cursory remarks, as matter for future disquisition. To inquire why an object, by means of the particulars mentioned, appears beautiful, would I am afraid be a vain attempt. It seems the most probable opinion, that the nature of man was originally framed with a relish for them, in order to answer wise and good purposes. The final causes have not hitherto been ascertained, though they are not probably beyond our reach. One thing is clear, that regularity, uniformity, order, and simplicity, contribute each of them to readiness of apprehension; and enable us to form more distinct images of objects, than can be done with the utmost attention where these particulars are not found. This final cause is, I acknowledge, too slight, to account satisfactorily for a taste that makes a figure so illustrious in the nature of man. That this branch of our constitution has a purpose still more important, we have

great reason to believe. With respect to proportion, I am still less successful. In several instances, accurate proportion is connected with utility. This in particular is the case of animals; for those that are the best proportioned, are the strongest and most active. But instances are still more numerous, where the proportions we relish the most, have no connection, so far as we see, with utility. Writers on architecture insist much upon the proportions of a column; and assign different proportions to the Doric, Ionic, and Corinthian. But no architect will maintain, that the most accurate proportions contribute more to use, than several that are less accurate and less agreeable. Neither will it be maintained, that the proportions assigned for the length breadth and height of rooms, tend to make them the more commodious. It appears then, so far as we can discover, that we have a taste for proportion independent altogether of utility. One thing indeed is certain, that any external object proportioned to our taste, is delightful. This furnishes a hint. May it not be thought a good final cause of proportion, that it contributes to our entertainment? The author of our nature has given many signal proofs, that this end is not below his care. And if so, why should we hesitate in assigning this as an additional final cause of regularity, and the other particulars above mentioned? We may be confirmed in this thought, by reflecting, that our taste, with respect to these, is not occasional or accidental, but uniform and universal, making an original branch of human nature.

One might fill a volume with the effects that are produced by the endless combinations of the principles of beauty. I have room only for a slight specimen, confined to the simplest figures. A circle and a square are each of them perfectly regular, being equally confined to a precise form, and admitting not the slightest variation. A square however is less beautiful than a circle, because it is less simple. A circle has parts as well as a square; but its parts not being distinct like those of a square, it makes one entire impression; whereas the attention is divided among the sides and angles of a square. The effect of simplicity may be illustrated by another example. A square, though not more regular than a hexagon or octagon, is more beautiful than either; for what other reason, than that a square is more simple, and the attention less divided? This reasoning will appear still more solid when we consider any regular polygon of very many sides; for of such figure the mind can

never have any distinct perception. Simplicity thus contributes to beauty.

A square is more beautiful than a parallelogram. The former exceeds the latter in regularity and in uniformity of parts. But this holds with respect to intrinsic beauty only; for in many instances, utility comes in to cast the balance on the side of the parallelogram. This figure for the doors and windows of a dwelling-house, is preferred because of utility; and here we find the beauty of utility prevailing over that of regularity and uniformity.

A parallelogram again depends, for its beauty, on the proportion of its sides. The beauty is lost by a great inequality of sides. It is also lost, on the other hand, by the approximation toward equality. Proportion in this circumstance degenerates into imperfect uniformity; and the figure upon the whole appears an unsuccessful attempt toward a square.

An equilateral triangle yields not to a square in regularity nor in uniformity of parts, and it is more simple. But an equilateral triangle is less beautiful than a square, which must be owing to inferiority of order in the position of its parts. The sides of an equilateral triangle incline to each other in the same angle, which is the most perfect order they are susceptible of. But this order is obscure, and far from being so perfect as the parallelism of the sides of a square. Thus order contributes to the beauty of visible objects, not less than simplicity and regularity.

A parallelogram exceeds an equilateral triangle in the orderly disposition of its parts; but being inferior in uniformity and simplicity, it is less beautiful.

Uniformity is singular in one capital circumstance, that it is apt to disgust by excess. A number of things contrived for the same use, such as chairs spoons, etc. cannot be too uniform. But a scrupulous uniformity of parts in a large garden or field, is far from being agreeable. Uniformity among connected objects, belongs not to the present subject. It is handled in the chapter of uniformity and variety.

In all the works of nature, simplicity makes an illustrious figure. The works of the best artists are directed by it. Profuse ornament in painting, gardening, or architecture, as well as in dress and language, shows a mean or corrupted taste.

Poets, like painters, thus unskilled to trace
The naked nature and the living grace,

> With gold and jewels cover every part,
> And hide with ornaments their want of art.

No one property recommends a machine more than its simplicity; not singly for better answering its purpose, but by appearing in itself more beautiful. Simplicity has a capital effect in behaviour and manners; no other particular contributing more to gain esteem and love. The artificial and intricate manners of modern times, have little of dignity in them. General theorems, abstracting from their importance, are delightful by their simplicity, and by the easiness of their application to a variety of cases. We take equal delight in the laws of motion, which, with the greatest simplicity, are boundless in their influence

A gradual progress from simplicity to complex forms and profuse ornament, seems to be the fate of all the fine arts; resembling behaviour, which from original candour and simplicity has degenerated into artificial refinements. At present, written productions are crowded with words, epithets, figures, etc. In music, sentiment is neglected, for the luxury of harmony, and for difficult movement which surprises in its execution. In *taste* properly so called, poignant sauces with complicated mixtures of different flavours, prevail among people of condition. The French, accustomed to the artificial red on their women's cheeks, think the modest colouring of nature displayed on a fine face altogether insipid.

The same tendency appears in the progress of the arts among the ancients. Of this we have traces still remaining in architecture. Some vestige of the oldest Grecian buildings prove them to be of the Doric order. The Ionic succeeded, and seems to have been the favourite order, while architecture was in its height of glory. The Corinthian came next in vogue: and in Greece, the buildings of that order appear mostly to have been erected after the Romans got footing there. At last came the Composite with all its extravagances, where proportion is sacrificed to finery and crowded ornament.

But what taste is to prevail next? For fashion is in a continual flux, and taste must vary with it. After rich and profuse ornaments become familiar, simplicity appears by contrast lifeless and insipid. This would be an insurmountable obstruction, should any man of genius and taste endeavour to restore ancient simplicity.

In reviewing what is said above, I am under some apprehension of an objection, which, as it may possibly occur to the reader, ought to be obviated. A mountain, it will be observed, is an agreeable object, without so much as the appearance of regularity; and a chain of mountains still more agreeable, without being arranged in any order. But these facts considered in a proper light, afford not an objection. Regularity, order, and uniformity, are intimately connected with beauty; and in this view only, have I treated them. Every regular object, for example, must in respect of its regularity be beautiful. But I have not said, that regularity, order, and uniformity, are essential to beauty, so as that it cannot exist without them. The contrary appears in the beauty of colour. Far less have I said, that an object cannot be agreeable in any respect independent of these qualities. Grandeur, as distinguished from beauty, requires very little regularity. This will appear more fully when that article is handled. In the mean time, to show the difference betwixt beauty and grandeur with respect to regularity, I shall give a few examples. Imagine a small body, let it be a globe, in a continual flux of figure, from the most perfect regularity till there remain no appearance of that quality. The beauty of this globe, depending on its regular figure, will gradually wear away with its regularity; and when it is no longer regular, it no longer will appear beautiful. The next example shall be of the same globe, gradually enlarging its sizes, but retaining its figure. In this body, we at first perceive the beauty of regularity only. But so soon as it begins to swell into a great size, it appears agreeable by its greatness, which joins with the beauty of regularity to make it a delightful object. In the last place, let it be imagined, that the figure as well as the quantity of matter are in a continual flux; and that the body, while it increases in size, becomes less and less regular, till it lose altogether the appearance of that quality. In this case, the beauty of regularity wearing off gradually, gives place to an agreeableness of a different sort, *viz.* that of greatness: and at last the emotion arising from greatness will be in perfection, when the beauty of regularity is gone. Hence it is, that in a large object the want of regularity is not much regarded by the spectator who is struck with its grandeur. A swelling eminence is agreeable, though not strictly regular. A towering hill is delightful, if it have but any distant resemblance of a cone. A small surface ought to be smooth; but in a wide-extended plain, considerable inequalities are overlooked. This observation holds equally in works of art.

The slightest irregularity in a house of a moderate size hurts the eye; while the mind, struck with the grandeur of a superb edifice, which occupies it totally, cannot bear to descend to its irregularities unless extremely gross. In a large volume we pardon many defects that would make an epigram intolerable. In short, the observation holds in general, that beauty is connected with regularity in great objects as well as in small; but with a remarkable difference, that in passing from small to great, regularity is less and less required.

The distinction betwixt primary and secondary qualities in matter, seems now fully established. Heat and cold, though seeming to exist in bodies, are discovered to be effects caused by these bodies in a sensitive being. Colour, which the eye represents as spread upon a substance, has no existence but in the mind of the spectator. Perceptions of this kind, which, by a delusion of sense, are attributed to external subjects, are termed *secondary qualities,* in contradistinction to figure, extension, solidity, which are primary qualities, and which are not separable, even in imagination, from the subjects they belong to. This suggests a curious inquiry: whether beauty be a primary or only a secondary quality of objects? The question is easily determined with respect to the beauty of colour; for if colour be a secondary quality existing nowhere but in the mind of the spectator, its beauty must be of the same kind. This conclusion must also hold with respect to the beauty of utility, which is plainly a conception of the mind, arising not merely from sight, but from reflecting that the thing is fitted for some good end or purpose. The question is more intricate with respect to the beauty of regularity. If regularity be a primary quality, why not also its beauty? That this is not a good consequence, will appear from considering, that beauty, in its very conception, refers to a percipient; for an object is said to be beautiful, for no other reason but that it appears so to a spectator. The same piece of matter which to man appears beautiful, may possibly to another being appear ugly. Beauty therefore, which for its existence depends upon the percipient as much as upon the object perceived, cannot be an inherent property of either. What else then can it be, but a perception in the mind occasioned by certain objects? The same reasoning is applicable to the beauty of order, of uniformity, of grandeur. Accordingly, it may be pronounced in general, that beauty in no case whatever is a real quality of matter. And hence it is wittily observed by the poet, that beauty is not in

the continence, but in the lover's eye. This reasoning is undoubtedly solid: and the only case of doubt or hesitation is, that we are taught a different lesson by sense. By a singular determination of nature, we perceive both beauty and colour as belonging to the object; and, like figure or extension, as inherent properties. This mechanism is uncommon; and when nature, to fulfil her intention, chooses any singular method of operation, we may be certain of some final cause that cannot be reached by ordinary means. It appears to me, that a perception of beauty in external objects is requisite to attach us to them. Does not this mechanism, in the first place, greatly promote industry, by prompting a desire to possess things that are beautiful? Does it not further join with utility, in prompting us to embellish our houses and enrich our fields? These however are but slight effects, compared with the connections which are formed among individuals in society by means of this singular mechanism. The qualifications of the head and heart, are undoubtedly the most solid and most permanent foundations of such connections. But as external beauty lies more in view, and is more obvious to the bulk of mankind than the qualities now mentioned, the sense of beauty possesses the more universal influence in forming these connections. At any rate, it concurs in any eminent degree with mental qualifications, to produce social intercourse, mutual good-will, and consequently mutual aid and support, which are the life of society.

It must not however be overlooked, that this sense does not tend to advance the interests of society, but when in a due mean with respect to strength. Love in particular arising from a sense of beauty, loses, when excessive, its sociable character. The appetite for gratification, prevailing over affection for the beloved object, is ungovernable; and tends violently to its end, regardless of the misery that must follow. Love in this state is no longer a sweet agreeable passion. It becomes painful like hunger or thirst; and produces no happiness but in the instant of fruition. This discovery suggests a most important lesson, that moderation in our desire and appetites, which fits us for doing our duty, contributes at the same time the most so happiness. Even social passions, when moderate, are more pleasant than when they swell beyond proper bounds.

READING XI

THE STANDARD OF TASTE[2]

That there is no disputing about 'taste', meaning taste in its most extensive sense, is a saying so generally received as to have become a proverb. One thing indeed is evident, that if the proverb hold true with respect to any one external sense, it must hold true with respect to all. If the pleasures of the palate disdain a comparative trial and reject all criticism, the pleasures of touch, of smell, of sound, and even of sight, must be equally privileged. At this rate, a man is not within the reach of censure, even where, insensible to beauty, grandeur, or elegance, he prefers the Saracen's head upon a sign-post before the best tablature of Raphael, or a rude Gothic tower before the finest Grecian building: nor where he prefers the smell of a rotten carcass before that of the most odoriferous flower: not jarring discords before the most exquisite harmony.

But we must not stop here. If the pleasure of external sense be exempted from criticism, why not every one of our pleasures, from whatever source derived? If taste in the proper sense of the word cannot be disputed, there is as little room for disputing it in its figurative sense. The proverb accordingly comprehends both; and in that large sense may be resolved into the following general proposition, That with respect to the sensitive part of our nature, by which some objects are agreeable some disagreeable, there is not such a thing as a *good* or *bad*, *a right* or *wrong*; that every man's taste is to himself an ultimate standard without appeal; and consequently that there is no ground of censure against any one, if such a one there be, who prefers Blackmore before Homer, selfishness before benevolence, or cowardice before magnanimity.

The proverb in the foregoing instances, is indeed carried very far. It seems difficult, however, to sap its foundation, or with success to attack it from any quarter. For in comparing the various tastes of individuals, it is not obvious what standard must be appealed to. Is not every man equally a judge of what is agreeable or disagreeable to himself. Does it not seem odd, and perhaps absurd, that a man *ought not* to be pleased when he is, or that he *ought* to be pleased when he is not?

[2] From *The Elements of Criticism* (Edinburgh, 1762).

This reasoning may perplex, but, in contradiction to sense and feeling, will never afford conviction. A man of taste must necessarily feel the reasoning to be false, however unqualified to detect the fallacy. At the same time, though no man of taste will subscribe to the proverb as holding true in every case, no man will venture to affirm that it holds true in no case. Subjects there are undoubtedly, that we may like or dislike indifferently, without any imputation upon our taste. Were a philosopher to make scale for human pleasures with many divisions, in order that the value of each pleasure may be denoted by the place it occupies, he would not think of making divisions without end, but would rank together many pleasures arising perhaps from different objects, either as being equally valuable, or differing so imperceptibly as to make a separation unnecessary. Nature has taken this course, so far as appears to the generality of mankind. There may be subdivisions without end; but we are only sensible of the grosser divisions, comprehending each of them many pleasures of various kinds. To these the proverb is applicable in the strictest sense; for with respect to pleasures of the same rank, what ground can there be for preferring one before another? If a preference in fact be given by any individual, it cannot be taste, but custom, imitation, or some peculiarity of mind.

Nature in her scale of pleasure, has been sparing of divisions: she has wisely and benevolently filled every division with many pleasures; in order that individuals may be contented with their own lot, without envying the happiness of others: many hands must be employed to procure us the conveniences of life; and it is necessary that the different branches of business, whether more or less agreeable, be filled with hands. A taste too nice and delicate, would obstruct this plan; for it would crowd some employment, leaving others, not less useful, totally neglected. In our present condition, happy it is, that the plurality are not delicate in their choice. They fall in readily with the occupations, pleasures, food, and company, that fortune throws in their way; and if at first there be any displeasing circumstance, custom soon makes it easy.

The proverb will be admitted so far as it regards the particulars now explained. But when applied in general to every subject of taste, the difficulties to be encountered are insuperable. What shall we say, in particular, as to the difficulty that arises from human nature itself? Do we not talk of a good and a bad taste, of a

right and a wrong taste? And upon that supposition, do we not, with great confidence, censure writers, painters, architects, and every one who deals in the fine arts? Are such criticisms absurd and void of foundation? Have the foregoing expressions, familiar in all languages and among all people, no sort of meaning? This can hardly be: what is universal must have a foundation in nature. If we can reach this foundation, the standard of taste will no longer be a secret.

All living creatures are by nature distributed into classes; the individuals of each, however diversified by slighter differences, having a wonderful uniformity in their capital parts internal and external. Each class is distinguishable from others by an external form, and not less distinguishable by an internal constitution, manifested by certain powers, feelings, desires, and actions, peculiar to the individuals of each class. Thus each class may be conceived to have a common nature, which, in framing the individuals belonging to the class, is taken for a model or standard.

Independent altogether of experience, men have a sense of conviction of a common nature or standard, not only in their own species, but in every species of animals. And hence it is a matter of wonder, to find any individual deviating from the common nature of the species, whether in its internal or external construction: a child born with an aversion to its mother's milk, is a matter of wonder, not less than if born without a mouth, or with more than one.

With respect to this common nature or standard, we are so constituted as to conceive it to be *perfect* or *right*; and consequently that individuals *ought* to be made conformable to it. Every remarkable deviation accordingly from the standard, makes an impression upon us of imperfection, irregularity, or disorder: it is disagreeable and raises in us a painful emotion: monstrous births, exciting the curiosity of a philosopher, fail not at the same time to excite aversion in a high degree.

Lastly, we have a conviction, that the common nature of man is invariable not less than universal: we conceive that it has no relation to time nor to place; but that it will be the same hereafter as at present, and as it was in time past; the same among all nations and in all corners of the earth. Nor are we deceived: giving allowance for the difference of culture and gradual refinement of manners, the fact corresponds to our conviction.

This conviction of a common nature or standard, and of its perfection, is the foundation of morality; and accounts clearly for that remarkable conception we have, of a right and a wrong taste in morals. It accounts not less clearly for the conception we have of a right and a wrong taste in the fine arts. A person who rejects objects generally agreeable, and delights in objects generally disagreeable, is condemned as a monster: we disapprove his taste as bad or wrong; and we have a clear conception that he deviates from the common standard. If man were so framed as not to have any notion of a common standard, the proverb mentioned in the beginning would hold universally, not only in the fine arts but in morals: upon that supposition, the taste of every man, with respect to both, would to himself be an ultimate standard. But the conviction of a common standard being made a part of our nature, we intuitively conceive a taste to be right or good if conformable to the common standard, and wrong or bad if disconformable.

No particular concerning human nature is more universal, than the uneasiness a man feels when in matters of importance his opinions are rejected by others. Why should difference in opinion create uneasiness, more than difference in stature, in countenance, or in dress? The sense of a common standard is the only principle that can explain this mystery. Every man, generally speaking, taking it for granted that his opinions agree with the common sense of mankind, is therefore disgusted with those of a contrary opinion, not as differing from him, but as differing from the common standard. Hence in all disputes, we find the parties, each of them equally, appealing constantly to the common sense of mankind as the ultimate rule or standard. Were it not for this standard, of which the conviction is universal, I cannot discover the slightest foundation for rancour or animosity when persons differ in essential points more than in points purely indifferent. With respect to the latter, which are not supposed to be regulated by any standard, individuals are permitted to think for themselves with impunity. The same liberty is not indulged with respect to the former; for what reason, other than that the standard by which these are regulated, ought, as we judge, to produce a uniformity of opinion in all men? In a word, to this sense of a common standard must be wholly attributed the pleasure we take in those who espouse the same principles and opinions with ourselves, as well as the aversion we have at those who differ from us. In matters left indifferent by the standard, we find nothing of the

same pleasure or pain. A bookish man, unless swayed by convenience, relishes not the contemplative more than the active part of mankind: his friends and companions are chosen indifferently out of either class. A painter consorts with a poet or musician, as readily as with those of his own art; and one is not the more agreeable to me for loving beef, as I do, nor the less agreeable for preferring mutton.

I have said, that my disgust is raised, not by differing from me, but by differing from what I judge to be the common standard. This point, being of importance, ought to be firmly established. Men, it is true, are prone to flatter themselves, by taking it for granted, that their opinions and their taste are in all respects agreeable to the common standard. But there may be exceptions, and experience shows there are some. There are instances without number, of persons who cling to the grosser amusements of gaming, eating, drinking, without having any relish for more elegant pleasures, such, for example, as are afforded by the fine arts. Yet these very persons, taking the same language with the rest of mankind, pronounce in favour of the more elegant pleasures: they invariably approve those who have a more refined taste, and are ashamed of their own as low and sensual. It is in vain to think of giving a reason for this singular impartiality against self, other than the authority of the common standard. Every individual of the human species, the most grovelling not excepted, has a natural sense of the dignity of human nature. Hence every man is esteemed and respected in proportion to the dignity of his character, sentiments, and actions. And from the instances now given we discover, that the sense of the dignity of human nature is so vigorous, as even to prevail over self-partiality, and to make us despise our own taste compared with the more elevated taste of others.

In our sense of a common standard and in the pleasure individuals give us by their conformity to it, a curious final cause is discovered. A uniformity of taste and sentiment in matters of importance, forms an intimate connection among individuals, and is a great blessing in the social state. With respect to morals in particular, unhappy it would be for mankind did not this uniformity prevail: it is necessary that the actions of all men be uniform with respect to right and wrong; and in order to uniformity of action, it is necessary that all men think the same way in these particulars: if they differ through any irregular bias, the common sense of mankind is appealed to as the rule; and it is the province

of judges, in matters especially of equity, to apply that rule. The same uniformity, it is yielded, is not so strictly necessary in other matters of taste: men, though connected in general as members of the same state, are, by birth, office, or occupation, separated and distinguished into different classes; and are thereby qualified for different amusements: variety of taste, so far, is no obstruction to the general connection. But with respect to the more capital pleasures, such as are best enjoyed in common, uniformity of taste is necessary for two great ends, first to connect individuals the more intimately in the social life, and next to advance these pleasures to their highest perfection. With respect to the first, if instead of a common taste, every man had a taste peculiar to himself, leading him to place his happiness upon things indifferent or perhaps disagreeable to others, these capital pleasures could not be enjoyed in common: every man would pursue his own happiness by flying from others; and instead of a natural tendency to union, remarkable in the human species, union would be our aversion: man would not be a consistent being: his interest would lead him to society, and his taste would draw him from it. The other end will be best explained by entering upon particulars. Uniformity of taste gives opportunity for sumptuous and elegant buildings, for fine gardens, and extensive embellishments, which please universally. Works of this nature could never have reached any degree of perfection, had every man a taste peculiar to himself: there could not be any suitable reward, either of profit or honour, to encourage men of genius to labour in such works. The same uniformity of taste is equally necessary to perfect the arts of music, sculpture, and painting, and to support the expense they require after they are brought to perfection. Nature is in every particular consistent with herself. We are formed by nature to have a high relish for the fine arts, which are a great source of happiness, and extremely friendly to virtue. We are, at the same time, formed with a uniformity of taste, to furnish proper objects for this high relish: if uniformity of taste did not prevail, the fine arts could never have made any figure.

 Thus, upon a sense common to the species, is erected a standard of taste, which without hesitation is applied to the taste of every individual. This standard, ascertaining what actions are right what wrong, what proper what improper, has enabled moralists to establish rules for our conduct from which no person is allowed to swerve. We have the same standard for ascertaining in all the

fine arts, what is beautiful or ugly, high or low, proper or improper, proportioned or disproportioned. And here, as in morals, we justly condemn every taste that swerves from what is thus ascertained by the common standard.

The discovery of a rule or standard for trying the taste of individuals in the fine arts as well as in morals, is a considerable advance, but completes not our journey. We have a great way yet to travel. It is made out that there is a standard: but it is not made out, by what means we shall prevent mistaking a false standard for that of nature. If from opinion and practice we endeavour to ascertain the standard of nature, we are betrayed into endless perplexities. Viewing this matter historically, nothing appears more various and more wavering than taste in the fine arts. If we judge by numbers, the Gothic taste of architecture will be preferred before that of Greece; and the Chinese taste probably before both. It would be endless, to recount the various tastes of gardening that have prevailed in different ages, and still prevail in different countries. Despising the modest colouring of nature, women of fashion in France daub their cheeks with a red powder. Nay, the unnatural swelling in the neck, a disease peculiar to the inhabitants of the Alps, is relished by that people. But we ought not to be discouraged by such untoward instances. For do we not find the like contradictions with respect to morals? Was it not once held lawful, for a man to expose his infant children, and, when grown up, to sell them for slaves? Was it not held equally lawful, to punish children for the crime of their parents? Was not the murder of an enemy in cold blood a universal practice? What stronger instance can be given, than the abominable practice of human sacrifices, not less impious than immoral? Such aberrations from the rules of morality, prove only, that men, originally savage and brutish, acquire not rationality or any delicacy of taste, till they be long disciplined in society. To ascertain the rules of morality, we appeal not to the common sense of savages, but of men in their more perfect state: and we make the same appeal, in forming the rules that ought to govern the fine arts. In neither can we safely rely on a local or transitory taste; but on what is the most universal and the most lasting among polite nations.

In this very manner, a standard for morals has been established with a good deal of accuracy; and so well fitted for practice, that in the hands of able judges it is daily applied with general satisfaction. The standard of taste in the fine arts, is not yet brought to

such perfection. And there is an obvious reason for its slower progress. The sense of a right and a wrong in action, is conspicuous in the breast of every individual, almost without exception. The sense of a right and a wrong in the fine arts, is more faint and wavering: it is by nature a tender plant, requiring much culture to bring it to maturity: in a barren soil it cannot live; and in any soil, without cultivation, it is weak and sickly. I talk chiefly with relation to its more refined objects: for some objects make such lively impressions of beauty, grandeur, and proportion, as without exception to command the general taste. There appears to me great contrivance, in distinguishing thus the moral sense from a taste in the fine arts. The former, as a rule of conduct and as a law we ought to obey, must be clear and authoritative. The latter is not entitled to the same authority, since it contributes to our pleasure and amusement only. Were it more strong and lively, it would usurp upon our duty, and call off the attention from matters of greater moment. Were it more clear and authoritative, it would banish all difference of taste: a refined taste would not form a character, nor be entitled to esteem. This would put an end to rivalship, and consequently to all improvement.

But to return to our subject. However languid and cloudy the common sense of mankind may be with respect to the fine arts, it is yet the only standard in these as well as in morals. And when the matter is attentively considered, this standard will be found less imperfect than it appears to be at first sight. In gathering the common sense of mankind upon morals, we may safely consult every individual. But with respect to the fine arts, our method must be different: a wary choice is necessary; for to collect votes indifferently, will certainly mislead us: those who depend for food on bodily labour, are totally void of taste; of such a taste at least as can be of use in the fine arts. This consideration bars the greater part of mankind; and of the remaining part, many have their taste corrupted to such a degree as to unqualify them altogether for voting. The common sense of mankind must then be confined to the few that fall not under these exceptions. But as such selection seems to throw matters again into uncertainty, we must be more explicit upon this branch of our subject.

Nothing tends more than voluptuousness to corrupt the whole internal frame, and to vitiate our taste, not only in the fine arts, but even in morals. It never fails, in course of time, to extinguish all the sympathetic affections, and to bring on a beastly selfishness

which leaves nothing of man but the shape. About excluding persons of this stamp there will be no dispute. Let us next bring under trial, the opulent whose chief pleasure is expense. Riches, coveted by most men for the sake of superiority and to command respect, are generally bestowed upon costly furniture, numerous attendants, a princely dwelling, every thing superb and gorgeous, to amaze and humble all beholders. Simplicity, elegance, propriety, and everything natural, sweet, or amiable, are despised or neglected; for these are not at the command of riches, and make no figure in the public eye. In a word, nothing is relished, but what serves to gratify pride, by an imagined exaltation of the possessor above those he reckons the vulgar. Such a tenor of life contracts the heart and makes every principle give way to self-interest. Benevolence and public spirit, with all their refined emotions, are little felt and less regarded. And if these be excluded, there can be no place for the faint and delicate emotions of the fine arts.

The exclusion of classes so many and various, reduce within a narrow compass those who are qualified to be judges in the fine arts. Many circumstances are necessary to form a judge of this sort: there must be a good natural taste: this taste must be improved by education, reflection, and experience: it must be preserved alive, by a regular course of life, by using the goods of fortune with moderation, and by following the dictates of improved nature which gives welcome to every rational pleasure without deviating into excess. This is the tenor of life which of all contributes the most to refinement of taste; and the same tenor of life contributes the most to happiness in general.

If there appear much uncertainty in a standard that requires so painful and intricate a selection, we may possibly be reconciled to it by the following consideration, that, with respect to the fine arts, there is less difference of taste than is commonly imagined. Nature has marked all her works with indelible characters of high or low, plain or elegant, strong or weak. These, if at all perceived, are seldom misapprehended by any taste; and the same marks are equally perceptible in works of art. A defective taste is incurable; and it hurts none but the possessor, because it carries no authority to impose upon others. I know not if there be such a thing as a taste naturally bad or wrong; a taste, for example, that prefers a grovelling pleasure before one that is high and elegant. Grovelling pleasures are never preferred: they are only made welcome by those

who know no better. Differences about objects of taste, it is true, are endless: but they generally concern trifles, or possibly matters of equal rank where the preference may be given either way with impunity. If, on any occasion, the dispute goes deeper and persons differ where they ought not, a depraved taste will readily be discovered on one or other side, occasioned by imitation, custom, or corrupted manners, such as are described above.

If, after all that is said, the standard of taste be thought not yet sufficiently ascertained, there is still one resource in which I put great confidence. What I have in view, are the principles that constitute the sensitive part of our nature. By means of these principles, common to all men, a wonderful uniformity is preserved among the emotions and feelings of different individuals; the same object making upon every person the same impression; the same in kind, at least, if not in degree. There have been aberrations, as above observed, from these principles; but soon or late they always prevail, by restoring the wanderers to the right track. The uniformity of taste here accounted for, is the very thing that in other words is termed the common sense of mankind. And this discovery leads us to means for ascertaining the common sense of mankind or the standard of taste, more unerringly than the selection above insisted on. Every doubt with relation to this standard, occasioned by the practice of different nations and different times, may be cleared by applying to the principles that ought to govern the taste of every individual. In a word, a thorough acquaintance with these principles will enable us to form the standard of taste; and to lay a foundation for this valuable branch of knowledge, is the declared purpose of the present undertaking.

Thomas Reid

(1710–1796)

Reid is without a doubt one of the most significant of the eigh-teenth-century Scots philosophers, indeed, the only one who has been credited with founding an approach to philosophical inquiry that has been thought to be distinctively Scottish. Called the 'Scottish Common Sense philosophy', it is distinguished by its rejection of the assumption running through Locke, Berkeley and Hume that we perceive the world through the mediation of men-tal objects like ideas. For Reid, the theory of ideas was a remnant of Aristotelian metaphysics infecting the heart of a properly empirical and inductive investigation of the mind and the origins of knowledge, and it led directly to the scepticism of Hume. In place of the theory of ideas he produced an analysis of perception as a mechanism of belief formation, unmediated by mental objects such as ideas. Because of various misinterpretations of Reid's poorly named notion of 'common sense', his thought has often been marginalised by philosophers who have thought him to be appealing to the opinions of the common man against the conclusions of reason, but in recent years his thought is experienc-ing a revival among contemporary philosophers.

Reid entered Marischal College in Aberdeen in 1722 at the age of twelve, graduating at the age of sixteen, when he became the college librarian, a post he was to fill for ten years while he contin-ued to pursue his studies in philosophy. In 1737 he became the minister at the church at Newmacher, a village outside Aberdeen, that brought with it a modest income and provided further opportunity for him to pursue his philosophical studies. In 1752 he was appointed to a chair in philosophy at King's College in Aberdeen where he joined a thriving atmosphere of intellectual

debate and began work on his first major work, *An Inquiry into the Principle of the Human Mind on the Principles of Common Sense* (1764). The year this work was published he moved to Glasgow to take up the Chair of Moral Philosophy that had been vacated by Adam Smith. Reid held the position until the age of seventy one, when he retired and began work on his most accomplished works, the *Essays on the Intellectual Powers* (1785) and *Essays on the Active Powers* (1788). The extract from Reid's admittedly meagre treatment of aesthetic questions that follows is taken from one of the final essays in the former of these two publications.

Reid's account of beauty differs from his contemporaries' in a number of respects. There is no internal sense at work in his account and, most strikingly, beauty is conceived of as both real and expressive of mind. The beauty of nature, for example, is expressive of the mind of its creator, just as the work of art is expressive of its creator's mind. Like all of his philosophical writings, Reid's essay on beauty is subtle, and its subtlety is often masked by the clarity and simplicity of his prose. His position is quite unique among the Scottish philosophers, and is challenging in part for this reason.

Further Reading

James Manns, *Reid and His French Disciples: Aesthetics and Metaphysics*, Leiden: Brill Academic Press, 1994.

Peter Kivy, *The Seventh Sense*, 2nd edn., Oxford: Oxford University Press, 2003, Chapter 19.

READING XII

OF BEAUTY[1]

Beauty is found in things so various, and so very different in nature, that it is difficult to say wherein it consists, or what there can be common to all the objects in which it is found.

Of the objects of sense, we find beauty in colour, in sound, in form, in motion. There are beauties of speech, and beauties of thought; beauties in the arts, and in the sciences; beauties in actions, in affections, and in characters.

In things so different, and so unlike, is there any quality, the same in all, which we may call by the name of beauty? What can it

[1] From *Essays on the Intellectual Powers* (London, 1785).

be that is common to the thought of a mind, and the form of a piece of matter, to an abstract theorem, and a stroke of wit?

I am indeed unable to conceive any quality in all the different things that are called beautiful, that is the same in them all. There seems to be no identity, nor even similarity, between the beauty of a theorem and the beauty of a piece of music, though both may be beautiful. The kinds of beauty seem to be as various as the objects to which it is ascribed.

But why should things so different be called by the same name? This cannot be without a reason. If there be nothing common in the things themselves, they must have some common relation to us, or to something else, which leads us to give them the same name.

All the objects we call beautiful agree in two things, which seem to concur in our sense of beauty. *First*, when they are perceived, or even imagined, they produce a certain agreeable emotion or feeling in the mind; and *secondly*, this agreeable emotion is accompanied with an opinion or belief of their having some perfection or excellence belonging to them.

Whether the pleasure we feel in contemplating beautiful objects may have any necessary connection with the belief of their excellence, or whether that pleasure be conjoined with this belief, by the good pleasure only of our maker, I will not determine.

Though we may be able to conceive these two ingredients of our sense of beauty disjoined, this affords no evidence that they have no necessary connection. It has indeed been maintained, that whatever we can conceive, is possible: but I endeavoured, in treating of conception, to show, that this opinion, though very common, is a mistake. There may be, and probably are, many necessary connections of things in nature, which we are too dim sighted to discover.

The emotion produced by beautiful objects is gay and pleasant. It sweetens and humanises the temper, is friendly to every benevolent affection, and tends to allay sullen and angry passions. It enlivens the mind, and disposes it to other agreeable emotions, such as those of love, hope, and joy. It gives a value to the object, abstracted from its utility.

In things that may be possessed as property, beauty greatly enhances the price. A beautiful dog or horse, a beautiful coach or house, a beautiful picture or prospect, is valued by its owner and by others, not only for its utility, but for its beauty.

If the beautiful object be a person, his company and conversation are, on that account, the more agreeable, and we are disposed to love and esteem him. Even in a perfect stranger, it is a powerful recommendation, and disposes us to favour and think well of him, if of our own sex, and still more if of the other.

> There is nothing, says Mr Addison, that makes its way more directly to the soul than beauty, which immediately diffuses a secret satisfaction and complacence through the imagination, and gives a finishing to any thing that is great and uncommon. The very first discovery of it strikes the mind with an inward joy, and spreads a cheerfulness and delight through all its faculties.

As we ascribe beauty, not only to persons, but to inanimate things, we give the name of love or liking to the emotion, which beauty, in both these kinds of objects, produces. It is evident, however, that liking to a person is a very different affection of mind from liking to an inanimate thing. The first always implies benevolence; but what is inanimate cannot be the object of benevolence. The two affections, however different, have a resemblance in some respects; and, on account of that resemblance, have the same name: and perhaps beauty, in these two different kinds of objects, though it has one name, may be as different in its nature as the emotions which it produces in us.

Besides the agreeable emotion which beautiful objects produce in the mind of the spectator, they produce also an opinion or judgment of some perfection or excellence in the object. This I take to be a second ingredient in our sense of beauty, though it seems not to be admitted by modern philosophers.

The ingenious Dr Hutcheson, who perceived some of the defects of Mr Locke's system, and made very important improvements upon it, seems to have been carried away by it, in his notion of beauty. In his *Inquiry Concerning Beauty*. Section 1. 'Let it be observed', says he, 'that, in the following papers, the word beauty is taken for the idea raised in us, and the sense of beauty for our power of receiving that idea'. And again:

> Only let it be observed, that, by absolute or original beauty, is not understood any quality supposed to be in the object which should, of itself, be beautiful, without relation to any mind which perceives it: for beauty, like other names of sensible ideas, properly denotes the perception of some mind; so cold, hot, sweet, bitter, denote the sensations in our minds, to which perhaps there is no resemblance in the objects which excite these ideas in us; however, we generally imagine otherwise. Were there no mind, with a

sense of beauty, to contemplate objects, I see not how they could be called beautiful.

There is no doubt an analogy between the external senses of touch and taste, and the internal sense of beauty. This analogy led Dr Hutcheson, and other modern philosophers, to apply to beauty, what Descartes and Locke had taught concerning the secondary qualities, perceived by the external senses.

Mr Locke's doctrine concerning the secondary qualities of body, is not so much an error in judgment as an abuse of words. He distinguished very properly between the sensations we have of heat and cold, and that quality or structure in the body which is adapted by nature to produce those sensations in us. He observed very justly, that there can be no similitude between one of these and the other. They have the relation of an effect to its cause, but no similitude. This was a very just and proper correction of the doctrine of the Peripatetics, who taught, that all our sensations are the very form and image of the quality in the object by which they are produced.

What remained to be determined was, whether the words, heat and cold, in common language, signify the sensations we feel, or the qualities which are the cause of these sensations. Mr Locke made heat and cold to signify only the sensations we feel, and not the qualities which are the cause of them. And in this, I apprehend, lay his mistake. For it is evident, from the use of language, that hot and cold, sweet and bitter, are attributes of external objects, and not of the person who perceives them. Hence, it appears a monstrous paradox to say, there is no heat in the fire, no sweetness in sugar: but, when explained according to Mr Locke's meaning, it is only, like most other paradoxes, an abuse of words.

The sense of beauty may be analysed in a manner very similar, to the sense of sweetness. It is an agreeable feeling or emotion, accompanied with an opinion or judgment of some excellence in the object, which is fitted by nature to produce that feeling.

The feeling is, no doubt, in the mind, and so also is the judgment we form of the object: but this judgment, like all others, must be true or false. If it be a true judgment, there is some real excellence in the object. And the use of all languages shows, that the name of beauty belongs to this excellence of the object, and not to the feelings of the spectator.

To say that there is in reality no beauty in those objects in which all men perceive beauty, is to attribute to man fallacious senses. But we have no ground to think so disrespectfully of the author of our being; the faculties he hath given us are not fallacious; nor is that beauty, which he hath so liberally diffused over all the works of his hands, a mere fancy in us, but a real excellence in his works, which express the perfection of their divine author.

We have reason to believe, not only that the beauties we see in nature are real, and not fanciful, but that there are thousands which our faculties are too dull to perceive. We see many beauties, both of human and divine art, which the brute animals are incapable of perceiving; and superior beings may excel us as far in their discernment of true beauty as we excel the brutes.

The man who is skilled in painting or statuary, sees more of the beauty of a fine picture or statue than a common spectator. The same thing holds in all the fine arts. The most perfect works of art have a beauty that strikes even the rude and ignorant; but they see only a small part of that beauty which is seen in such works by those who understand them perfectly, and can produce them.

This may be applied with no less justice to the works of nature. They have a beauty that strikes even the ignorant and inattentive. But the more we discover of their structure, of their mutual relations, and of the laws by which they are governed, the greater beauty, and the more delightful marks of art, wisdom and goodness, we discern.

Thus the expert anatomist sees numberless beautiful contrivances in the structure of the human body, which are unknown to the ignorant.

Although the vulgar eye sees much beauty in the face of the heavens, and in the various motions and changes of the heavenly bodies, the expert astronomer, who knows their order and distances, their periods, the orbits they describe in the vast regions of space, and the simple and beautiful laws by which their motions are governed, and all the appearances of their stations, progressions, and retrogradations, their eclipses, occultations, and transits are produced, sees a beauty, order, and harmony reign through the whole planetary system, which delights the mind. The eclipses of the sun and moon, and the blazing tails of comets, which strike terror into barbarous nations, furnish the most pleasing entertainment to his eye, and a feast to his understanding.

In every part of nature's works, there are numberless beauties, which, on account of our ignorance, we are unable to perceive. Superior beings may see more than we; but he only who made them, and, upon a review, pronounced them all to be very good, can see all their beauty.

Our determinations with regard to the beauty of objects, may, I think, be distinguished into two kinds; the first we may call instinctive, the other rational.

Some objects strike us at once, and appear beautiful at first sight, without any reflection, without our being able to say why we call them beautiful, or being able to specify any perfection which justifies our judgment. Something of this kind there seems to be in brute animals, and in children before the use of reason; nor does it end with infancy, but continues through life.

In the plumage of birds, and of butterflies, in the colours and form of flowers, of shells, and of many other objects, we perceive a beauty that delights; but cannot say what it is in the object that should produce that emotion.

The beauty of the object may in such cases be called an occult quality. We know well how it affects our senses; but what it is in itself we know not. But this, as well as other occult qualities, is a proper subject of philosophical disquisition; and, by a careful examination of the objects to which nature hath given this amiable quality, we may perhaps discover some real excellence in the object, or, at least, some valuable purpose that is served by the effect which it produces upon us.

This instinctive sense of beauty, in different species of animals, may differ as much as the external sense of taste, and in each species be adapted to its manner of life. By this perhaps the various tribes are led to associate with their kind, to dwell among certain objects rather than others, and to construct their habitation in a particular manner.

There seem likewise to be varieties in the sense of beauty in the individuals of the same species, by which they are directed in the choice of a mate, and in the love and care of their offspring.

'We see', says Mr Addison, 'that every different species of sensible creatures has its different notions of beauty, and that each of them is most affected with the beauties of its own kind. This is nowhere more remarkable than in birds of the same shape and proportion, where we often see the mate determined in his court-

ship by the single grain or tincture of a feather, and never discovering any charms but in the colour of its own species.

> The shining Down, proud Crest, and purple Wings:
> But cautious with a searching Eye explores
> The female Tribes, his proper Mate to find,
> With kindred Colours marked?: Did he not so,
> The Grove with painted Monsters would abound,
> The ambiguous product of unnatural Love.
> The Blackbird hence selects her sooty Spouse;
> The Nightingale her musical Compeer,
> Lured by the well-known Voice: the Bird of Night,
> Smith with his dusky Wings, and greenish Eyes,
> Woos his dun Paramour. The beauteous Race
> Speak the chaste Loves of the Progenitors;
> When, by the Spring invited, they exult
> In Woods and Fields, and to the Sun unfold
> Their Plumes, that with paternal Colours glow.[2]

In the human kind there are varieties in the taste of beauty, of which we can no more assign a reason than of the variety of their features, though it is easy to perceive that very important ends are answered by both. These varieties are most observable in the judgments we form of the features of the other sex; and in this the intention of nature is most apparent.

As far as our determinations of the comparative beauty of objects are instinctive, they are no subject of reasoning or of criticism; they are purely the gift of nature, and we have no standard by which they may be measured.

But there are judgments of beauty that may be called rational, being grounded on some agreeable quality of the object which is distinctly conceived, and may be specified.

This distinction between a rational judgment of beauty and that which is instinctive, may be illustrated by an instance.

In a heap of pebbles, one that is remarkable for brilliancy of colour and regularity of figure, will be picked out of the heap by a child. He perceives a beauty in it, puts a value upon it, and is fond of the property of it. For this preference, no reason can be given, but that children are, by their constitution, fond of brilliant colours, and of regular figures.

Suppose again that an expert mechanic views a well-constructed machine. He sees all its parts to be made of the fittest materials, and of the most proper form; nothing superfluous,

[2] Joseph Addison, *The Spectator*, No. 412 (1712).

nothing deficient; every part adapted to its use, and the whole fitted in the most perfect manner to the end for which it is intended. He pronounces it to be a beautiful machine. He views it with the same agreeable emotion as the child viewed the pebble; but he can give a reason for his judgment, and point out the particular perfections of the object on which it is grounded.

Although the instinctive and the rational sense of beauty may be perfectly distinguished in speculation, yet, in passing judgment upon particular objects, they are often so mixed and confounded, that it is difficult to assign to each its own province. Nay, it may often happen, that a judgment of the beauty of an object, which was at first merely instinctive, shall afterwards become rational, when we discover some latent perfection of which that beauty in the object is a sign.

As the sense of beauty may be distinguished into instinctive and rational; so I think beauty itself may be distinguished into original and derived.

As some objects shine by their own light, and many more by light that is borrowed and reflected; so I conceive the lustre of beauty in some objects is inherent and original, and in many others is borrowed and reflected.

There is nothing more common in the sentiments of all mankind, and in the language of all nations, than what may be called a communication of attributes; that is, transferring an attribute, from the subject to which it properly belongs, to some related or resembling subject.

The various objects which nature presents to our view, even those that are most different in kind, have innumerable similitudes, relations, and analogies, which we contemplate with pleasure, and which lead us naturally to borrow words and attributes from one object to express what belongs to another. The greatest part of every language under heaven is made up of words borrowed from one thing, and applied to something supposed to have some relation or analogy to their first signification.

The attributes of body we ascribe to mind, and the attributes of mind to material objects. To inanimate things we ascribe life, and even intellectual and moral qualities. And although the qualities that are thus made common belong to one of the subjects in the proper sense, and to the other metaphorically, these different senses are often so mixed in our imagination, as to produce the same sentiment with regard to both.

It is therefore natural, and agreeable to the strain of human sentiments and of human language, that in many cases the beauty which originally and properly is in the thing signified, should be transferred to the sign; that which is in the cause to the effect; that which is in the end to the means; and that which is in the agent to the instrument.

If what was said in the last chapter of the distinction between the grandeur which we ascribe to qualities of mind, and that which we ascribe to material objects, be well founded, this distinction of the beauty of objects will easily be admitted as perfectly analogous to it. I shall therefore only illustrate it by an example.

There is nothing in the exterior of a man more lovely and more attractive than perfect good breeding. But what is this good breeding? It consists of all the external signs of due respect to our superiors, condescension to our inferiors, politeness to all with whom we converse or have to do, joined in the fair sex with that delicacy of outward behaviour which becomes them. And how comes it to have such charms in the eyes of all mankind? For this reason only, as I apprehend, that it is a natural sign of that temper, and those affections and sentiments with regard to others, and with regard to ourselves, which are in themselves truly amiable and beautiful.

This is the original, of which good breeding is the picture; and it is the beauty of the original that is reflected to our sense by the picture. The beauty of good breeding, therefore, is not originally in the external behaviour in which it consists, but is derived from the qualities of mind which it expresses. And though there may be good breeding without the amiable qualities of mind, its beauty is still derived from what it naturally expresses.

Having explained these distinctions of our sense of beauty into instinctive and rational, and of beauty itself into original and derived, I would now proceed to give a general view of those qualities in objects, to which we may justly and rationally ascribe beauty, whether original or derived.

But here some embarrassment arises from the vague meaning of the word beauty, which I had occasion before to observe.

Sometimes it is extended, so as to include everything that pleases a good taste, and so comprehends grandeur and novelty, as well as what in a more restricted sense is called beauty. At other times, it is even by good writers confined to the objects of sight, when they are either seen, or remembered, or imagined. Yet it is

admitted by all men, that there are beauties in music; that there is beauty as well as sublimity in composition, both in verse and in prose; that there is beauty in characters, in affections, and in actions. These are not objects of sight; and a man may be a good judge of beauty of various kinds, who has not the faculty of sight.

To give a determinate meaning to a word so variously extended and restricted, I know no better way than what is suggested by the common division of the objects of taste into novelty, grandeur, and beauty. Novelty, it is plain, is no quality of the new object, but merely a relation which it has to the knowledge of the person to whom it is new. Therefore, if this general division be just, every quality in an object that pleases a good taste, must, in one degree or another, have, either grandeur or beauty. It may still be difficult to fix the precise limit betwixt grandeur and beauty; but they must together comprehend everything fitted by its nature to please a good taste, that is, every real perfection and excellence in the objects we contemplate.

In a poem, in a picture, in a piece of music, it is real excellence that pleases a good taste. In a person, every perfection of the mind, moral or intellectual, and every perfection of the body, gives pleasure to the spectator as well as to the owner, when there is no envy nor malignity to destroy that pleasure.

It is therefore in the scale of perfection and real excellence that we must look for what is either grand or beautiful in objects. What is the proper object of admiration is grand, and what is the proper object of love and esteem is beautiful.

This, I think, is the only notion of beauty that corresponds with the division of the objects of taste which has been generally received by philosophers. And this connection of beauty, with real perfection, was a capital doctrine of the Socratic school. It is often ascribed to Socrates in the dialogues of Plato and of Xenophon.

We may therefore take a view, first, of those qualities of mind to which we may justly and rationally ascribe beauty, and then of the beauty we perceive in the objects of sense. We shall find, if I mistake not, that, in the first, original beauty is to be found, and that the beauties of the second class are derived from some relation they bear to mind, as the signs or expressions of some amiable mental quality, or as the effects of design, art, and wise contrivance.

As grandeur naturally produces admiration, beauty naturally produces love. We may therefore justly ascribe beauty to those qualities which are the natural objects of love and kind affection.

Of this kind chiefly are some of the moral virtues, which in peculiar manner constitute a lovely character: innocence, gentleness, condescension, humanity, natural affection, public spirit, and the whole train of the soft and gentle virtues. These qualities are amiable from their very nature, and on account of their intrinsic worth.

There are other virtues that raise admiration, and are therefore grand; such as magnanimity, fortitude, self-command, superiority to pain and labour, superiority to pleasure, and to the smiles of fortune as well as to her frowns.

These awful virtues constitute what is most grand in the human character; the gentle virtues, what is most beautiful and lovely. As they are virtues, they draw the approbation of our moral faculty; as they are becoming and amiable, they affect our sense of beauty.

Next to the amiable moral virtues, there are many intellectual talents which have an intrinsic value, and draw our love and esteem to those who possess them. Such are, knowledge, good sense, wit, humour, cheerfulness, good taste, excellence in any of the fine arts, in eloquence, in dramatic action; and we may add, excellence in every art of peace or war that is useful in society.

There are likewise talents which we refer to the body, which have an original beauty and comeliness; such as health, strength, and agility, the usual attendants of youth; skill in bodily exercises, and skill in the mechanic arts. These are real perfections of the man, as they increase his power, and render the body a fit instrument for the mind.

I apprehend, therefore, that it is in the moral and intellectual perfections of mind, and in its active powers, that beauty originally dwells; and that from this as the fountain, all the beauty which we perceive in the visible world is derived . . .

But neither mind, nor any of its qualities or powers, is an immediate object of perception to man. We are, indeed, immediately conscious of the operations of our own mind; and every degree of perfection in them gives the purest pleasure, with a proportional degree of self-esteem, so flattering to self-love, that the great difficulty is to keep it within just bounds, so that we may not think of ourselves above what we ought to think.

Other minds we perceive only through the medium of material objects, on which their signatures are impressed. It is through this medium that we perceive life, activity, wisdom, and every moral and intellectual quality in other beings. The signs of those qualities are immediately perceived by the senses; by them the qualities themselves are reflected to our understanding; and we are very apt to attribute to the sign the beauty or the grandeur, which is properly and originally in the things signified.

The invisible Creator, the Fountain of all perfection, hath stamped upon all his works signatures of his divine wisdom, power, and benignity, which are visible to all men. The works of men in science, in the arts of taste, and in the mechanical arts, bear the signatures of those qualities of mind which were employed in their production. Their external behaviour and conduct in life expresses the good or bad qualities of their mind.

In every species of animals, we perceive by visible signs their instincts, their appetites, their affections, their sagacity. Even in the inanimate world there are many things analogous to the qualities of mind; so that there is hardly anything belonging to mind which may not be represented by images taken from the objects of sense; and, on the other hand, every object of sense is beautified, by borrowing attire from the attributes of mind.

Thus the beauties of mind, though invisible in themselves, are perceived in the objects of sense, on which their image is impressed.

If we consider, on the other hand, the qualities in sensible objects to which we ascribe beauty, I apprehend we shall find in all of them some relation to mind, and the greatest in those that are most beautiful.

When we consider inanimate matter abstractly, as a substance endowed with the qualities of extension, solidity, divisibility, and mobility, there seems to be nothing in these qualities that affects our sense of beauty. But when we contemplate the globe which we inhabit, as fitted by its form, by its motions, and by its furniture, for the habitation and support of an infinity of various orders of living creatures, from the lowest reptile up to man, we have a glorious spectacle indeed with which the grandest and the most beautiful structures of human art can bear no comparison.

The only perfection of dead matter is its being, by its various forms and qualities, so admirably fitted for the purposes of animal life, and chiefly that of man. It furnishes the materials of every

art that tends to the support or the embellishment of human life. By the supreme artist, it is organised in the various tribes of the vegetable kingdom, and endowed with a kind of life; a work which human art cannot imitate, nor human understanding comprehend.

In the bodies and various organs of the animal tribes, there is a composition of matter still more wonderful and more mysterious, though we see it to be admirably adapted to the purposes and manner of life of every species. But in every form, unorganised, vegetable, or animal, it derives its beauty from the purposes to which it is subservient, or from the signs of wisdom, or of other mental qualities which it exhibits.

The qualities of inanimate matter, in which we perceive beauty, are, sound, colour, form, and motion; the first an object of hearing, the other three of sight; which we may consider in order.

In a single note, sounded by a very fine voice, there is a beauty which we do not perceive in the same note, sounded by a bad voice, or an imperfect instrument. I need not attempt to enumerate the perfections in a single note, which give beauty to it. Some of them have names in the science of music, and there perhaps are others which have no names. But I think it will be allowed, that every quality which gives beauty to a single note, is a sign of some perfection, either in the organ, whether it be the human voice or an instrument, or in the execution. The beauty of the sound is both the sign and the effect of this perfection; and the perfection of the cause is the only reason we can assign for the beauty of the effect.

In composition of sounds, or a piece of music, the beauty is either in the harmony, the melody, or the expression. The beauty of expression must be derived, either from the beauty of the thing expressed, or from the art and skill employed in expressing it properly.

In harmony, the very names of concord and discord are metaphorical, and suppose some analogy between the relations of sound, to which they are figuratively applied, and the relations of minds and affections, which they originally and properly signify.

As far as I can judge by my ear, when two or more persons of a good voice and ear, converse together in amity and friendship, the tones of their different voices are concordant, but become discordant when they give vent to angry passions; so that, without hearing what is said, one may know by the tones of the different voices, whether they quarrel or converse amicably. This, indeed,

is not so easily perceived in those who have been taught, by good-breeding, to suppress angry tones of voice, even when they are angry, as in the lowest rank, who express their angry passions without any restraint.

When discord arises occasionally in conversation, but soon terminates in perfect amity, we receive more pleasure than from perfect unanimity. In like manner, in the harmony of music, discordant sounds are occasionally introduced, but it is always in order to give a relish to the most perfect concord that follows.

Whether these analogies, between the harmony of a piece of music, and harmony in the intercourse of minds, be merely fanciful, or have any real foundation in fact, I submit to those who have a nicer ear, and have applied it to observations of this kind. If they have any just foundation, as they seem to me to have, they serve to account for the metaphorical application of the names of concord and discord to the relations of sounds; to account for the pleasure we have from harmony in music; and to show, that the beauty of harmony is derived from the relation it has to agreeable affections of mind.

With regard to melody, I leave it to the adepts in the science of music, to determine, whether music, composed according to the established rules of harmony and melody, can be altogether void of expression; and whether music that has no expression can have any beauty. To me it seems, that every strain in melody that is agreeable, is an imitation of the tones of the human voice in the expression of some sentiment or passion, or an imitation of some other object in nature; and that music, as well as poetry, is an imitative art.

The sense of beauty in the colours, and in the motions of inanimate objects is, I believe, in some cases instinctive. We see, that children and savages are pleased with brilliant colours and sprightly motions. In persons of an improved and rational taste, there are many sources from which colours and motions may derive their beauty. They, as well as the forms of objects, admit of regularity and variety. The motions produced by machinery, indicate the perfection or imperfection of the mechanism, and may be better or worse adapted to their end, and from that derive their beauty or deformity.

The colours of natural objects, are commonly signs of some good or bad quality in the object; or they may suggest to the imagination something agreeable or disagreeable.

In dress and furniture, fashion has a considerable influence on the preference we give to one colour above another.

A number of clouds of different and ever-changing hue, seen on the ground of a serene azure sky at the going down of the sun, present to the eye of every man a glorious spectacle. It is hard to say, whether we should call it grand or beautiful. It is both in a high degree. Clouds towering above clouds, variously tinged, according as they approach nearer to the direct rays of the sun, enlarge our conceptions of the regions above us. They give us a view of the furniture of those regions, which, in an unclouded air, seem to be a perfect void; but are now seen to contain the stores of wind and rain, bound up for the present, but to be poured down upon the earth in due season. Even the simple rustic does not look upon this beautiful sky, merely as a show to please the eye, but as a happy omen of fine weather to come.

The proper arrangement of colour, and of light and shade, is one of the chief beauties of painting; but this beauty is greatest, when that arrangement gives the most distinct, the most natural, and the most agreeable image of that which the painter intended to represent.

If we consider, in the last place, the beauty of form or figure in inanimate objects, this, according to Dr Hutcheson, results from regularity, mixed up with variety. Here it ought to be observed, that regularity, in all cases, expresses design and art: for nothing regular was ever the work of chance; and where regularity is joined with variety, it expresses design more strongly. Besides, it has been justly observed, that regular figures are more easily and more perfectly comprehended by the mind than the irregular, of which we can never form an adequate conception.

Although straight lines and plain surfaces have a beauty from their regularity, they admit of no variety, and therefore are beauties of the lowest order. Curve lines and surfaces admit of infinite variety, joined with every degree of regularity; and therefore, in many cases, excel in beauty those that are straight.

But the beauty arising from regularity and variety, must always yield to that which arises from the fitness of the form for the end intended. In every thing made for an end, the form must be adapted to that end; and every thing in the form that suits the end, is a beauty; every thing that unfits it for its end, is a deformity.

The forms of a pillar, of a sword, and of a balance are very different. Each may have great beauty; but that beauty is derived

from the fitness of the form, and of the matter for the purpose intended.

Were we to consider the form of the earth itself, and the various furniture it contains, of the inanimate kind; its distribution into land and sea, mountains and valleys, rivers and springs of water, the variety of soils that cover its surface, and of mineral and metallic substances laid up within it, the air that surrounds it, the vicissitudes of day and night, and of the seasons; the beauty of all these, which indeed is superlative, consists in this, that they bear the most lively and striking impression of the wisdom and goodness of their author, in contriving them so admirably for the use of man, and of their other inhabitants.

The beauties of the vegetable kingdom are far superior to those of inanimate matter, in any form which human art can give it. Hence, in all ages, men have been fond to adorn their persons and their habitations with the vegetable productions of nature.

The beauties of the field, of the forest, and of the flower-garden, strike a child long before he can reason. He is delighted with what he sees; but he knows not why. This is instinct, but it is not confined to childhood; it continues through all the stages of life. It leads the florist, the botanist, the philosopher, to examine and compare the objects which nature, by this powerful instinct, recommends to his attention. By degrees, he becomes a critic in beauties of this kind, and can give a reason why he prefers one to another. In every species, he sees the greatest beauty in the plants or flowers that are most perfect in their kind, which have neither suffered from unkindly soil, nor inclement weather; which have not been robbed of their nourishment by other plants, nor hurt by any accident. When he examines the internal structure of those productions of nature, and traces them from their embryo state in the seed to their maturity, he sees a thousand beautiful contrivances of nature, which feast his understanding more than their external form delighted his eye.

Thus, every beauty in the vegetable creation, of which he has formed any rational judgment, expresses some perfection in the object, or some wise contrivance in its author.

In the animal kingdom, we perceive still greater beauties than in the vegetable. Here we observe life, and sense, and activity, various instincts and affections, and, in many cases, great sagacity. These are attributes of mind, and have an original beauty.

As we allow to brute animals a thinking principle or mind, though far inferior to that which is in man; and as, in many of their intellectual and active powers, they very much resemble the human species, their actions, their motions, and even their looks, derive a beauty from the powers of thought which they express.

There is a wonderful variety in their manner of life; and we find the powers they possess, their outward form, and their inward structure, exactly adapted to it. In every species, the more perfectly any individual is fitted for its end and manner of life, the greater is its beauty.

In a racehorse, everything that expresses agility, ardour, and emulation, gives beauty to the animal. In a pointer, acuteness of scent, eagerness on the game, and tractableness, are the beauties of the species. A sheep derives its beauty from the fineness and quantity of its fleece; and in the wild animals, every beauty is a sign of their perfection in their kind.

It is an observation of the celebrated Linnaeus, that, in the vegetable kingdom, the poisonous plants have commonly a lurid and disagreeable appearance to the eye, of which he gives many instances. I apprehend the observation may be extended to the animal kingdom, in which we commonly see something shocking to the eye in the noxious and poisonous animals.

The beauties which anatomists and physiologists describe in the internal structure of the various tribes of animals; in the organs of sense, of nutrition, and of motion, are expressive of wise design and contrivance, in fitting them for the various kinds of life for which they are intended.

Thus, I think, it appears, that the beauty which we perceive in the inferior animals, is expressive either of such perfections as their several natures may receive, or expressive of wise design in him who made them, and that their beauty is derived from the perfections which it expresses.

But of all the objects of sense, the most striking and attractive beauty is perceived in the human species, and particularly in the fair sex . . . The most minute and systematical account of beauty in the human species, and particularly in the fair sex, I have met with, is in *Crito; or a Dialogue on Beauty*, said to be written by the author of *Polymetis* [Joseph Spence (1752)].

I shall borrow from that author some observations, which, I think, tend to show that the beauty of the human body is derived from the signs it exhibits of some perfection of the mind or person.

All that can be called beauty in the human species may be reduced to these four heads; colour, form, expression, and grace. The two former may be called the body, the two latter the soul of beauty.

The beauty of colour is not owing solely to the natural liveliness of flesh-colour and red, nor to the much greater charms they receive from being properly blended together; but is also owing, in some degree, to the idea they carry with them of good health, without which all beauty grows languid and less engaging, and with which it always recovers an additional strength and lustre. This is supported by the authority of Cicero: 'Comeliness and beauty of person are inseparable from the notion of health'.

Here I observe, that as the colour of the body is very different in different climates, every nation preferring the colour of its climate; and as among us one man prefers a fair beauty, another a brunette, without being able to give any reason for this preference; this diversity of taste has no standard in the common principles of human nature, but must arise from something that is different in different nations, and in different individuals of the same nation.

I observed before, that fashion, habit, associations, and perhaps some peculiarity of constitution, may have great influence upon this internal sense, as well as upon the external. Setting aside the judgments arising from such causes, there seems to remain nothing that, according to the common judgment of mankind, can be called beauty in the colour of the species, but what expresses perfect health and liveliness, and in the fair sex softness and delicacy; and nothing that can be called deformity but what indicates disease and decline. And if this be so, it follows, that the beauty of colour is derived from the perfections which it expresses. This, however, of all the ingredients of beauty, is the least.

The next in order is form, or proportion of parts. The most beautiful form, as the author thinks, is that which indicates delicacy and softness in the fair sex, and in the male either strength or agility. The beauty of form, therefore, lies all in expression.

The third ingredient, which has more power than either colour or form, he calls expression, and observes, that it is only the expression of the tender and kind passions that gives beauty; that all the cruel and unkind ones add to deformity; and that, on this account, good nature may very justly be said to be the best feature, even in the finest face. Modesty, sensibility, and sweetness,

blended together, so as either to enliven or to correct each other, give almost as much attraction as the passions are capable of adding to a very pretty face.

It is owing, says the author, to the great force of pleasingness which attends all the kinder passions, that lovers not only seem, but really are, more beautiful to each other than they are to the rest of the world; because, when they are together, the most pleasing passions are more frequently exerted in each of their faces than they are in either before the rest of the world. There is then, as a French author very well expresses it, a soul upon their countenances, which does not appear when they are absent from one another, or even in company that lays a restraint upon their features.

There is a great difference in the same face, according as the person is in a better or a worse humour, or more or less lively. The best complexion, the finest features, and the exactest shape, without anything of the mind expressed in the face, is insipid and unmoving. The finest eyes in the world, with an excess of malice or rage in them, will grow shocking. The passions can give beauty without the assistance of colour or form, and take it away where these have united most strongly to give it; and therefore this part of beauty is greatly superior to the other two.

The last and noblest part of beauty is grace, which the author thinks undefinable.

Nothing causes love so generally and irresistibly as grace. Therefore, in the mythology of the Greeks and Romans, the Graces were the constant attendants of Venus the goddess of love. Grace is like the cestus of the same goddess, which was supposed to comprehend everything that was winning and engaging, and to create love by a secret and inexplicable force, like that of some magical charm.

There are two kinds of grace, the majestic and the familiar; the first more commanding, the last more delightful and engaging. The Grecian painters and sculptors used to express the former most strongly in the looks and attitudes of their Minervas, and the latter in those of Venus. This distinction is marked in the description of the personages of virtue and pleasure in the ancient fable of the choice of Hercules.

Graceful, but each with different grace they move,
This striking sacred awe, that softer winning love.

In the persons of Adam and Eve in Paradise, Milton has made the same distinction.

> For contemplation he, and valour form'd,
> For softness she, and sweet attractive grace.

Though grace be so difficult to be defined, there are two things that hold universally with relation to it. *First,* there is no grace without motion; some genteel or pleasing motion, either of the whole body or of some limb, or at least some feature. Hence, in the face, grace appears only on those features that are moveable, and change with the various emotions and sentiments of the mind, such as the eyes and eyebrows, the mouth and parts adjacent. When Venus appeared to her son Aeneas in disguise, and, after some conversation with him, retired, it was by the grace of her motion in retiring that he discovered her to be truly a goddess.

> She spoke, and as she turned away, her roseate neck flashed bright. From her head her ambrosial tresses breathed celestial fragrance; down to her feet fell her raiment, and in her step she was revealed, a very goddess. He knew her as his mother, etc.[3]

A *second* observation is, that there can be no grace with impropriety, or that nothing can be graceful that is not adapted to the character and situation of the person.

From these observations, which appear to me to be just, we may, I think, conclude, that grace, as far as it is visible, consists of those motions, either of the whole body, or of a part or feature, which express the most perfect propriety of conduct and sentiment in an amiable character.

Those motions must be different in different characters; they must vary with every variation of emotion and sentiment; they may express either dignity or respect, confidence or reserve, love or just resentment, esteem or indignation, zeal or indifference. Every passion, sentiment, or emotion, that in its nature and degree is just and proper, and corresponds perfectly with the character of the person, and with the occasion, is what we may call the soul of grace. The body or visible part consists of those motions and features which give the true and unaffected expression of this soul.

Thus, I think, all the ingredients of human beauty, as they are enumerated and described by this ingenious author, terminate in

[3] Virgil, *Aeneid*, Book I.

expression: they either express some perfection of the body, as a part of the man, and an instrument of the mind, or some amiable quality or attribute of the mind itself.

It cannot indeed be denied, that the expression of a fine countenance may be unnaturally disjoined from the amiable qualities which it naturally expresses: but we presume the contrary, till we have clear evidence; and even then, we pay homage to the expression, as we do to the throne when it happens to be unworthily filled.

Whether what I have offered to show, that all the beauty of the objects of sense is borrowed, and derived from the beauties of mind which it expresses or suggests to the imagination, be well founded or not; I hope this terrestrial Venus will not be deemed less worthy of the homage which has always been paid to her, by being conceived more nearly allied to the celestial, than she has commonly been represented.

To make an end of this subject, taste seems to be progressive as man is. Children, when refreshed by sleep, and at ease from pain and hunger, are disposed to attend to the objects about them; they are pleased with brilliant colours, gaudy ornaments, regular forms, cheerful countenances, noisy mirth, and glee. Such is the taste of childhood, which we must conclude to be given for wise purposes. A great part of the happiness of that period of life is derived from it; and therefore it ought to be indulged. It leads them to attend to objects which they may afterwards find worthy of their attention. It puts them upon exerting their infant faculties of body and mind, which, by such exertions, are daily strengthened and improved.

As they advance in years and in understanding, other beauties attract their attention, which, by their novelty or superiority, throw a shade upon those they formerly admired. They delight in feats of agility, strength, and art; they love those that excel in them, and strive to equal them. In the tales and fables they hear, they begin to discern beauties of mind. Some characters and actions appear lovely, others give disgust. The intellectual and moral powers begin to open, and, if cherished by favourable circumstances, advance gradually in strength, till they arrive at that degree of perfection, to which human nature, in its present state, is limited.

In our progress from infancy to maturity, our faculties open in a regular order appointed by nature; the meanest first; those of

more dignity in succession, until the moral and rational powers finish the man. Every faculty furnishes new notions, brings new beauties into view, and enlarges the province of taste; so that we may say, there is a taste of childhood, a taste of youth, and a manly taste. Each is beautiful in its season; but not so much so, when carried beyond its season. Not that the man ought to dislike the things that please the child, or the youth, but to put less value upon them, compared with other beauties, with which he ought to be acquainted.

Our moral and rational powers justly claim dominion over the whole man. Even taste is not exempted from their authority; it must be subject to that authority in every case wherein we pretend to reason or dispute about matters of taste; it is the voice of reason that our love or our admiration ought to be proportioned to the merit of the object. When it is not grounded on real worth, it must be the effect of constitution, or of some habit or casual association. A fond mother may see a beauty in her darling child, or a fond author in his work, to which the rest of the world are blind. In such cases, the affection is pre-engaged, and, as it were, bribes the judgment, to make the object worthy of that affection. For the mind cannot be easy in putting a value upon an object beyond what it conceives to be due. When affection is not carried away by some natural or acquired bias, it naturally is and ought to be led by the judgment . . .

James Beattie

(1735–1802)

Born in the village of Laurencekirk near Aberdeen, Beattie was educated at Marischal College in Aberdeen, where he distinguished himself as one of Alexander Gerard's students. After taking his degree he became a schoolmaster, first in the village of Fordoun near his birthplace and then at the grammar school in Aberdeen, before eventually being appointed to the Chair of Moral Philosophy at Marischal College in 1760. Throughout this time he had not only been studying philosophy, he was also honing his skills as a poet, and he continued to write poetry throughout his career — indeed it is easy to get the impression he took more pleasure and pride in his poetry, even when it was his philosophy that won him renown. After taking up his position at Marischal he joined a noted society of Aberdeen thinkers that included among its members Reid, Gerard, the philosopher and theologian George Campbell, and the teacher of medicine, John Gregory. Reid in particular provided inspiration for Beattie's philosophical development, and the latter is usually included in the school of common sense philosophy that Reid founded. His first published work was *The Nature and Immutability of Truth* (1770), which was an instant success, earning a wide general readership in Britain and abroad, but generally earning him little but scorn from the philosophical community. Beattie's work had none of Reid's subtlety and insight, though like Reid, his target is Hume and his scepticism. His argument comes across more as impassioned assertion of common beliefs in place of philosophical defence, or engagement with the real issues. His book did however earn him an honorary degree from Oxford University,

an audience with King George III and the commission of a fine portrait by Joshua Reynolds.

In 1783 he published a collection of diverse essays, from which the 'Illustrations of Sublimity' is taken. There are some eccentric claims made in the essay, including his derivation of the word sublime from the Latin *super limas*, meaning 'above the slime or mud of this world'. Setting that aside, there is little original in Beattie's study of the sublime, but it does sum up and represent all of the conclusions of the previous two decades of study of the concept. A wholly familiar account of the effects of the sublime in nature is offered, the usual emotions and causes are cited, and these are then transferred by analogy from nature to art and moral excellence. Nevertheless, Beattie's treatment is interesting because his analysis puts so much emphasis upon horror, and the sort of horror that would soon be associated with gothic literature. Moreover, his poetic sensibility does equip him to find many very fine examples to accompany his discussion.

Further Reading

James Harris, 'Introduction' to *James Beattie: Selected Philosophical Writings*, Exeter: Imprint Academic, 2004.
Everard King, James Beattie, Boston: Twayne, 1997.

READING XIII

ILLUSTRATIONS OF SUBLIMITY[1]

What we admire, or consider as great, we are apt to speak of in such terms, as if we conceived it to be high in place: and what we look upon as less important we express in words that properly denote low situation. We go up to London; and thence down into the country. The Jews spoke in the same manner of their metropolis, which was to them the object of religious veneration. 'Jerusalem', says the Psalmist, 'is a city, to which the tribes go up': and the parable of the good Samaritan begins thus, 'A certain man went down from Jerusalem to Jericho'. Conformably to the same idiom, heaven is supposed to be above, and hell to be beneath; and we say, that generous minds endeavour to reach the summit of excellence, and think it beneath them to do, or design, any thing that is base. The terms base, grovelling, low, &c.

[1] Taken from *Dissertations* (London, 1783).

and those of opposite import, elevated, aspiring, lofty, as applied in a figurative sense to the energies of mind, do all take their rise from the same modes of thinking. The Latins expressed admiration by a verb which properly signifies to look up (*suspicere*); and contempt by another (*despicere*) whose original meaning is to look down. A high feat is erected for a king, or a chief magistrate, and a lofty pedestal for the statue of a hero; partly, no doubt, that they may be seen at the greater distance, and partly also, out of respect to their dignity.

But mere local elevation is not the only source of sublimity. Things that surpass in magnitude; as a spacious building, a great city, a large river, a vast mountain, a wide prospect, the ocean, the expanse of heaven, fill the mind of the beholder with the same agreeable astonishment. And observe, that it is rather the relative magnitude of things, as compared with others of the same kind, that raises this emotion, than their absolute quantity of matter. That may be a sublime edifice, which in real magnitude falls far short of a small hill that is not sublime: and a river two furlongs in breadth is a majestic appearance, though in extent of water it is nothing when compared with the ocean.

Great number, too, when it gives rise to admiration, may be referred to the same class of things. Hence an army, or navy, a long succession of years, eternity, and the like, are sublime, because they at once please and astonish. In contemplating such ideas or objects, we are conscious of something like an expansion of our faculties, as if we were exerting our whole capacity to comprehend the vastness of that which commands our attention. This energy of the mind is pleasing, as all mental energies are when accompanied with pain: and the pleasure is heightened by our admiration of the object itself; for admiration is always agreeable.

In many cases, great number is connected with other grand ideas, which add to its own grandeur. A fleet, or army, makes us think of power, and courage, and danger, and presents a variety of brilliant images. A long succession of years brings to view the vicissitude of human things, and the uncertainty of life, which sooner or later must yield to death, the irresistible destroyer. And eternity reminds of that awful consideration, our own immortality; and is connected with an idea still more sublime, and indeed the most sublime of all, namely, with the idea of Him, who fills

immensity with his presence; creates, preserves, and governs all things; and is from everlasting to everlasting.

In general, whatever awakens in us this pleasurable astonishment is accounted sublime, whether it be connected with quantity and number, or not. The harmony of a loud and full organ conveys, no doubt, an idea of expansion and of power; but, independently of this, it overpowers with so sweet a violence, as charms and astonishes at the same time: and we are generally conscious of an elevation of mind when we hear it, even though the ear be not sensible of any melody. Thunder and tempest are still more elevating, when one hears them without fear; because the sound is still more stupendous; and because they fill the imagination with the magnificent idea of the expanse of heaven and earth, through which they direct their terrible career, and of that almighty being, whose will controls all nature. The roar of cannon, in like manner, when considered as harmless, gives a dreadful delight; partly by the overwhelming sensation wherewith it affects the ear, and partly by the ideas of power and danger, triumph and fortitude, which it conveys to the fancy.

Those passions of the soul yield a pleasing astonishment, which discover a high degree of moral excellence, or are in any way connected with great number, or great quantity. Benevolence and piety are sublime affections; for the object of the one is the Deity himself, the greatest, and the best; and that of the other is the whole human race, or the whole system of percipient beings. Fortitude and generosity are sublime emotions: because they discover a degree of virtue, which is not everywhere to be met with; and exert themselves in actions, that are at once difficult, and beneficial to mankind. Great intellectual abilities, as the genius of Homer, or of Newton, we cannot contemplate without wonder and delight; and must therefore refer to that class of things whereof I now speak. Nay great bodily strength is a sublime object; for we are agreeably astonished, when we see it exerted, or hear of its effects. There is even a sublime beauty, which both astonishes and charms: but this will be found in those persons only, or chiefly, who unite fine features with a majestic form; such as we may suppose an ancient statuary would have represented Juno, or Minerva, Achilles, or Apollo.

When great qualities prevail in any person, they form what is called a sublime character. Every good man is a personage of this order: but a character may be sublime, which is not completely

good, nay, which is upon the whole very bad. For the test of sublimity is not moral approbation, but that pleasurable astonishment wherewith certain things strike the beholder. Sarpedon, in the *Iliad*, is a sublime character, and at the same time a good one: to the valour of the hero he joins the benignity of a gracious prince, and the moderation of a wise man. Achilles, though in many respects not virtuous, is yet a most sublime character. We hate his cruelty, passionate temper, and love of vengeance: but we admire him for his valour, strength, swiftness, generosity, beauty, and intellectual accomplishments, for the warmth of his friendship, and for his filial tenderness. In a word, notwithstanding his violent nature, there is in his general conduct a mixture of goodness and of greatness, with which we are both pleased and astonished. Julius Cesar was never considered as a man of strict virtue. But, in reading his *Memoirs*, it is impossible not to be struck with the sublimity of his character: that strength of mind, which nothing can bear down; that self-command, which is never discomposed; that intrepidity in danger; that address in negotiation; that coolness and recollection in the midst of perplexity; and that unwearied activity, which crowds together in every one of his campaigns as many great actions as would make a hero. Nay even in Satan, as Milton has represented him in *Paradise Lost*, though there are no qualities that can be called good in a moral view; nay, though every purpose of that wicked spirit is bent to evil, and to that only; yet there is the grandeur of a ruined archangel: there is force able to contend with the most boisterous elements; and there is boldness, which no power, but what is Almighty, can intimidate. These qualities are astonishing: and, though we always detest his malignity, we are often compelled to admire that very greatness by which we are confounded and terrified.

And be not surprised, that we sometimes admire what we cannot approve. These two emotions may, and frequently do, coincide: Sarpedon and Hector, Epaminondas and Aristides, David and Jonathan, we approve and admire. But they do not necessarily coincide: for goodness calls forth the one, and greatness the other; and that which is great is not always good, and that may be good which is not great. Troy in flames, Palmyra in ruins, the ocean in a storm, and Etna in thunder and conflagration, are magnificent appearances, but do not immediately impress our minds with the idea of good: and a clear fountain is not a grand object, though in many parts of the world it would be valued above all

treasures. So in the qualities of the mind and body: we admire the strong, the brave, the eloquent, the beautiful, the ingenious, the learned; but the virtuous only we approve. There have been authors indeed, one at least there has been, who, by confounding admiration with approbation, laboured to confound intellectual accomplishments with moral virtues; but it is shameful inaccuracy, and vile sophistry: one might as well endeavour to confound crimes with misfortunes, and strength of body with purity of mind: and say, that to be a knave and to lose a leg are equally worthy of punishment, and that one man deserves as much praise for being born with a healthy constitution, as another does for leading a good life.

But if sublime ideas are known by their power of inspiring agreeable astonishment, and if Satan in *Paradise Lost* is a sublime idea, does it not follow, that we must be both astonished at his character, and pleased with it? And is it possible to take pleasure in a being, who is the author of evil, and the adversary of God and man?

I answer; that, though we know there is an evil spirit of this name, we know also, that Milton's Satan is partly imaginary; and we believe, that those qualities are so in particular, which we admire in him as great: for we have no reason to think, that he has really that boldness, irresistible strength, or dignity of form, which the poet ascribes to him. So far, therefore, as we admire him for sublimity of character, we consider him, not as the great enemy of our souls, but as a fictitious being, and a mere poetical hero. Now the human imagination can easily combine ideas in an assemblage, which are not combined in nature; and make the same person the object of admiration in one respect, who in another is detestable: and such inventions are in poetry the more probable, because such persons are to be met with in real life. Achilles and Alexander, for example, we admire for their magnanimity, but abhor for their cruelty. And the poet, whose aim is to please, finds it necessary to give some good qualities to his bad characters; for, if he did not, the reader would not be interested in their fortune, nor, consequently, pleased with the story of it.

In the *picture* of a burning city, we may admire the splendour of the colours, the undulation of the flames, the arrangements of light and shade, and the other proofs of the painter's skill; and nothing gives a more exquisite delight of the melancholy kind, than Virgil's account of the burning of Troy. But this does not

imply, that we should, like Nero, take any pleasure in such an event, if it were real and present. Indeed, few appearances are more beautiful, or more sublime, than a mass of flame, rolling in the wind, and blazing to heaven: whence illuminations, bonfires, and fireworks make part of a modern triumph. Yet destruction by fire is of all earthly things the most terrible.

An object more astonishing, both to the eye, and to the ear, there is hardly in nature, than (what is sometimes to be seen in the West Indies) a plantation of sugar-canes on fire, flaming to a vast height, sweeping the whole country, and every moment sending forth a thousand explosions, like those of artillery. A good description of such a scene we should admire as sublime; for a description can neither burn nor destroy. But the planter, who sees it desolating his fields, and ruining all his hopes, can feel no other emotions than horror and sorrow. In a word, the sublime, in order to give pleasing astonishment, must be either imaginary, or not immediately pernicious.

There is a kind of horror, which may be infused into the mind both by natural appearances, and by verbal description; and which, though it make the blood seem to run cold, and produce a momentary fear, is not unpleasing, but may be even agreeable: and therefore, the objects that produce it are justly denominated sublime. Of natural appearances that affect the mind in this manner, are vast caverns, deep and dark woods, overhanging precipices, the agitation of the sea in a storm: and some of the sounds above mentioned have the same effect, as those of cannon and thunder. Verbal descriptions infusing sublime horror are such as convey lively ideas, of the objects of superstition, as ghosts and enchantments; or of the thoughts that haunt the imaginations of the guilty; or of those external things, which are pleasingly terrible, as storms, conflagrations, and the like.

It may seem strange, that horror of any kind should give pleasure. But the fact is certain. Why do people run to see battles, executions and shipwrecks? Is it, as an Epicurean would say, to compare themselves with others, and exult in their own security while they see the distress of those who suffer? No, surely: good minds are swayed by different motives. Is it, that they may be at hand, to give every assistance in their power to their unhappy brethren? This would draw the benevolent, and even the tender-hearted, to a shipwreck; but to a battle, or to an execution, could not bring spectators, because there the humanity of individuals is

of no use. It must be, because a sort of gloomy satisfaction, or terrific pleasure, accompanies the gratification of that curiosity which events of this nature are apt to raise in minds of a certain frame.

No parts of Tasso are read with greater relish, than where he describes the darkness, silence, and other horrors, of the enchanted forest: and the poet himself is so sensible of the captivating influence of such ideas over the human imagination, that he makes the catastrophe of the poem in some measure depend upon them. Milton is not less enamoured 'of forests and enchantments drear'; as appears from the use to which he applies them in *Comus* . . . Forests in every age must have had attractive horrors: otherwise so many nations would not have resorted thither, to celebrate the rites of superstition. And the inventors of what is called the Gothic, but perhaps should rather be called the Saracen, architecture, must have been enraptured with the same imagery, when, in forming and arranging the pillars and aisles of their churches, they were so careful to imitate the rows of lofty trees in a deep grove.

Observe a few children assembled about a fire, and listening to tales of apparitions and witchcraft. You may see them grow pale, and crowd closer and closer through fear: while he who is snug in the chimney corner, and at the greatest distance from the door, considers himself as peculiarly fortunate; because he thinks that, if the ghost should enter, he has a better chance to escape, than if he were in a more exposed situation. And yet, notwithstanding their present, and their apprehension of future, fears, you could not perhaps propose any amusement that would at this time be more acceptable. The same love of such horrors as are not attended with sensible inconvenience continues with us through life: and Aristotle has affirmed, that the end of tragedy is to purify the soul by the operations of pity and terror.

The mind and body of man are so constituted, that, without action, neither can the one be healthy, nor the other happy. And as bodily exercises, though attended with fatigue, as dancing, or with some degree of danger, as hunting, are not on that account the less agreeable; so those things give delight, which rouse the soul, even when they bring along with them horror, anxiety, or sorrow, provided these passions be transient, and their causes rather imaginary than real.

The most perfect models of sublimity are seen in the works of nature. Pyramids, palaces, fireworks, temples, artificial lakes and canals, ships of war, fortifications, hills levelled and caves hollowed by human industry, are mighty efforts, no doubt, and awaken in every beholder a pleasing admiration; but appear as nothing, when we compare them, in respect of magnificence, with mountains, volcanoes, rivers, cataracts, oceans, the expanse of heaven, clouds and storms, thunder and lightening, the sun, moon, and stars. So that, without the study of nature, a true taste in the sublime is absolutely unattainable. And we need not wonder at what is related of Thomson, the author of *The Seasons*; who, on hearing that a certain learned gentleman of London was writing an epic poem, exclaimed, 'He write an Epic poem! It is impossible: he never saw a mountain in his life'. This at least is certain, that if we were to strike out of Homer, Virgil, and Milton, those descriptions and sentiments that allude to the grand phenomena of nature, we should deprive these poets of the best part of their sublimity.

And yet, the true sublime may be attained by human art. Music is sublime, when it inspires devotion, courage, or other elevated affections: or when by its mellow and sonorous harmonics it overwhelms the mind with sweet astonishment: or when it infuses that pleasing horror abovementioned; which, when joined to words descriptive of terrible ideas, it sometimes does very effectually.

Architecture is sublime, when it is large and durable, and withal so simple and well-proportioned as that the eye can take in all its greatness at once. For when an edifice is loaded with ornaments, our attention to them prevents our attending to the whole; and the mind, though it may be amused with the beauty or the variety of the little parts, is not struck with that sudden astonishment, which accompanies the contemplation of sublimity. Hence the Gothic style of building, where it abounds in minute decorations, and where greater pains are employed on the parts, than in adjusting the general harmony of the fabric, is less sublime than the Grecian, in which proportion, simplicity, and usefulness, are more studied than ornament. It is true, that Gothic buildings may be very sublime: witness the old cathedral churches. But this is owing, rather to their vast magnitude, to the stamp of antiquity that is impressed on them, and to their having been so long appro-

priated to religious service, than to those peculiarities that distinguish their architecture from the Grecian.

The Chinese mode of building has no pretensions to sublimity; its decorations being still more trivial than the Gothic; and because it derives no dignity from associated ideas, and has no vastness of magnitude to raise admiration. Yet is it not without its charms. There is an air of neatness in it, and of novelty, which to many is pleasing, and which of late it has been much the fashion to imitate.

Painting is sublime, when it displays men invested with great qualities, as bodily strength, or actuated by sublime passions, as courage, devotion, benevolence. That picture by Guido Rheni, which represents Michael triumphing over the evil spirit, I have always admired for its sublimity, though some critics are not pleased with it. The attitude of the angel, who holds a sword in his right hand in a threatening posture, conveys to me the idea of dignity and grace, as well as of irresistible strength. Nor is the majestic beauty of his person less admirable: and his countenance, though in a slight degree expressive of contempt or indignation, retains that sweet composure, which we think essential to the angelic character. His limbs and wings are, it is true, contrasted: but the contrast is so far from being finical, that, if we consider the action, and the situation, we must allow it to be not only natural, but unavoidable, and such as a winged being might continue in for some time without inconvenience. Guido is not equally fortunate in his delineation of the adversary; who is too mean, and too ludicrous, a figure, to cope with an archangel, or to require, for his overthrow, the twentieth part of that force which appears to be exerted against him. Painting is also sublime, when it imitates grand natural appearances, as mountains, precipices, storms, huge heaps of rocks and ruins, and the like.

At the time when Raphael began to distinguish himself, two styles of painting were cultivated in Italy. His master Pietro Perugino copied nature with an exactness bordering on servility: so that his figures had less dignity and grace than their originals. Michaelangelo ran into the opposite extreme; and, with an imagination fraught with great ideas, and continually aspiring to sublimity, so enlarged the proportions of nature, as to raise his men to giants, and stretch out every form into an extension that might almost be called monstrous. To the penetration of Raphael both styles seemed to be faulty, and both in an equal degree. The one

appeared insipid in its accuracy, and the other almost ridiculous in its extravagance. He therefore pursued a middle course; tempering the fire of Michaelangelo with the caution of Perugino: and thus exhibited the true sublime of painting; wherein the graces of nature are heightened, but nothing is gigantic, disproportioned, or improbable. While we study his cartoons, we seem to be conversing with a species of men, like ourselves indeed, but of heroic dignity and size.

This great artist is in painting, what Homer is in poetry. Homer magnifies in like manner; and transforms men into heroes and demigods; and, to give the more grandeur to his narrative, sets it off with marvellous events, which, in his time, though not improbable, were however astonishing. But Ariosto, and the authors of the Old Romance, resemble Michaelangelo in exalting their champions, not into heroes, but into giants and monsters. Achilles, though superior to all men in valour, would not venture to battle without his arms: but a warrior of romance, whether armed or not, could fell a troop of horse to the earth at one blow, tear up trees by the root, and now and then throw a piece of a mountain at the enemy. The true sublime is always natural and credible: but unbounded exaggerations, that surpass all proportion and all belief, are more apt to provoke laughter than astonishment.

Poetry becomes sublime in many ways: and this is the only fine art, which can at present supply us with examples, I shall from it select a specimen or two of the different sorts of sublimity.

1. Poetry is sublime, when it elevates the mind. This indeed is a general character of greatness. But I speak here of sentiments so happily conceived and expressed, as to raise our affections above the low pursuits of sensuality and avarice, and animate us with the love of virtue and of honour. As a specimen, let me recommend the account, which Virgil gives in his eighth book, of the person, family, and kingdom of Evander; an Arcadian prince, who, after being trained up in all the discipline of Greece, established himself and his people in that part of Italy, where a few centuries after was built the great metropolis of the Roman empire. In the midst of poverty, that good old man retains a philosophical and a royal dignity. 'This habitation (says he, to Aeneas, who had made him a visit) has been honoured with the presence of Hercules himself. Dare, my guest, to despise riches; and do thou also fashion thyself into a likeness of God' or, as some render it, 'do

thou also make thyself worthy of immortality'.[2] There is strength in the expression, whereof our language is not capable. 'I despise the world,' says Dryden, 'when I read it, and myself when I attempt to translate it'.

2. Poetry is sublime, when it conveys a lively idea of any grand appearance in art or nature. A nobler description of this sort I do not at present remember, than that which Virgil gives, in the first book of the *Georgic*, of a dark night, with wind, rain, and lightening: where Jupiter appears, encompassed with clouds and storms, darting his thunderbolts, and overturning the mountains, while the ocean is roaring, the earth trembling, the wild beasts fled away, the rain pouring down in torrents, the woods resounding to the tempest, and all mankind overwhelmed with consternation. The following is a . . . literal translation: but I know not how to imitate, in modern language, the awful . . . simplicity of the original.

> High in the midnight storm enthroned, Heaven's Sire
> Hurls from his blazing arm the bolt of fire.
> Earth feels with trembling; every beast is fled;
> And nations prostrate fall, overwhelmed with dread.
> Athos rolls headlong, where his lightnings fly,
> The rocks of Rhodope in ruin lie,
> Or huge Keraunia. With redoubled rage
> The torrent rain and bellowing wind engage;
> Loud in the woods afar the tempests roar,
> And mountain billows burst in thunder on the shore.

This description astonishes, both by the grandeur, and by the horror, of the scene, which is either wrapt in total darkness, or made visible by the glare of lightning. And the poet has expressed it with the happiest solemnity of style, and a sonorous harmony of numbers. As examples of the same sort of sublimity, namely of great images with a mixture of horror, I might call the reader's attention to the storm in the beginning of the *Aeneid*, the death of Cacus in the eighth book, to the account of Tartarus in the sixth, and that of the burning of Troy in the second. But in the style of dreadful magnificence, nothing is superior, and scarce any thing equal, to Milton's representation of hell and chaos, in the first and second books of *Paradise Lost*.

In the concluding paragraph of the same work, there is brought together, with uncommon strength of fancy, and rapidity of nar-

[2] Virgil, *Aeneid*, Book 8, ll. 364–5.

rative, a number of circumstances, wonderfully adapted to the purpose of filling the mind with ideas of terrific grandeur: the descent of the cherubim; the flaming sword; the archangel leading in haste our first parents down from the heights of paradise, and then disappearing; and, above all, the scene that presents itself on their looking behind them.

> They, looking back, all the eastern cliff beheld
> Of Paradise, so late their happy feat,
> Waved over by that flaming brand; the gate
> With dreadful faces thronged and fiery arms.

To which the last verses form the most striking contrast that can be imagined.

> Some natural tears they dropped, but wiped them soon.
> The world was all before them, where to choose
> Their place of rest, and Providence their guide.
> They, hand in hand, with wandering steps, and slow,
> Through Eden took their solitary way.

The final couplet renews our sorrow; by exhibiting, with picturesque accuracy, the most mournful scene in nature; which yet is so prepared, as to raise comfort, and dispose to resignation. And thus, while we are at once melting in tenderness, elevated with pious hope, and overwhelmed with the grandeur of description, the divine poem concludes. What luxury of mental gratification is here! Who would exchange this frame of mind (if nature could support it) for any other! How exquisitely does the faith of a Christian accord with the noblest feelings of humanity!

3. Poetry is sublime, when, without any great pomp of images or of words, it infuses horror by a happy choice of circumstances. When Macbeth (in Shakespeare) goes to consult the witches, he finds them performing rites in a cave; and, upon asking what they were employed about, receives no other answer than this short one, 'A deed without a name'. One's blood runs cold at the thought, that their work was of so accursed a nature, that they themselves had no name to express it by, or were afraid to speak of it by any name. Here is no solemnity of style, nor any accumulation of great ideas; yet here is the true sublime; because here is something that astonishes the mind, and fills it, without producing any real inconvenience.

Among other omens, which preceded the death of Dido, Virgil relates, that, when she was making an oblation of wine, milk and

incense upon the altar, she observed the milk grow black, and found that the wine was changed into blood. This the poet improves into a circumstance of the utmost horror, when he adds, that she never mentioned it to any person, not even to her sister, who was her confidante on all other occasions: insinuating, that it filled her with so dreadful apprehension, that she had not courage even to attempt to speak of it — perhaps I may be more struck with this, than many others are; as I once knew a young man, who was in the same state of mind, after having been frightened in his sleep, or, as he imagined, by a vision, which he had seen about two years before he told me of it. With much entreaty I prevailed on him to give me some account of his dream: but there was one particular, which he said that he would not, nay that he durst not, mention; and, while he was saying so, his haggard eyes, pale countenance, quivering lips, and faltering voice, presented to me such a picture of horror, as I never saw before or since. I ought to add, that he was, in all other respects, in his perfect mind, cheerful, and active, and not more than twenty years of age.

Horror has long been a powerful, and a favourite, engine in the hands of the tragic poet. Aeschylus employed it more than any other ancient artist. In his play called *The Furies*, he introduced Orestes haunted by a company of those frightful beings; intending thereby an allegorical representation of the torment which that hero suffered in his mind, in consequence of having slain his mother Clytemnestra, for the part she had taken in the murder of his father. But to raise the greater horror in the spectators, the poet was at pains to describe, with amazing force of expression, the appearance of the Furies; and he brought upon the stage no fewer than fifty of them; whose infernal looks, hideous gestures, and horrible screams, had such effects on the women and children, that, in the subsequent exhibitions of the play, the number of furies was by an express law limited, first to fifteen, and afterwards to twelve. There are, no doubt, sublime strokes in the poet's account of these furies; and there is something very great in the idea of a person haunted by his own thoughts, in the form of such terrific beings. Yet horror of this kind I would hardly call sublime, because it is addressed rather to the eyes, than to the mind; and because it is easier to disfigure a man so, as to make him have the appearance of an ugly woman, than, by a brief description, or well-chosen sentiment, to alarm and astonish the fancy. Shakespeare has, in my opinion, excited horror of more genuine sublim-

ity, and withal more useful in a moral view, when he makes Macbeth, in short and broken starts of exclamation, and without any pomp of images or of words, give an utterance half-suppressed to those dreadful thoughts that were passing in his mind immediately before and after the murder of Duncan, his guest, kinsman, sovereign, and benefactor. The agonies of a guilty conscience were never more forcibly represented, than in this tragedy; which may indeed be said, in the language of Aristotle, to purify the mind by the operation of terror and pity; and which abounds more in that species of the sublime whereof I now speak, than any other performance in the English tongue . . .

4. Poetry is sublime, when it awakens in the mind any great and good affection, as piety, or patriotism. This is one of the noblest effects of the art. *The Psalms* are remarkable, beyond all other writings, for their power of inspiring devout emotions. But it is not in this respect only that they are sublime. Of the divine nature they contain the most magnificent descriptions that the soul of man can comprehend. The hundred and fourth psalm, in particular, displays the power and goodness of providence, in creating and preserving the world, and the various tribes of animals in it, with such majestic brevity and beauty, as it is vain to look for in any human composition. The morning song of Adam and Eve, and many other parts of *Paradise Lost*, are noble effusions of piety, breathed in the most captivating strains: and Thomson's Hymn on the Seasons, if we overlook an unguarded word or two, is not inferior.

Of that sublimity which results from the strong expression of patriotic sentiments, many examples might be quoted from the Latin poets, particularly Virgil, Horace, and Lucan: but there is a passage in Homer that suits the present purpose better than any other that now occurs. While Hector is advancing to attack the Greek entrenchments, an eagle lets fall a wounded serpent in the middle of his army. This Polydamas considers as a bad omen, and advises him to order a retreat. Hector rejects the advice with indignation. 'Shall I be deterred from my duty, (says he) and from executing the commands of Jupiter, by the flight of birds? Let them fly on my right hand or on my left, towards the setting or towards the rising sun, I will obey the counsel of Jove, who is the king of gods and of men'. And then he adds that memorable aphorism, 'To defend our country is the best of all auguries', or as Pope has very well expressed it:

> Without a sign, his sword the brave man draws,
> And asks no omen, but his country's cause.

If we attend to all the circumstances, and reflect that both Hector and Homer believed in auguries, we must own that the sentiment is wonderfully great.

I might also quote, from the same book of the *Iliad*, Sarpedon's speech to Glaucus; which contains the noblest lesson of political wisdom, and the most enlivening motives to magnanimity. I shall not translate it literally, but confine myself to the general scope of the argument; and I shall give it in prose, that it may not seem to derive any part of its dignity from the charm of poetical numbers.

> Why, O Glaucus, do we receive from our people in Lycia the hon-
> ours of sovereignty, and so liberal a provision? Is it not in the
> hope, that we are to distinguish ourselves by our virtue, as much
> as we are distinguished by our rank? Let us act accordingly: that,
> when they see us encountering the greatest perils of war, they
> may say, we deserve the honours and the dignity which we pos-
> sess. If indeed (continues he) by declining danger we could secure
> ourselves against old age and the grave, I should neither fight
> myself in the front of the battle, nor exhort you to do so. But since
> death is unavoidable, and may assail us from so many thousand
> quarters, let us advance, and either gain renown by victory, or by
> our fall give glory to the conqueror.

The whole is excellent: but the grandeur and generosity of the conclusion can never be too highly applauded.

5. Poetry is also sublime, when it describes in a lively manner the visible effects of any of those passions that give elevation to the character. Such is that passage, in the conclusion of the same twelfth book of the *Iliad*, which paints the impetuosity and terri-ble appearance of Hector, storming the entrenchments, and pur-suing the enemy to their ships. Extraordinary efforts of magnanimity, valour, or any other virtue, and extraordinary exertions of strength or power, are grand objects, and give sub-limity to those pictures or poems, in which they are well repre-sented. All the great poets abound in examples.

Yet in great strength, for example, there may be unwieldiness, or awkwardness, or some other contemptible quality, whereby the sublime is destroyed. Polyphemus is a match for five hundred Greeks; but he is not a grand object. We hate his barbarity, and despise his folly, too much, to allow him a single grain of admira-tion. Ulysses, who in the hands of Polypheme was nothing, is incomparably more sublime, when, in walking to his palace, dis-

guised like a beggar, he is insulted, and even kicked, by one of his own slaves, who was in the service of those rebels that were tempting his queen, plundering his household, and alienating the affections of his people. Homer tells us, that the hero stood firm, without being moved from his place by the stroke; that he deliberated for a moment, whether he should at one blow fell the traitor to the earth; but that patience and prudential thoughts restrained him. The brutal force of the Cyclops is not near so striking as this picture; which displays bodily strength and magnanimity united. For what we despise we never admire; and therefore despicable greatness cannot be sublime.

Archibald Alison

(1757–1839)

It is fair to say that Alison was not among the most famous of the enlightenment thinkers. Although his only work on aesthetics was published toward the end of the century, it went largely unnoticed until the second edition was published in 1811, whereupon it had a short life of considerable fame. Alison was born in Edinburgh, studied at Glasgow University before moving on to Oxford and then becoming ordained a minister in the Church of England in 1784. His duties as a clergyman rather than the work of a scholar characterise his life, but when he returned to Edinburgh in 1800 he began to move in the foremost intellectual circles, counting for example Dugald Stewart among his closest friends. Indeed, Stewart acknowledges the influence of Alison upon his own aesthetic theory. Still a nineteenth century commentator, after enthusiastically recalling the renown and influence of Alison in his youth, remarks:

> time has sobered down this enthusiasm, and Alison is reckoned neither to have invented a new theory (for its leading idea had been distinctly announced by David Hume); nor to have sifted it with the most philosophical analysis, or expressed it in the happiest language.

In Alison we do not have the glittering intellectual achievements that we find in so many of the other Scottish philosophers, but that is not in itself any reason to ignore the qualities of his work.

Building in many respects upon the earlier work of Alexander Gerard, who extensively uses the association of ideas as an important tool of explanation of aesthetic phenomena, Alison provides perhaps the most complete and nuanced associationist account of taste, the imagination, and the aesthetic qualities of beauty and

the sublime. The extract that follows is from his analysis of the operation of the imagination, which he argues is crucial for the operation of the faculty of taste as it sets a train of thought in motion that corresponds to the complex emotion that is caused by beauty.

Further Reading

George Dickie, *The Century of Taste*, Oxford: Oxford University Press, 1996.

W.J. Hipple, *The Beautiful, The Sublime and the Picturesque in Eighteenth Century Aesthetic Theory*, Carbondale: Southern Illinois University Press, 1957.

READING XIV

ANALYSIS OF THE EXERCISE OF IMAGINATION[1]

The illustrations in the preceding chapter seem to show, that whenever the emotions of sublimity or beauty are felt, that exercise of imagination is produced, which consists in the indulgence of a train of thought; that when this exercise is prevented, these emotions are unfelt or unperceived; and that whatever tends to increase this exercise of mind, tends in the same proportion to increase these emotions. If these illustrations are just, it seems reasonable to conclude, that the effect produced upon the mind, by objects of sublimity and beauty, consists in the production of this exercise of imagination.

Although, however, this conclusion seems to me both just and consonant to experience, yet it is in itself too general, to be considered as a sufficient account of the nature of that operation of mind which takes place in the case of such emotions. There are many trains of ideas of which we are conscious, which are unattended with any kind of pleasure. There are other operations of mind, in which such trains of thought are necessarily produced, without exciting any similar emotion. Even in the common hours of life, every man is conscious of a continued succession of thoughts passing through his mind, suggested either by the presence of external objects, or arising from the established laws of association: such trains of thought, however, are seldom attended with

[1] From *Essays on the Nature and Principle of Taste* (Edinburgh, 1790).

pleasure, and still seldomer with an emotion, corresponding, in any degree, to the emotions of sublimity or beauty.

There are, in like manner, many cases where objects excite a train of thought in the mind, without exciting any emotion of pleasure or delight. The prospect of the house, for instance, where one has formerly lived, excites very naturally a train of conceptions in the mind; yet it is by no means true that such an exercise of imagination is necessarily accompanied with pleasure, for these conceptions not only may be, but very often are of a kind extremely indifferent, and sometimes also simply painful. The mention of an event in history, or of a fact in science, naturally leads us to the conception of a number of related events, or similar facts; yet it is obvious, that in such a case the exercise of mind which is produced, if it is accompanied with any pleasure at all, is in most cases accompanied with a pleasure very different from that which attends the emotions of sublimity or beauty.

If therefore some train of thought, or some exercise of imagination is necessary for the production of the emotions of taste, it is obvious that this is not every train of thought of which we are capable. To ascertain, therefore, with any precision, either the nature or the causes of these emotions, it is previously necessary to investigate the nature of those trains of thought that are produced by objects of sublimity and beauty, and their difference from those ordinary trains, which are unaccompanied with such pleasure.

As far as I am able to judge, this difference consists in two things. First, in the nature of the ideas or conceptions which compose such trains: and, secondly, in the nature or law of their succession.

1. In our ordinary trains of thought, every man must be conscious that the ideas which compose them, are very frequently of a kind which excite no emotions either of pleasure or pain. There is an infinite variety of our ideas, as well as of our sensations, that may be termed indifferent, which are perceived without any sentiment either of pain or pleasure, and which pass as it were before the mind, without making any farther impression than simply exciting the consciousness of their existence. That such ideas compose a great part, and perhaps the greatest part of our ordinary trains of thought, is apparent from the single consideration, that such trains are seldom attended with emotion of any kind.

The trains of thought which are suggested by external objects, are very frequently of a similar kind. The greater part of such objects are simply indifferent, or at least are regarded as indifferent in our common hours either of occupation or amusement: the conceptions which they produce, by the laws of association, partake of the nature or character of the object which originally excited them, and the whole train passes through our mind without leaving any farther emotion, than perhaps that general emotion of pleasure which accompanies the exercise of our faculties. It is scarcely possible for us to pass an hour of our lives without experiencing some train of thought of this kind, suggested by some of the external objects which happen to surround us. The indifference with which such trains are either pursued or deserted, is a sufficient evidence, that the ideas of which they are composed, are in general of a kind unfitted to produce any emotion, either of pleasure or pain.

In the case of those trains of thought, on the contrary, which are suggested by objects either of sublimity or beauty, I apprehend it will be found, that they are in all cases composed of ideas capable of exciting some affection or emotion; and that not only the whole succession is accompanied with that peculiar emotion, which we call the emotion of beauty or sublimity, but that every individual idea of such a succession is in itself productive of some simple emotion or other. Thus the ideas suggested by the scenery of spring, are ideas productive of emotions of cheerfulness, of gladness, and of tenderness. The images suggested by the prospect of ruins, are images belonging to pity, to melancholy, and to admiration. The ideas, in the same manner, awakened by the view of the ocean in a storm, are ideas of power, of majesty, and of terror. In every case where the emotions of taste are felt, I conceive it will be found, that the train of thought which is excited, is distinguished by some character of emotion, and that it is by this means distinguished from our common or ordinary successions of thought. To prevent a very tedious and unnecessary circumlocution, such ideas may perhaps, without any impropriety, be termed ideas of emotion; and I shall beg leave therefore to use the expression in this sense.

The first circumstance, then, which seems to distinguish those trains of thought which are produced by objects either of sublimity or beauty, is, that the ideas or conceptions of which they are composed, are ideas of emotion.

2. In our ordinary trains of thought, there seldom appears any general principle of connection among the ideas which compose them. Each idea, indeed, is related, by an established law of our nature, to that which immediately preceded and that which immediately follows it, but in the whole series there is no predominant relation or bond of connection. This want of general connection is so strong, that even that most general of all relations, the relation either of pleasure or pain, is frequently violated. Images both of the one kind and the other succeed each other in the course of the train; and when we put an end to it, we are often at a loss to say, whether the whole series was pleasant or painful. Of this irregularity, I think every man will be convinced, who chooses to attend to it.

In those trains, on the contrary, which are suggested by objects of sublimity or beauty, however slight the connection between individual thoughts may be, I believe it will be found, that there is always some general principle of connection which pervades the whole, and gives them some certain and definite character. They are either gay, or pathetic, or melancholy, or solemn, or awful, or elevating, &c. according to the nature of the emotion which is first excited. Thus the prospect of a serene evening in summer, produces first an emotion of peacefulness and tranquillity, and then suggests a variety of images corresponding to this primary impression. The sight of a torrent, or of a storm, in the same manner, impresses us first with sentiments of awe, or solemnity, or terror, and then awakens in our minds a series of conceptions allied to this peculiar emotion. Whatever may be the character of the original emotion, the images which succeed seem all to have a relation to this character; and if we trace them back, we shall discover not only a connection between the individual thoughts of the train, but also a general relation among the whole, and a conformity to that peculiar emotion which first excited them.

The train of thought, therefore, which takes place in the mind, upon the prospect of objects of sublimity and beauty, may be considered as consisting in a regular or consistent train of ideas of emotion, and as distinguished from our ordinary trains of thought, first, in respect of the nature of the ideas of which it is composed, by their being ideas productive of emotion: and secondly, in respect of their succession, by their being distinguished by some general principle of connection, which subsists through the whole extent of the train.

The truth of the account which I have now given of the nature of that train of thought which attends the emotions of sublimity and beauty, must undoubtedly at last be determined by its conformity to general experience and observation. There are some considerations, however, of a very obvious and familiar kind, which it may be useful to suggest to the reader, for the purpose of affording him a method of investigating with accuracy the truth of this account.

If it is true that the ideas which compose that train of thought, which attends the emotions of taste, are uniformly ideas of emotion, then it ought in fact to be found, that no objects or qualities are experienced to be beautiful or sublime, but such as are productive of some simple emotion.

If it is true that such trains of thought are uniformly distinguished by some general principle of connection, then it ought also to be found, that no composition of objects or qualities produces such emotions, in which this unity of character or of emotion is not preserved. I shall endeavour, at some length, to illustrate the truth of both these propositions.

READING XV

OF THE EFFECT OF SUBLIMITY AND BEAUTY UPON THE IMAGINATION[2]

The emotions of sublimity and beauty are uniformly ascribed, both in popular and in philosophical language, to the imagination. The fine arts are considered as the arts which are addressed to the imagination, and the pleasures they afford are described, by way of distinction, as the pleasures of the imagination. The nature of any person's taste, is, in common life, generally determined by the nature or character of his imagination, and the expression of any deficiency in this power of mind, is considered as synonymous with the expression of a similar deficiency in point of taste.

Although, however, this connection is so generally acknowledged, it is not perhaps as generally understood in what it consists, or what is the nature of that effect which is produced upon the imagination by objects of sublimity and beauty. I shall endeavour, therefore, in the first place, to state what seems to me

[2] From *Essays on the Nature and Principle of Taste* (London, 1790).

the nature of this effect, or, in what that exercise of imagination consists, which is so generally supposed to take place, when these emotions are felt.

When any object, either of sublimity or beauty, is presented to the mind, I believe every man is conscious of a train of thought being immediately awakened in his imagination, analogous to the character or expression of the original object. The simple perception of the object, we frequently find, is insufficient to excite these emotions, unless it is accompanied with this operation of mind, unless, according to common expression, our imagination is seized, and our fancy busied in the pursuit of all those trains of thought which are allied to this character or expression.

Thus, when we feel either the beauty or sublimity of natural scenery — the gay lustre of a morning in spring, or the mild radiance of a summer evening, the savage majesty of a wintry storm, or the wild magnificence of a tempestuous ocean — we are conscious of a variety of images in our minds, very different from those which the objects themselves can present to the eye. Trains of pleasing or of solemn thought arise spontaneously within our minds: our hearts swell with emotions, of which the objects before us seem to afford no adequate cause; and we are never so much satiated with delight, as when, in recalling our attention, we are unable to trace either the progress or the connection of those thoughts, which have passed with so much rapidity through our imagination.

The effect of the different arts of taste is similar. The landscapes of Claude Lorraine, the music of Handel, the poetry of Milton, excite feeble emotions in our minds when our attention is confined to the qualities they present to our senses, or when it is to such qualities of their composition that we turn our regard. It is then, only, we feel the sublimity or beauty of their productions, when our imaginations are kindled by their power, when we lose ourselves amid the number of images that pass before our minds, and when we waken at last from this play of fancy, as from the charm of a romantic dream . . . And in the production of such trains of thought, seems to consist the effect which objects of sublimity and beauty have upon the imagination.

For the truth of this observation itself, I must finally appeal to the consciousness of the reader; but there are some very familiar considerations, which it may be useful to suggest, that seem very

strongly to show the connection between this exercise of imagination, and the existence of the emotions of sublimity or beauty . . .

First, if the mind is in such a state as to prevent this freedom of imagination, the emotion, whether of sublimity or beauty, is unperceived. In so far as the beauties of art or nature affect the external senses, their effect is the same upon every man who is in possession of these senses. But to a man in pain or in grief, whose mind, by these means, is attentive only to one object or consideration, the same scene, or the same form, will produce no feeling of admiration, which, at other times, when his imagination was at liberty, would have produced it in its fullest perfection. Whatever is great or beautiful in the scenery of external nature, is almost constantly before us; and not a day passes, without presenting us with appearances, fitted both to charm and to elevate our minds; yet it is in general with a heedless eye that we regard them, and only in particular moments that we are sensible of their power. There is no man, for instance, who has not felt the beauty of sunset; yet everyone can remember many instances, when this most striking scene had no effect at all upon his imagination; and when he has beheld all the magnificence with which nature generally distinguishes the close of day, without one sentiment of admiration or delight. There are times, in the same manner, when we can read the *Georgics*, or the *Seasons*, with perfect indifference, and with no more emotion, than what we feel from the most uninteresting composition in prose; while in other moments, the first lines we meet with take possession of our imagination, and awaken in it such innumerable trains of imagery, as almost leave the fancy of the poet behind. In these, and similar cases of difference in our feelings, from the same objects, it will always be found, that the difference arises from the state of our imaginations; from our disposition to follow out the train of thought which such objects naturally produce, or our incapacity to do it, from some other idea, which has at that time taken possession of our minds, and renders us unable to attend to anything else. That state of mind, every man must have felt, is the most favourable to the emotions of taste, in which the imagination is free and unembarrassed, or, in which the attention is so little occupied by any private or particular object of thought, as to leave us open to all the impressions, which the objects that are before us can produce. It is upon the vacant and the unemployed, accordingly, that the objects of taste make the strongest impression. It is in such hours

alone, that we turn to the compositions of music, or of poetry, for amusement. The seasons of care, of grief, or of business, have other occupations, and destroy, for the time at least, our sensibility to the beautiful or the sublime, in the same proportion that they produce a state of mind unfavourable to the indulgence of imagination.

Secondly, the same thing is observable in criticism. When we sit down to appreciate the value of a poem, or of a painting, and attend minutely to the language or composition of the one, or to the colouring or design of the other, we feel no longer the delight which they at first produce. Our imagination in this employment is restrained, and, instead of yielding to its suggestions, we studiously endeavour to resist them, by fixing our attention upon minute and partial circumstances of the composition. How much this operation of mind tends to diminish our sense of its beauty, every one will feel, who attends to his own thoughts on such an occasion, or who will recollect how different was his state of mind, when he first felt the beauty either of the painting or the poem. It is this, chiefly, which makes it so difficult for young people, possessed of imagination, to judge of the merits of any poem or fable, and which induces them so often to give their approbation to compositions of little value. It is not that they are incapable of learning in what the merits of such compositions consist, for these principles of judgment are neither numerous nor abstruse. It is not that greater experience produces greater sensibility, for this everything contradicts; but it is, because everything, in that period of life, is able to excite their imaginations, and to move their hearts, because they judge of the composition, not by its merits, when compared with other works, or by its approach to any abstract or ideal standard but by its effect in agitating their imaginations, and leading them into that fairy land, in which the fancy of youth has so much delight to wander. It is their own imagination which has the charm, which they attribute to the work that excites it; and the simplest tale, or the poorest novel, is, at that time, as capable at awakening it, as afterwards the eloquence of Virgil or Rousseau. All this, however, all this flow of imagination, in which youth and men of sensibility are so apt to indulge, and which so often brings them pleasure at the expense of their taste, the labour of criticism destroys. The mind, in such an employment, instead of being at liberty to follow whatever trains of imagery the composition before it can excite, is either fettered to the

consideration of some of its infinite and solitary parts; or pauses amid the rapidity of its conceptions, to make them the objects of its attention and review. In these operations, accordingly, the emotion, whether of beauty or sublimity, is lost, and if it is wished to be recalled, it can only be done by relaxing this vigour of attention, and resigning ourselves again to the natural stream of our thoughts. The mathematician who investigates the demonstrations of the Newtonian philosophy, the painter who studies the designs of Raphael, the poet who reasons upon the measure of Milton, all, in such occupations, lose the delight which these several productions can give; and when they are willing to recover their emotion, must withdraw their attention from those minute considerations, and leave their fancy to expatiate at will, amid all the great or pleasing conceptions, which such productions of genius can raise.

Thirdly, the effect which is thus produced upon the mind by temporary exertions of attention, is also more permanently produced by the difference of original character; and the degree in which the emotions of sublimity or beauty are felt, is in general proportioned to the prevalence of those relations of thought in the mind, upon which this exercise of imagination depends. The principal relation which seems to take place in those trains of thought that are produced by objects of taste, is that of resemblance; the relation, of all others, the most loose and general, and which affords the greatest range of thought for our imagination to pursue. Wherever, accordingly, these emotions are felt, it will be found, not only that this is the relation which principally prevails among our ideas, but that the emotion itself is proportioned to the degree in which it prevails.

In the effect which is produced upon our minds, by the different appearances of natural scenery, it is easy to trace this progress of resembling thought, and to observe, how faithfully the conceptions which arise in our imaginations, correspond to the impressions which the characters of these seasons produce. What, for instance, is the impression we feel from the scenery of spring? The soft and gentle green with which the earth is spread, the feeble texture of the plants and flowers, the youth of animals just entering into life, and the remains of winter yet lingering among the woods and hills all conspire to infuse into our minds somewhat of that fearful tenderness with which infancy is usually beheld. With such a sentiment, how innumerable are the ideas which present

themselves to our imagination! Ideas, it is apparent, by no means confined to the scene before our eyes, or to the possible desolation which may yet await its infant beauty, but which almost involuntary extend themselves to analogies with the life of man, and bring before us all those images of hope or fear, which, according to our peculiar situations, have the dominion of our heart! The beauty of autumn is accompanied with a similar exercise of thought: the leaves begin then to drop from the trees; the flowers and shrubs, with which the fields were adorned in the summer months, decay; the woods and groves are silent; the sun himself seems gradually to withdraw his light, or to become enfeebled in his power. Who is there, who, at this season, does not feel his mind impressed with a sentiment of melancholy? Or who is able to resist that current of thought, which, from such appearances of decay, so naturally leads him to the solemn imagination of that inenviable fate, which is to bring on alike the decay of life, of empire, and of nature itself? In such cases of emotions, every man must have felt, that the character of the scene is no sooner impressed upon his mind, than various trains of correspondent imagery rise before his imagination; that whatever may be the nature of the impression, the general tone of his thoughts partakes of his nature or character; and that his delight is proportioned to the degree in which this uniformity of character prevails.

The same effect, however, is not produced upon all men. There are many, whom the prospect of such appearances in nature excites to no exercise of fancy whatever; who, by their original constitution, are more disposed to the employment of attention, than of imagination; and who, in the objects that are presented to them, are more apt to observe their individual and distinguishing qualities, than those by which they are related to other objects of their knowledge. Upon the minds of such men, the relation of resemblance has little power; the efforts of their imagination, accordingly, are either feeble or slow; and the general character for their understandings is that of steady and precise, rather than that of enlarged and extensive thought. It is, I believe, consistent with general experience, that men of this description are little sensible to the emotions of sublimity or beauty; and they who have attended to the language of such men, when objects of this kind have been presented to them, must have perceived that the emotion they felt, was no greater than what they themselves have

experienced in those cases, where they have exerted a similar degree of attention, or when any other cause has restrained the usual exercise of their imagination. To the qualities which are productive of simple emotion, to the useful, the agreeable, the fitting, or the convenient in objects, they have the same sensibility with other men; but of the superior and more complex emotion of beauty, they seem to be either altogether unconscious, or to share in it only in proportion to the degree in which they can relax this severity of attention, and yield to the relation of resembling thought.

It is in the same manner, that the progress of life generally takes from men their sensibility to the objects of taste. The season in which these are felt in their fullest degree is in youth, when, according to common expression, the imagination is warm, or in other words, when it is easily excited to that exertion upon which so much of the emotion of beauty depends. The business of life, in the greatest part of mankind, and the habits of more accurate thought, which are acquired by the few who reason and reflect, tend equally to produce in both, a stricter relation in the train of their thoughts, and greater attention to the objects of their consideration, than can either be expected, or can happen in youth. They become, by these means, not only less easily led to any exercise of imagination, but their associations become at the same time less consistent with the employment of it. The man of business, who has passed his life in studying the means of accumulating wealth, and the philosopher, whose years have been employed in the investigation of causes, have both not only acquired a constitution of mind very little fitted for the indulgence of imagination, but have acquired also associations of a very different kind from those which take place when imagination is employed. In the first of these characters, the prospect of any beautiful scene in nature would induce no other idea than that of its value. In the other, it would lead only to speculations upon the causes of the beauty that was ascribed to it. In both, it would thus excite ideas, which could be the foundation of no exercise of imagination, because they required thought and attention. To a young mind, on the contrary, possessed of any sensibility, how many pleasing ideas would not such a prospect afford? — ideas of peace, and innocence, and rural joy, and all the unblemished delights of solitude and contemplation. In such trains of imagery, no labour of thought, or habits of attention, are required; they rise spontane-

ously in the mind, upon the prospect of any object to which they bear the slightest resemblance, and they lead it almost insensibly along, in a kind of bewitching reverie, through all its store of pleasing or interesting conceptions. To the philosopher, or the man of business, the emotion of beauty, from such a scene, would be but feebly known; but by the young mind, which had such sensibility, it would be felt in all its warmth, and would produce an emotion of delight, which not only would be little comprehended by men of a severer or more thoughtful character, but which seems also to be very little dependent upon the object which excites it, and to be derived, in a great measure, from this exercise of mind itself.

In these familiar instances, it is obvious how much the emotions of taste are connected with this state or character of imagination; and how much those habits or employments of mind, which demand attention, or which limit it to the consideration of single objects, tend to diminish the sensibility of mankind to the emotions of sublimity or beauty.

Dugald Stewart

(1753–1828)

The inclusion of this essay in a collection of texts from the eighteenth century is certainly stretching the rubric of admission. In part it is justified because Stewart tells us that the ideas he records in his essays on aesthetics occurred to him well before they were written, and partly because Stewart's thought is firmly rooted in the eighteenth century. The child of the professor of mathematics at Edinburgh University, Stewart was born in university buildings and grew up surrounded by scholars and students. After finishing his course at Edinburgh he went to Glasgow to study philosophy under Thomas Reid. In 1772 at the age of 19, after a year in Glasgow, he stood in for his father as professor of mathematics at Edinburgh. This began his long association with that University, which saw him holding many chairs and teaching many subjects over the years, but none more famously than his tenure in the Chair of Moral Philosophy. In this role he acquired a formidable reputation as an educator, and many of his students occupied distinguished positions in government and society. By the end of his life he was a towering figure on the stage of European philosophy and letters, but by this time, however, the long tradition of Scottish enlightenment philosophy that Stewart represented was coming to an end and giving way to the influence of German idealism, and by the mid-nineteenth century Stewart's work was beginning to fall into a neglect that has not been reversed since.

Stewart began publishing late in his life, with most of his important works coming out after he had retired from his academic post. The *Philosophical Essays*, in which his essay on the beautiful appeared, collects together several sets of essays on

diverse subjects, covering the history of philosophy in the seventeenth and eighteenth centuries, the nature of language, the function of education and aesthetics. Of these latter essays, the treatment of taste is most prefigured by his earlier *Elements of the Philosophy of the Human Mind* (Vol. 1, 1792), but the tools of explanation he uses in the other essays is already present in his earlier thought as well. In particular, his strong endorsement of nominalist explanations of the meaning of general terms is fruitfully brought to bear upon the analysis of the meaning of 'beauty'. Stewart also presents an early variety of what would today be called aesthetic cognitivism, or the view that thought and understanding are at least as important to aesthetic experience as feelings and emotions. This is not to deny the important role of sentiment in the experience of the beautiful, but that judgments of beauty are not reports of the existence of a pleasurable feeling.

Stewart's essay is also striking to contemporary philosophical eyes for another reason. Early in the essay he argues that 'beauty' has no one meaning, but rather a multi-faceted meaning that has evolved over time as experiences of one sort become associated with others and the word beauty is transferred from one context of meaning to another. The way he presents this argument makes it a striking precursor of an influential argument that Wittgenstein put forward in the middle of the twentieth century, and which had a powerful affect upon philosophical aesthetics in the latter part of the century. If Stewart sometimes seems to be strikingly modern in his views, it is a pity that his aesthetic thought has been almost completely ignored.

Further Reading

Peter Kivy, *The Seventh Sense*, 2nd edition, Oxford: Oxford University Press, 2003.

READING XVI

ON THE BEAUTIFUL[1]

The word Beauty, and, I believe, the corresponding term in all languages whatever, is employed in a great variety of acceptations, which seem, on a superficial view, to have very little connection with each other; and among which it is not easy to trace the slightest shade of common or coincident meaning. It always, indeed, denotes something which gives not merely *pleasure* to the mind, but a certain *refined* species of pleasure, remote from those grosser indulgences which are common to us with the brutes; but it is not applicable universally in every case where such refined pleasures are received; being confined to those exclusively which form the proper objects of intellectual taste. We speak of beautiful colours, beautiful forms, beautiful pieces of music: We speak also of the beauty of virtue; of the beauty of poetical composition; of the beauty of style in prose; of the beauty of a mathematical theorem; of the beauty of a philosophical discovery. On the other hand, we do *not* speak of beautiful tastes, or of beautiful smells; nor do we apply this epithet to the agreeable softness, or smoothness, or warmth of tangible objects, considered solely in their relation to our sense of feeling. Still less would it be consistent with the common use of language, to speak of the beauty of high birth, of the beauty of a large fortune, or of the beauty of extensive renown.

It has long been a favourite problem with philosophers, to ascertain the common quality or qualities which entitles a thing to the denomination of *beautiful*; but the success of their speculations has been so inconsiderable, that little can be inferred from them but the impossibility of the problem to which they have been directed. The author of the article *Beau* in the French *Encyclopédie*, after some severe strictures on the solution proposed by his predecessors, is led, at last, to the following conclusions of his own, which he announces with all the pomp of discovery:

> Beauty consists in the perception of relations . . . Place beauty in the perception of *relations*, and you will have the history of its progress from the infancy of the world to the present hour. On the other hand choose for the distinguishing characteristic of the *beautiful in general*, any other quality you can possibly imagine, and you will immediately find your notion limited in its applica-

[1] From *Philosophical Essays* (1810).

tions to the modes of thinking prevalent in particular countries, or at particular periods of time. The perception of Relations is therefore the foundation of the *beautiful*; and it is this perception which, in different languages, has been expressed by so many different names, all of them denoting different modifications of the same general idea.

The same writer, in another article, defines Beauty 'to be the power of exciting in us the perception of *agreeable relations*'; to which definition he adds the following clause: 'I have said *agreeable*, in order to adapt my language to the general and common acceptation of the term Beauty; but I believe, that, *philosophically speaking*, every object is beautiful, which is fitted to excite in us the perception of *relations*'. On these passages I have nothing to offer, in the way either of criticism or of comment; as I must fairly acknowledge my incapacity to seize the idea which the author wishes to convey. To say that 'beauty consists in the perception of relations', without specifying what these relations are; and afterwards to qualify these relations by the epithet agreeable, *in deference to popular prejudices*, would infer, that this word is *philosophically* applicable to all those objects which are *vulgarly* denominated deformed or ugly; inasmuch as a total want of symmetry and proportion in the parts of an object does not, in the least, diminish the number of relations perceived; not to mention, that the same definition would exclude from the denomination of beautiful all the different modifications of *colour*, as well as various other qualities, which, according to the common use of language, fall unquestionably under that description. On the other hand, if the second, and more restricted definition be adhered to (that 'beauty consists in the perception of such relations *as are agreeable*'), no progress is made towards a solution of the difficulty. To inquire what the relations are which are *agreeable* to the mind, would, on this supposition, be only the original problem concerning the nature of the beautiful, proposed in a different and more circuitous form.

The speculations which have given occasion to these remarks have evidently originated in a prejudice which has descended to modern times from the scholastic ages; that when a word admits of a variety of significations, these different significations must all be *species* of the same *genus*; and must consequently include some essential idea common to every individual to which the generic

term can be applied. In the article just quoted, this prejudice is assumed as an indisputable maxim.

> Beautiful is a term which we apply to an infinite variety of things; but, by whatever circumstances these may be distinguished from each other, it is certain, either that we make a false application of the word, or that there exists, in all of them, a common quality, of which the term beautiful is the sign.

Of this principle, which has been an abundant source of obscurity and mystery in the different sciences, it would be easy to expose the unsoundness and futility; but, on the present occasion, I shall only remind my readers of the absurdities into which it led the Aristotelians on the subject of *causation*. The ambiguity of the word, which, in the Greek language, corresponds to the English word, *cause*, having suggested to them the vain attempt of tracing the common idea which, in the case of any *effect*, belongs to the *efficient*, to the *matter*, to the *form*, and to the *end*. The idle generalities we meet with in other philosophers, about the ideas of the *good*, the *fit*, and the *becoming*, have taken their rise from the same undue influence of popular epithets on the speculations of the learned.

Socrates, whose plain good sense appears in this, as in various other instances, to have fortified his understanding to a wonderful degree against the metaphysical subtleties which misled his successors, was evidently apprised fully of the justness of the foregoing remarks, if any reliance can be placed on the account given by Xenophon of his conversation with Aristippus about the Good and the Beautiful. Aristippus . . . asked Socrates if he knew anything that was good?

> Do you ask me [said Socrates] if I know anything *good* for a *fever*, or for an inflammation in the *eyes*, or as a preservative against a *famine*?

> By no means, returned the other

> Nay, then [replied Socrates], if you ask me concerning a *good* which is *good for nothing*, I know of none such; nor yet do I desire to know it.

> [Aristippus still urging him] But do you know (said he) anything Beautiful?

> A great many [returned Socrates].

> Are these all like to one another?

Far from it, Aristippus; there is a very considerable difference between them.

But how [said Aristippus] can *beauty* differ from *beauty*?

The question plainly proceeded on the same supposition which is assumed in the passage quoted above from Diderot; a supposition founded (as I shall endeavour to show) on a total misconception of the nature of the circumstances, which, in the history of language, attach different meanings to the same words; and which often, by slow and insensible gradations, remove them to such a distance from their primitive or radical sense, that no ingenuity can trace the successive steps of their progress. The variety of these circumstances is, in fact, so great, that it is impossible to attempt a complete enumeration of them, and I shall, therefore, select a few of the cases, in which the principle now in question appears most obviously and indisputably to fail.

I shall begin with supposing that the letters A, B, C, D, E, denote a series of objects; that A posses some one quality in common with B; B a quality in common with C; C a quality in common with D; D a quality in common with E — while, at the same time, no quality can be found which belongs in common to any *three* objects in the series. Is it not conceivable, that the affinity between A and B may produce a transference of the name of the first to the second; and that, in consequence of the other affinities which connect the remaining objects together, the same name may pass in succession from B to C; from C to D; and from D to E? In this manner, a common appellation will arise between A and E, although the two objects may, in their nature and properties, be so widely distant from each other, that no stretch of imagination can conceive how the thoughts were led from the former to the latter. The transitions, nevertheless, may have been all so easy and gradual, that, were they successfully detected by the fortunate ingenuity of a theorist, we should instantly recognize, not only the verisimilitude, but the truth of the conjecture . . .

These observations may, I hope, throw some additional light on a distinction pointed out by Mr Knight, in his *Analytical Inquiry into the Principles of Taste*, between the *transitive* and the *metaphorical* meanings of a word. 'As all epithets', he remarks, 'employed to distinguish qualities perceivable only by the intellect, were originally applied to objects of sense, the primary words in all languages belong to them; and are, therefore, applied *transitively*,

though not always *figuratively*, to objects of intellect or imagination'. The distinction appears to me to be equally just and important; and as the epithet *transitive* expresses clearly and happily the idea which I have been attempting to convey by the preceding illustration, I shall make no scruple to adopt it in preference to *figurative* or *metaphorical*, wherever I may find it better adapted to my purpose, in the further prosecution of this subject. It may not be altogether superfluous to add, that I use the word *transitive* as a *generic* term, and *metaphorical* as the *specific*; every metaphor being necessarily a *transitive* expression, although there are many *transitive* expressions which can, with no propriety, be said to be *metaphorical*.

A French author of the highest rank, both as a mathematician and as a philosopher (M. D'Alembert), had plainly the same distinction in view when he observed, that, beside the appropriate and the figurative meanings of a word, there is another (somewhat intermediate between the former two), which may be called its meaning *par extension*. In the choice of this phrase, he has certainly been less fortunate than Mr Knight; but, as he has enlarged upon his idea at some length, and with his usual perspicuity and precision, I shall borrow a few of his leading remarks, as the best comment I can offer on what has been already stated; taking the liberty only to substitute in my version the epithet *transitive*, instead of the phrase *par extension*, wherever the latter may occur in the original:

> Grammarians are accustomed to distinguish two sorts of meaning in words; first, the literal, original, or primitive meaning; and, secondly, the figurative or metaphorical meaning, in which the former is transferred to an object to which it is not naturally adapted. In the phrases, for example, *l' éclat de la lumière*, and *l'éclat de la vertu*, the word *éclat* is first employed literally, and afterwards figuratively. But, besides these, there is a sort of intermediate meaning, which may be distinguished by the epithet *transitive*. Thus, when I say, *l' éclat de la lumière, l' éclat du son, l' éclat de la vertu*, the word *éclat* is applied *transitively* from *light* to *noise*; from the sense of *sight*, to which it properly belongs, to that of *hearing*, with which it has no original connection. It would, at the same time, be incorrect to say, that the phrase *l' éclat du son* is figurative; inasmuch as this last epithet implies the application to some intellectual notion, of a word at first appropriated to an object of the external senses.

After illustrating this criticism by various other examples, D'Alembert proceeds thus:

> There is not, perhaps, in the French language, a single word susceptible of various interpretations, of which the different meanings may not all be traced from one common root, by examining the manner in which the radical idea has passed, by slight gradations, into the other senses in which the word is employed: And it would, in my opinion, be an undertaking equally philosophical and useful, to mark, in a dictionary, all the possible shades of signification belonging to the same expression, and to exhibit, in succession, the easy transitions by which the mind might have proceeded from the first to the last term of the series.[2]

In addition to these excellent remarks (which I do not recollect to have seen referred to by any succeeding writer), I have to observe farther, that, among the innumerable applications of language which fall under the general title of *transitive*, there are many which are the result of local or of casual associations; while others have their origins in the constituent principles of human nature, or in the universal circumstances of the human race. The former seem to have been the *transitions* which D'Alembert had in his view in the foregoing quotation; and to trace them belongs properly to the compilers of etymological and critical dictionaries. The latter form a most interesting object of examination to all who prosecute the study of the human mind; more particularly to those who wish to investigate the principles of philosophical criticism. A few slight observations on both may be useful, in preparing the way for the discussions which are to follow.

First, new applications of words have been frequently suggested by habits of association peculiar to the individuals by whom they were first introduced, or resulting naturally from the limited variety of ideas presented to them in the course of their professional employments, is matter of obvious and common remark. The genius even of some *languages* has been supposed to be thus affected by the pursuits which chiefly engrossed the attention of the nations by which they were spoken; the genius of Latin, for instance, by the habitual attention of the Romans to military operations; that of the Dutch by the early and universal familiarity of the inhabitants of Holland with the details connected with inland navigation, or with a seafaring life. It has been remarked by several writers, that the Latin word *intervallum* was evidently

[2] *Eclaircissements sur les Elémens de Philosophie*, ix.

borrowed from the appropriate phraseology of a camp; *inter vallos spatium*, — the space between the stakes or palisades which strengthened the rampart. None of them, however, has taken any notice of the insensible *transitions* by which it came successively to be employed in a more enlarged sense; first to express a limited portion of longitudinal extension in general; and afterwards limited portions of time as well as of space . . . The same word has passed into our language; and it is not a little remarkable, that it is now so exclusively appropriated to *time*, that to speak of the interval between two *places* would be censured as a mode of expression not agreeable to common use. Etymologies of this sort are, when satisfactory, or even plausible, amusing and instructive: but when we consider how very few the cases are, in which we have access thus to trace words to their first origin, it must appear manifest, into what absurdities the position of the Encyclopaedists is likely to lead those who shall adopt it as a maxim of philosophical investigation.

Other accidents, more capricious still, sometimes operate on language; as when a word is transferred from one object or event to another, merely because they happened both to engross public attention at the same period. The names applied to different colours, and to different articles of female dress, from the characters most prominent at the moment in the circles of fashion, afford sufficient instances of this species of association.

But, even where the transference cannot be censured as at all capricious, the application of the maxim in question will be found equally impracticable. This, I apprehend, happens in all the uses of language suggested by analogy; as when we speak of *the morning of our days*; of *the chequered condition of human life*; of *the lights of science*; or of *the rise and the fall of empires*. In all these instances, the metaphors are happy and impressive; but whatever advantages the poet or the orator may derive from them, the most accurate analysis of the different subjects thus brought into contact, will never enable the philosopher to form one new conclusion concerning the nature either of the one or of the other. I mention this particularly, because it has been too little attended to by those who have speculated concerning the powers of the Mind. The words which denote these powers are all borrowed (as I have already observed repeatedly) from material objects, or from physical operations; and it seems to have been very generally supposed, that this implied something common in the nature or

attributes of Mind and of Matter. Hence the real origin of those analogical theories concerning the former, which, instead of advancing our knowledge with respect to it, have operated more powerfully than any other circumstances whatever to retard the progress of that branch of science.

There are, however, no cases in which the transferences of words are more remarkable, than when the mind is strongly influenced, either by pleasurable or by painful sensations. The disposition we have to combine the causes of these, even when they arise from the accidental state of our own imagination or temper, with external objects presented simultaneously to our organs of perception; and the extreme difficulty, wherever our perceptions are complex, of connecting the effect with the particular circumstances on which it really depends, must necessarily produce a wide difference in the epithets which are employed by different individuals, to characterise the supposed sources of the pleasures and pains which they experience. These epithets, too, will naturally be borrowed from other more familiar feelings, to which they bear, or are conceived to bear, some resemblance; and hence a peculiar vagueness and looseness in the language used on all such subjects, and a variety in the established modes of expression, of which it is seldom possible to give a satisfactory explanation.

Secondly, although by far the greater part of the *transitive* or derivative applications of words depend on casual and unaccountable caprices of the feelings or of the fancy, there are certain cases in which they open a very interesting field of philosophical speculation. Such are those, in which an analogous transference of the corresponding term may be remarked universally, or very generally, in other languages; and in which, of course, the uniformity of the result must be ascribed to the essential principles of the human frame. Even in such cases, however, it will by no means be always found, on examination, that the various applications of the same term have arisen from any common quality, or qualities, in the objects to which they relate. In the greater number of instances, they may be traced to some natural and universal associations of ideas, founded in the common faculties, the common organs, and the common condition of the human race; and an attempt to investigate by what particular process this uniform result has been brought about, on so great a variety of occasions, while it has no tendency to involve us in unintelligible abstrac-

tions of the schools, can scarcely fail to throw some new light on the history of the human Mind.

I shall only add, at present, upon this preliminary topic, that, according to the different degrees of intimacy and of strength in the associations on which the *transitions* of language are founded, very different effects may be expected to arise. Where the association is slight and casual, the several meanings will remain distinct from each other, and will often, in process of time, assume the appearance of capricious varieties in the use of the same arbitrary sign. Where the association is so natural and habitual, as to become virtually indissoluble, the transitive meanings will coalesce into one complex conception; and every new *transition* will become a more comprehensive *generalisation* of the term in question.

With these views, I now proceed to offer a few observations on the successive generalisation of that word of which it is the chief object of this essay to illustrate the import. In doing so, I would by no means be understood to aim at any new theory on the subject; but only to point out what seems to me to be the true plan on which it ought to be studied. If, in the course of this attempt, I shall be allowed to have struck into the right path, and to have suggested some useful hints to my successors, I shall feel but little solicitude about the criticisms to which I may expose myself, by the opinions I am to hazard on incidental or collateral questions, not essentially connected with my general design.

Notwithstanding the great variety of qualities, physical, intellectual and moral, to which the word *beauty* is applicable, I believe it will be admitted, that, in its primitive and most general acceptation, it refers to the objects of sight. As the epithets *sweet* and *delicious* literally denote what is pleasing to the palate, and *harmonious* what is pleasing to the ear; as the epithets *soft* and *warm* denote certain qualities that are pleasing in objects of touch and feeling, so the epithet *beautiful* literally denotes what is pleasing to the eye. All these epithets, too, it is worthy of remark, are applied *transitively* to the perceptions of the other senses. We speak of *sweet* and of *soft* sounds; of *warm*, of *delicious*, and of *harmonious colouring*, with as little impropriety as of a *beautiful voice*, or of a *beautiful piece of music* . . . If the *transitive* applications of the word *beauty* be more numerous and more heterogeneous than those of the words *sweetness, softness*, and *harmony*, is it not probable that some account of this peculiarity may be derived from the

comparative multiplicity of those perceptions of which the eye is the common organ? Such, accordingly, is the very simple principle on which the following speculations proceed; and which it is the chief aim of these speculations to establish . . .

The first ideas of *beauty* formed by the mind are, in all probability, derived from *colours*. Long before infants receive any pleasures from the beauties of form or of motion (both of which require, for their perception, a certain effort of attention and thought), their eye may be caught and delighted with brilliant colouring, or with splendid illumination. I am inclined, too, to suspect that in the judgment of a peasant, this ingredient of beauty predominates over every other, even in his estimate of the perfections of the female form; and, in the inanimate creation, there seems to be little else which he beholds with any rapture . . .

From the admiration of *colours* the eye gradually advances to that of *forms*; beginning first with such as are the most obviously regular. Hence the pleasure which children, almost without exception, express when they see gardens laid out after the Dutch manner; and hence the epithet *childish* or *puerile*, which is commonly employed to characterise *this* species of taste; one of the earliest stages of its progress both in individuals and nations.

When, in addition to the pleasures connected with *colours*, external objects present those which arise from the modifications of *form*, the same name will be naturally applied to both the causes of the mixed emotion. The emotion appears, in point of fact, to our consciousness, simple and uncompounded, no person being able to say, while it is felt, how much of the effect is to be ascribed to either cause, in preference to the other; and it is the philosopher alone who ever thinks of attempting, by a series of observations and experiments, to accomplish such an analysis . . .

Similar remarks may be extended to the word beauty, when applied to *motion*, a species of beauty which may be considered as in part a modification of *form*; being perceived when a pleasing *outline* is sketched, or traced out, to the spectator's fancy. The beauty of motion has however, beside this, a charm peculiar to itself; more particularly when exhibited by an animated being — above all, when exhibited by an individual of our own species. In these cases, it produces that powerful effect, to the unknown cause of which we give the name of *grace* — an effect which seems to depend, in no inconsiderable degree, on the additional interest which the pleasing form derives from its fugitive and evanescent

existence; the memory dwelling fondly on the charm which has fled, while the eye is fascinated with the expectation of what is to follow. A fascination somewhat analogous to this is experienced when we look at the undulations of a flag streaming in the wind, at the wreathings and convulsions of a column of smoke, or at the momentary beauties and splendours of fireworks, amidst the darkness of the night. In the human figure, however, the enchanting power of graceful motion is probably owing chiefly to the living expression which it exhibits — an expression ever renewed and ever varied — of taste and of mental elegance.

From the combination of these three elements (of *colours*, of *forms*, and of *motion*), what a variety of complicated results may be conceived! And in any one of these results, who can ascertain the respective share of each element in its production? Is it wonderful, then, that the word beauty, supposing it first to have been applied to colours alone, should gradually and insensibly acquire a more extensive meaning?

In this enlargement, too, of the signification of the word, it is particularly worthy of remark, that it is not in consequence of the discovery of any quality belonging in common to colours, to forms, and to motion, considered abstractly, that the same word is applied to them indiscriminately. They all, indeed, agree in this, that they give pleasure to the spectator; but there cannot, I think, be a doubt that they please on principles essentially different; and that the transference of the word beauty, from the first to the last, arises solely from their undistinguishable cooperation in producing the same agreeable effect, in consequence of their being all perceived by the same organ, and at the same instant . . .

I have already taken notice of the pleasure which children very early manifest at the sight of regular forms, and uniform arrangements . . . The same love of regular forms, and uniform arrangements continues to influence powerfully in the maturity of reason and experience, the judgments we pronounce on works of human art, where regularity and uniformity do not interfere with the purposes of utility. In recommending these forms and arrangements, in the particular circumstances just mentioned, there is one principle which seems to have no inconsiderable influence, and which I shall take this opportunity of hinting at slightly, as I do not recollect to have seen it anywhere applied to questions of criticism. The principle I allude to is that of the *sufficient reason*, of which so much is made (and in my opinion sometimes very erro-

neously made) in the philosophy of Leibniz. What is it that, in anything which is merely ornamental, and which at the same time does not profess to be an imitation of nature, renders irregular forms displeasing? Is it not, at least *in part*, that irregularities are infinite; and that no circumstance can be imagined which should have decided the choice of the artist in favour of that particular figure which he has selected? The variety of regular figures (it must be acknowledged) is infinite also; but supposing the choice to be once fixed about the *number* of sides, no apparent caprice of the artist, in adjusting their relative proportions, presents a disagreeable and inexplicable puzzle to the spectator. Is it not also owing, *in part*, to this, that in things merely ornamental, where no use, even the most trifling, is intended, the circular form possesses a superiority over all the others?

In a house, which is completely detached from all other buildings, and which stands on a perfectly level foundation, why are we offended when the door is not placed exactly in the middle; or when there is a window on one side of the door and none corresponding to it on the other? Is it not that we are at a loss to conceive how the choice of the architect could be thus determined, where all circumstances appear to be so exactly alike? This disagreeable effect is, in a great measure, removed the moment any purpose or utility is discovered; or even when the contiguity of other houses, or some peculiarity in the shape of the ground, allows us to imagine, that some reasonable motive may have existed in the artist's mind, though we may be unable to trace it. An irregular castellated edifice, set down on a dead flat, conveys an idea of whim or of folly in the designer; and it would convey this idea still more strongly than it does, were it not that the imitation of something else, which we have previously seen with pleasure, makes the absurdity less revolting. The same, or yet greater irregularity, would not only satisfy, but delight the eye, in an ancient citadel, whose groundwork and elevations followed the rugged surface and fantastic projections of the rock on which it is built. The oblique position of a window in a house would be intolerable; but utility, or rather necessity, reconciles the eye to it at once in the cabin of a ship . . .

The remarks which have now been made apply, as is obvious, to the works of man alone. In those of nature, impressed as they are everywhere with the signatures of Almighty Power, and of Unfathomable Design, we do not look for that obvious uniformity

of plan which we expect to find in the productions of beings endowed with the same faculties, and actuated by the same motives as ourselves. A deviation from uniformity, on the contrary, in the grand outlines sketched by *her* hand, appears perfectly suited to that *infinity* which is associated, in our conceptions, with all her operations; while it enhances to an astonishing degree the delight arising from the regularity which, in her minuter details, she everywhere scatters in such inexhaustible profusion.

It is indeed by very slow degrees that this taste for natural beauty is formed; the first impulse of youth prompting it (as I before hinted) to subject nature to rules borrowed from the arts of human life. When such a taste however is at length acquired, the former not only appears false, but ludicrous; and perishes of itself, without any danger of again revising. The associations, on the other hand, by which the love of nature is strengthened, having their root in far higher and nobler principles of the mind than those attached to puerile judgments which they naturally supplant, are invariably confirmed more and more, in proportion to the advancement of reason and the enlargement of experience . . .